Pottery on the Wheel

12 11 10 09 08 5 4 3 2 1

Published by Allworth Press
An imprint of Allworth Communications, Inc.
10 East 23rd Street, New York, NY 10010

Cover design by Derek Bacchus
Interior design by Jacqueline Schuman
Cover photo by Steven Smolker

Library of Congress Cataloging-in-Publication Data

Woody, Elsbeth S.
 Pottery on the wheel / Elsbeth S. Woody.
 p. cm.
 Originally published: New York : Farrar, Straus and Giroux, 1975.
 ISBN-13: 978-1-58115-502-0 (pbk.)
 ISBN-10: 1-58115-502-6
 1. Pottery craft. I. Title.

 TT920.W66 2008
 738--dc22

 2007046498

Printed in Canada

To Mami and Margot
E.S.W.

To my parents
S.S.

Also by Elsbeth S. Woody
Handbuilding Ceramic Forms

CONTENTS

INTRODUCTION

The odd expression "throwing" on the wheel means "turning" a perfectly symmetrical pot from a solid piece of clay with the aid of a machine, the potter's wheel. The original meaning of the word "throwing" was "turning"; in this ancient craft the old meaning has remained alive. Clay vessels have been fashioned in this manner from the beginning of written history in Egypt, and thrown pottery can be dated in China and Europe as far back as 2000 B.C.

Before discussing in detail the process of throwing on the wheel, it will be useful for us to examine the basic properties of clay and the principles of throwing that are common to the whole process.

Clay is one of the most abundant materials on earth. There are many different types, which vary according to color, texture, and the temperature to which they can be fired. A potter mixes the various types of clay to produce a clay body that suits his particular needs.

Clay has some unique characteristics that make its use for the formation of vessels and other objects both possible and exciting. Clay is plastic when it contains the right amount of water. That means it can be pushed and stretched into almost any shape and it will hold that shape. Clay hardens as it dries, and when subjected to sufficient heat, it vitrifies and becomes almost indestructible. Also, clay shrinks somewhat as it dries and shrinks again when it vitrifies. For the purpose of throwing, one should know that clay supports its own weight well even when wet, but does not withstand the stress of projecting the wall outward. We are most interested in the plasticity of the clay when we are shaping clay on the wheel, since this property enables us to form the walls of the pot on the wheel and to stretch or contract the diameter of the pot.

The wheel is a mechanical device that allows us to make hollow, perfectly symmetrical, round forms out of a solid ball of clay. There are many types of wheels available, but from the earliest time of its use almost five thousand years ago, it has basically consisted of a circular wheelhead that rotates horizontally around a central axis. This rotating motion can be powered by man or by motor.

Anyone who has watched a pot being thrown on the potter's wheel either thinks it is easy or is convinced that some magic is involved. Anyone who has tried it knows neither is true. Throwing on the potter's wheel is a manual skill; no more, no less. The skill has to be acquired step by step and by repeating certain motions until they become automatic, very much as one learns to drive a car or to use a typewriter. Needless to say, this requires patience and discipline. One's compulsion to make a teapot after the first two lessons is like the desire to drive in rush-hour traffic after two driving lessons; but just as most people manage to learn to drive, most people can learn to throw a pot.

Even though throwing is a manual skill, it is not the hands alone that are involved. The whole body and the mind are used. The area of contact between the clay and the potter may be less than a square inch, but the position of the body in relation to the clay, the position of the arms, the tension that permeates the body from the toes to the fingertips, are all important.

The most important principle of throwing is to make use of the circular motion of the wheel. Because of the circular motion the potter can touch the clay only at one point and still control all the clay. The potter exploits the circular motion at all times; the novice must constantly remind himself of this, until it becomes second nature.

Even though the motion of the wheel allows the potter to control a large area of clay by applying pressure at only one point, the resulting friction demands that the area of contact be kept small. The smaller the area of contact, the greater the control over the clay, and the more effective the use of one's strength. A layer of water is used to cut down on the amount of friction and the constant lubrication of hands and clay is necessary. Hands and clay should never be dry. If they do dry, release the clay slowly and lubricate by squeezing water from a sponge onto the clay, then use the sponge to remove excess water from the wheelhead. Then begin where you left off, applying pressure just as gradually as you released it.

Since the clay is formed by applying pressure to a specific area of the clay, the amount of pressure varies and can be described only in relative terms. In general, the pressure is in direct proportion to the responsiveness of the clay. When the clay is a solid ball the pressure is greater than when the hands touch a thin wall of clay. Whenever one changes pressure or stops a particular motion—in particular, when one releases the clay—one must do so very gradually. Clay responds to any change in pressure; too abrupt a change will force it off center. The way the pressure is applied is also important. Clay is never forced but is coerced into its proper place by firm persuasion. Therefore, the hands and tools are always held like a tangent on a circle, not like the extension of the radius. The tool or hand will then touch the pot in only one place and at the proper angle.

A beginner's misconception is that a great deal of physical strength is required. Although a certain amount of strength is necessary, brute force is detrimental to the process. Steadiness and a kind of inner center and sensitivity to the clay are more important than physical strength.

It must be said that there is no one way to throw on the potter's wheel. Every potter develops his or her own way. The procedures discussed in this book are common to all potters but should serve only as a basis to be used until you fall naturally into your own style. If what you learn to do feels right and does the job, it *is* right.

Throwing is a rhythmic and flowing process, a dialogue between the potter and the clay, with the hands as the link. It is hard to convey the process in still photographs. What I have done is dissect the throwing process and photograph each step, pointing out the important underlying principles in close-up detail, freezing the process at crucial moments so the novice can study and imitate the exact position of the hands, the tools, the body. Imitation is an important part of learning a manual skill and I think the text and photographs given here will aid the learner. Real feel for the clay will come only with long, thoughtful practice on the wheel.

A note to left-handed people: left-handers may substitute left for right, but they also must change the direction of the rotation of the wheel from counterclockwise to clockwise (some electric wheels do not turn in this direction) and work on the left-hand side of the wheel. In the Orient, potters throw left-handed and have produced some of the most beautiful ceramics in existence. You will find that throwing is an activity that is basically ambidextrous; each hand plays an equally important part.

1

Basic Shapes
and Techniques

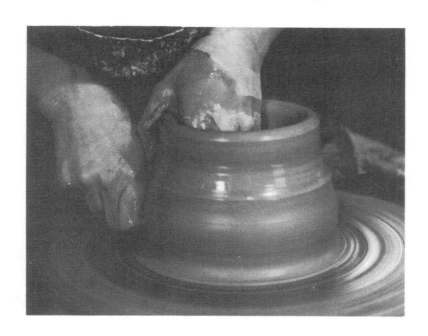

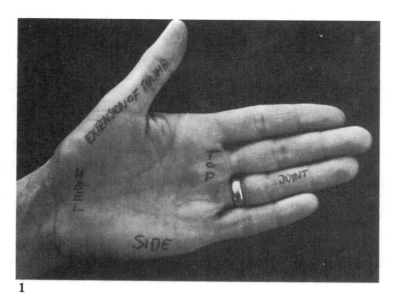

1

The forming process for all pots on the wheel consists of centering the clay, dropping the hole, opening up the clay, raising the clay, shaping, and trimming. Each step is dependent on the successful completion of the previous one. These steps will be discussed in detail, giving the position of the hands and body, the contact and pressure area of hands and clay, the speed of wheel rotation, and the amount of pressure exerted by the hands. First we discuss throwing cylindrical forms and then throwing open shapes. The reason for this division is that all shapes fall into one of these two categories, and that from the outset the throwing procedure differs. The cylinder is the basic form from which most vase shapes, pitchers, teapots, bottles, and jugs are made. Plates, shallow or deep bowls, casseroles, and planters are open shapes.

Before beginning our discussion of throwing on the wheel, it is necessary to define certain terms. Throughout, I will distinguish between pressure area and contact area. *Pressure area* is the area of the hand where you apply pressure to the clay. *Contact area* is the area of the hand that touches or rides on the clay but does not exert any noticeable pressure.

In order to avoid confusion, the areas of the palm will be broken into the *top edge,* the area where the fingers join the palm; the *side edge,* the area running along the side of the hand from the root of the little finger to the wrist; the *heel,* where the hand meets the wrist; and finally, the *extension of the thumb* into the palm. The area on the fingers between two knuckles will be referred to as *joints,* numbering them by starting from the tip of the finger [1].*

The wheelhead will be divided like the face of a clock. The point nearest you will be considered six o'clock, opposite twelve o'clock, and so on.

Reference will also be made to the various consistencies of clay before it is fired. Clay at the proper working consistency is called plastic—it will not stick to your hands or be so hard that you cannot work it. When more water is added and the clay takes on the consistency of mayonnaise, we call it slip. The clay is leather hard when it has been allowed to dry somewhat but still contains moisture and can be dented with pressure from the fingers. Clay is bone dry when it is completely dry. At this stage it should not be worked.

* Numbers in brackets refer to photographs.

Tools and Wedging

Aside from the wheel, the tools needed for throwing are simple ones: a water bucket, an elephant-ear sponge, a needle tool, a flexible metal rib in the shape of half a heart, some modeling tools, two strands of fine wire twisted together with a piece of wood or a button at each end, and a pointed knife [2]. Bats, made out of plywood or plaster to throw open shapes on, braided nylon fishing line for cutting pots off the hump, and trimming tools are needed for specialized throwing techniques.

Every shop area, no matter how small, should have a slab of plaster about four inches thick for wedging and reprocessing clay. A large plastic garbage can is needed to reprocess clay in, as well as shelves and plywood boards for storing pots. The plastic covers used by dry cleaners will keep pots moist for days. Even though pots can be thrown in a relatively small space, the activity is a dirty one. People have thrown in bedrooms, kitchens, and family rooms; a garage or basement is better suited, however.

Throwing is only one aspect of making pots; a glazing area and a kiln are needed to finish the thrown pieces.

The preparation of the clay consists of finding a suitable clay body for throwing. Clay bodies can be purchased mixed with water to the proper consistency, but one always has to wedge the clay just prior to putting it on the wheel.

Wedging clay means kneading it in such a way that a perfectly homogeneous cone of clay results. Clay is wedged to remove all air bubbles and hard and soft lumps; and to distribute evenly all materials that make up the clay body. A well-wedged cone of clay is the first prerequisite for throwing a pot.

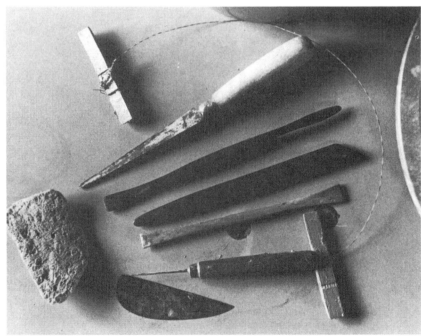

2

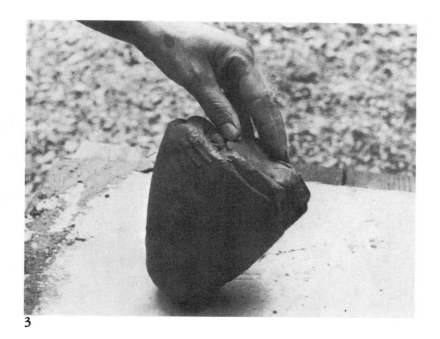

3

Wedging consists of two interlocking motions. The left hand rotates and guides the clay, while the right hand does the kneading. These two motions are done rapidly and from 40 to 100 times, depending on the condition of the clay. This technique of wedging is hard to learn, but is superior to the method of slicing the clay and piling the two slices on top of each other. The slicing and piling method has a tendency to splatter clay, but more serious defects are that more air is trapped than removed, and that it does not produce the cone shape, which facilitates centering.

In order to understand the position of the hands, one must start with the final product of wedging, a cone; in particular, a cone standing on its point [3]. The left hand is always placed, slightly cupped, over the bottom of the cone, while the right hand is placed on the side of the cone along the bottom edge.

With each sequence of interlocking motions between the left and the right hand, the cone is rotated on its point.

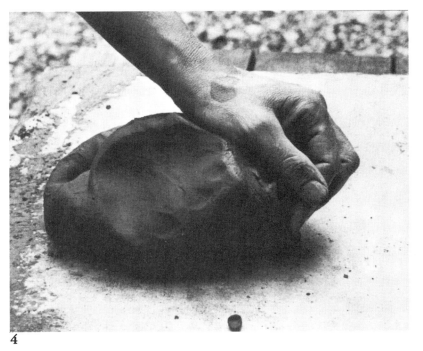

4

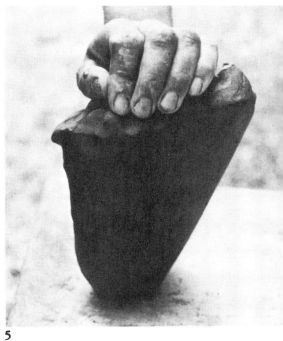

5

To begin, push the clay into a rough cone shape. Place the left hand, slightly cupped, over the bottom [4]. Lift the cone up on its point in a spiral clockwise motion with the left hand [5]. Place the right hand at the side of the cone with the thumb and index finger along the bottom edge [6]. Swivel the left hand counterclockwise one quarter turn [7]. Press down with the heel of the right hand, folding some clay from behind. The left hand remains on the clay but does not exert any pressure [8]. The left hand is then in a position to lift the clay in a clockwise spiral, the right hand goes behind the first indentation of the heel of the hand on the side of the cone, but along the bottom edge, and presses down, folding some more clay from behind; the left hand lifts . . . and so on.

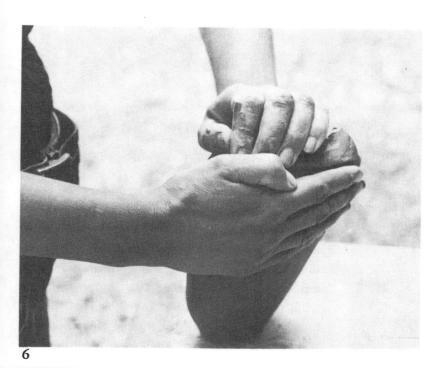

6

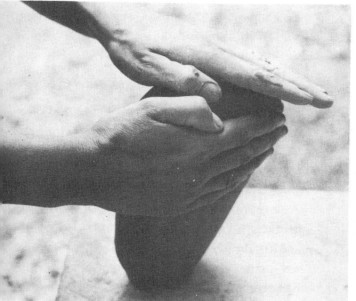

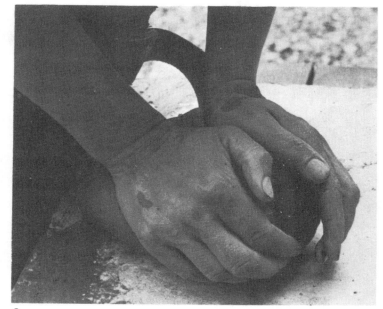

8

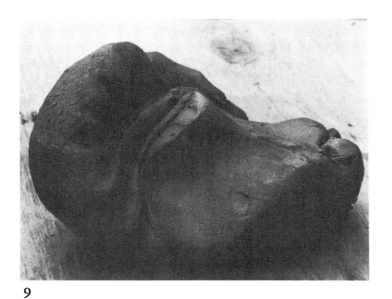

9

The clay should assume a tongue-like shape [9] with a clear pattern of folds, a sharp indentation from the heel of the right hand, and a slight indentation from the left hand. The two hands have totally different functions and actions. The left hand rotates the clay, lifts it into the right hand, and guides it, while the right hand presses the clay down. The clay is rotated only while it is lifted. It is pressed down straight, without rotation.

It is important to realize that wedging is done not only with the hands but with the entire body. Your feet should be planted firmly so you can rock back and forth, using the weight of your body when pressing down.

The surface you wedge on should be lower than a normal table, at about the height of your wrist, and slightly absorbent. For clay of the proper consistency, wedge on wood or hard asbestos board; for wet clay, use a slab of plaster. It is difficult to tell when the clay is sufficiently wedged —the length of wedging time is entirely determined by the condition of the clay. (If the clay is very lumpy, it is a good idea either to cut it into thin slices with a wire before wedging or to spread it with the heel of the hand over a clean, smooth surface in a thin layer [10].) When the clay feels dense and tightly structured, it has been sufficiently wedged. Start to press down less and less with the heel of the right hand, while still going through the other motions. This will produce the cone shape. The bottom of the cone can be rocked on the slab to produce a smooth convex surface.

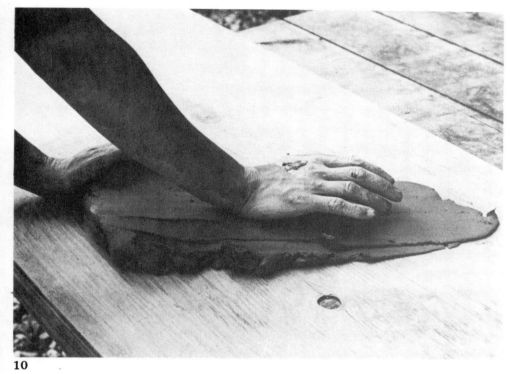

10

Summary

- Push clay into rough cone shape [3].

- Place left hand over bottom of cone [4].

- Lift clay with left hand in clockwise spiral. Note twist of wrist [5].

- Place right hand at side of cone with thumb and index finger along bottom edge slightly behind cone [6].

- Swivel left hand counterclockwise without moving clay [7].

- Press down straight with heel of right hand, folding some clay from behind [8].

- Repeat rapidly 40 to 100 times, or until clay feels wedged. Then go through motions but press down less and less until cone shape is formed.

- Lumpy clay should be spread thinly on clean, slightly absorbent surface prior to wedging [10].

Throwing Cylindrical Shapes

Centering

Centering, one of the most vital and difficult steps to learn, means moving the clay into a perfectly symmetrical position on the central axis of the rotating wheelhead. This is achieved in two steps: the cone-shaped, wedged clay is first pushed into a higher and thinner cone [11–14] and then brought down into a truncated cone shape [16–20]. This procedure is then repeated to a lesser extent until the clay is centered [22–5]. The important thing in centering is that the potter has to resist at all times the movement of the uncentered clay. If the hands are held in a fixed position, the clay will eventually adapt to the shape that is described with the hands. Remember that clay is an inert mass with no will of its own and is soft and pliable. The potter has the will, the power, and the determination to control the few pounds of clay.

First, firmly place the cone of clay on the dry wheelhead as close to the center as possible. The wheelhead should be between the legs. The body of the thrower should hover over it as close to the clay as possible. Brace your arms firmly against your body, feeling a tension throughout. Position your left hand so that the fingers are at right angles to the palm. The fingers of the right hand should be stretched out. Move gradually toward the clay with the wheel going counterclockwise at a fast rate [11]. Be ready from the outset to resist the force of the uncentered clay. Do not place your hands on the clay unless you are ready to take control.

The pressure area of the left hand is the heel of the palm. On the right hand it is the top edge. Both are placed vertically against the clay. The fingertips of the left hand may touch the clay without exerting pressure. The hands should be placed opposite each other across the central axis and start at the bottom of the cone, about a quarter of an inch above the wheelhead [12]. Exert firm pressure toward the center of the clay and slowly move the hands up, slightly tilting the hands in-

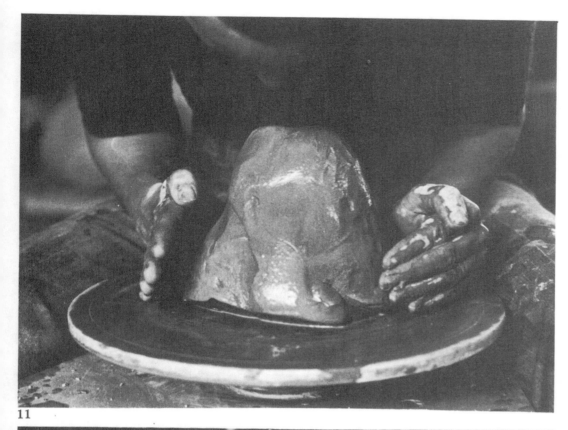

11

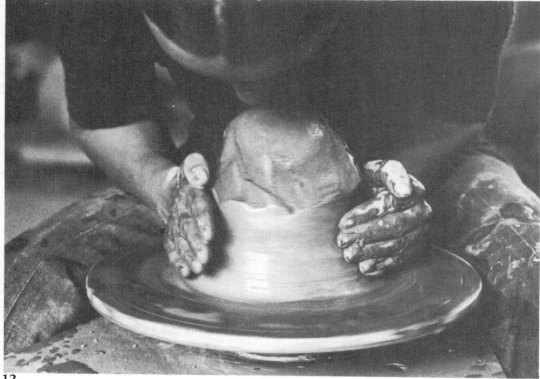

12

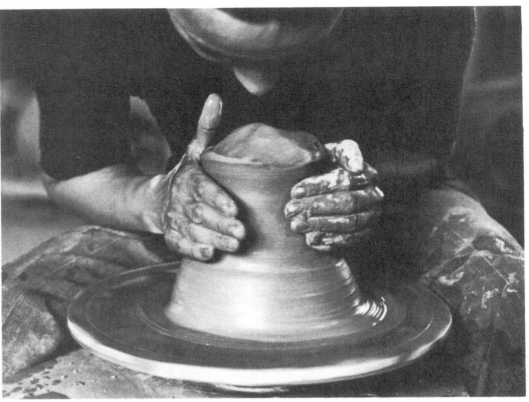

13

ward on top in order to achieve a cone shape [13, 14]. When the top edge is reached, release the clay slowly [14]. Under no circumstances give in to the clay; establish a diameter with your hands and hold it until the clay adapts to it.

It is essential to realize that whatever happens to the clay happens because of something you are doing to it. If the clay does not rise into a higher and thinner cone, more pressure is needed; if the clay is twisted off, too much pressure has been used; and if an uneven shape results, the pressure has not been consistent. If a spiral is created the upward movement of the hands has been too rapid. If a cup-shaped hollow is formed at the top of the cone, you have pulled up the surface of the cone and not exerted enough pressure to-

ward the center of the cone. And if the clay remains uncentered, your hands moved with the clay rather than resisting it. It is important that the motion be carried through consistently, without abruptly backing up and going over areas dealt with previously. Remember to keep your hands and the clay wet enough.

Before the next step of pushing the clay down, the first half inch of clay above the wheelhead should be centered by taking the excess clay off. This is known as undercutting. Using a sponge, move the right hand toward the clay from the outside edge of the wheelhead, taking the excess clay off [15]. This can be repeated as often as is necessary and is usually done after each major step.

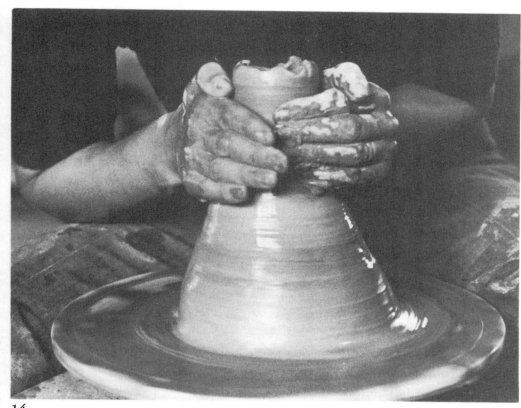

14

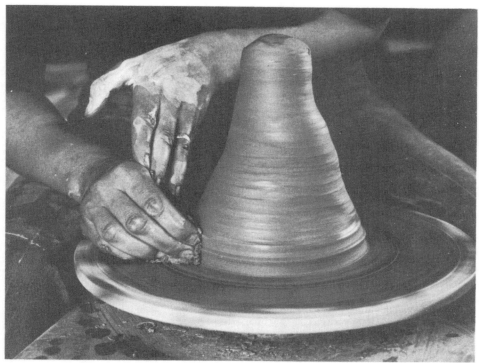

15

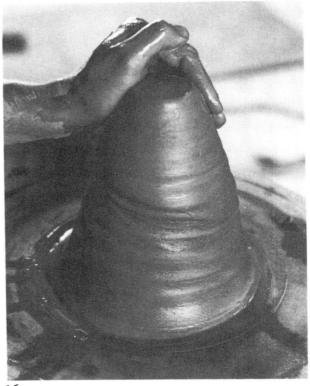

16

When bringing the clay down, the two hands perform different functions. The right hand pushes the clay down while the left hand controls the diameter of the cone. First place your left elbow firmly against your ribs and the extension of your left thumb vertically against the side of the cone at the top [16]. Note that the pressure area is the extension of the thumb only and not the whole hand. The fingertips may touch the clay, but they do not exert any pressure. Lean with your body into that elbow until you feel that you are controlling the clay. Also note that the contact area is slightly tilted inward toward the top to keep a cone shape. The function of the left hand is to control the side of the cone; it receives the clay that is pushed down with the right hand and establishes a diameter to which the clay adjusts itself.

The right hand pushes the clay down [17]. Note the small contact area at the side of the hand, reaching from the center of the clay back toward you. The two hands interlock with the thumb of the right hand braced on the top of the left hand, and they move down together [18]. Check your hands to see if you are really touching only with the areas described.

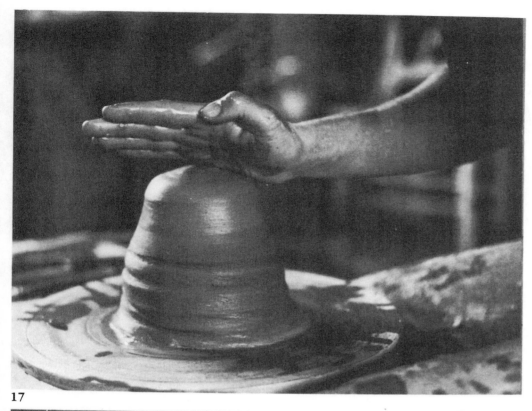

17

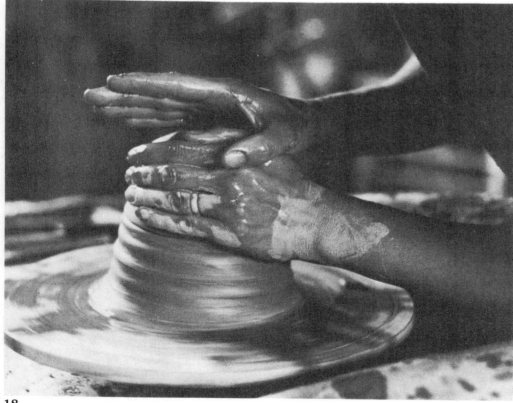

18

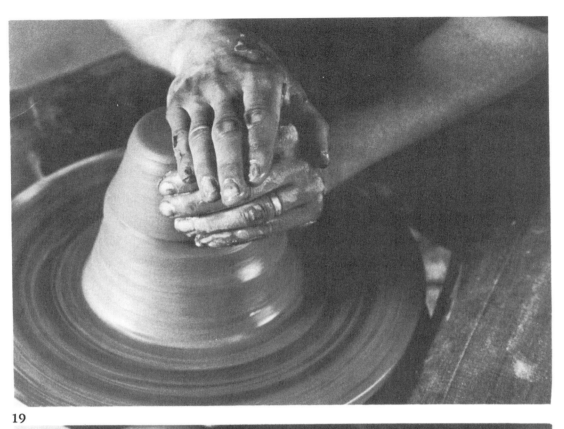

19

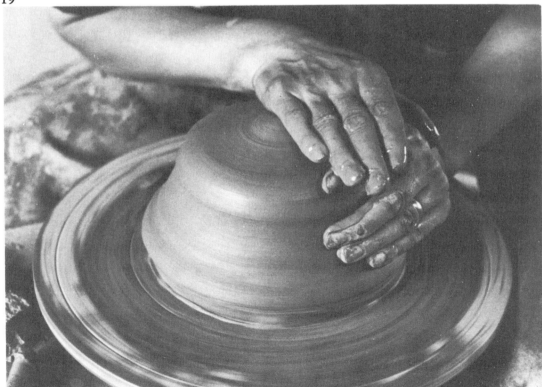

20

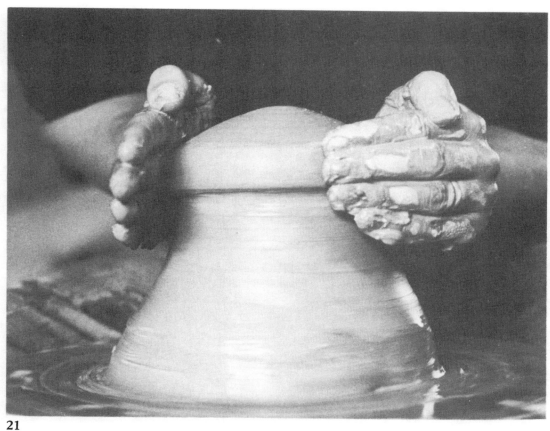

21

If equal pressure is applied from the top and the side, the clay will not move down. It is necessary to press slightly more from the top and to allow the diameter of the cone to expand a bit in order to move the clay down. Also, the tilt of the pressure area of the left hand ensures that this hand helps in moving the clay down, since it presses not just horizontally but also slightly downward [19, 20].

At no time allow the clay to assume the form of a mushroom. This may happen for two reasons: either the left hand is not at its proper place on the cone or it does not exert enough pressure. To avoid trapping air, push against the widest part of the mushroom with the hands in the same position as in pushing the cone up [21]. Then continue to push the clay down.

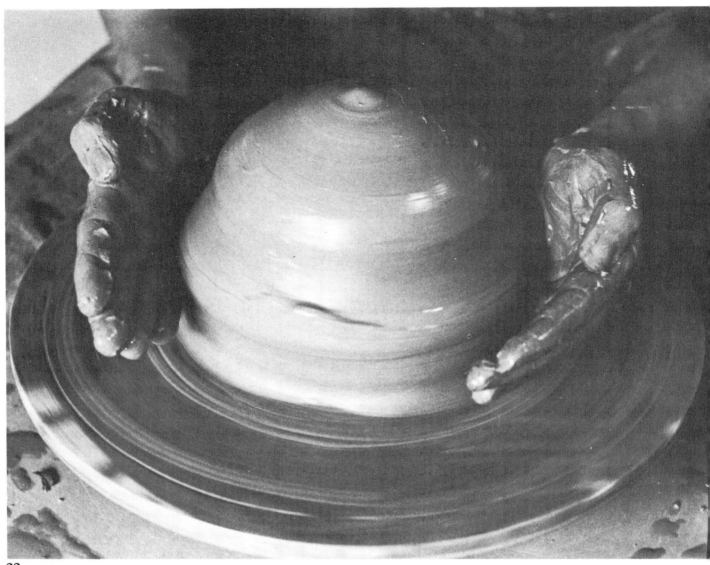

22

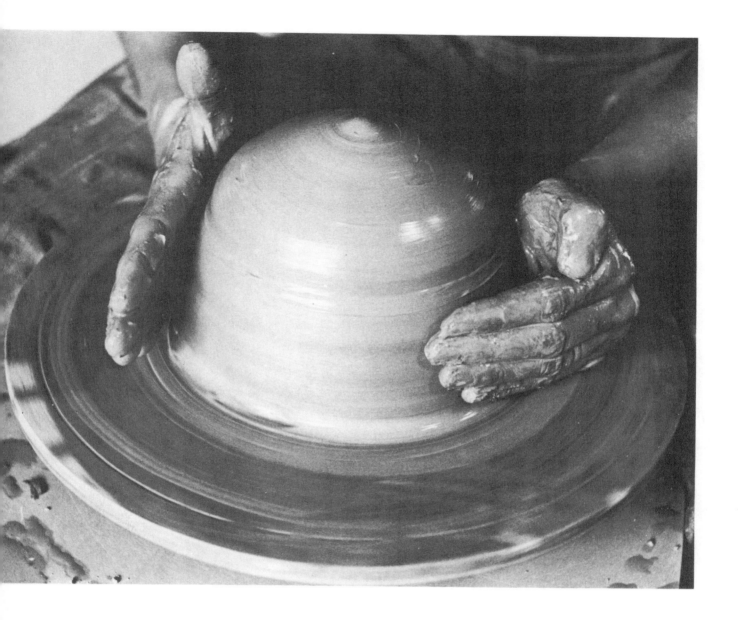

When pushing the clay down for the first time, avoid spreading the clay too much. Keep the truncated cone more high than wide, otherwise it is difficult to push it up again without forming a cup shape.

The major part of centering should be accomplished by this action of moving the clay up and down, but a repetition of these steps is almost always necessary. Pushing the clay up, however, is done to a lesser degree. When moving the clay up again, start out by undercutting slightly at the bottom with the side edges of the palms [22] in order to create a bulge against which you can then press with the full width of the hands [23]. To-

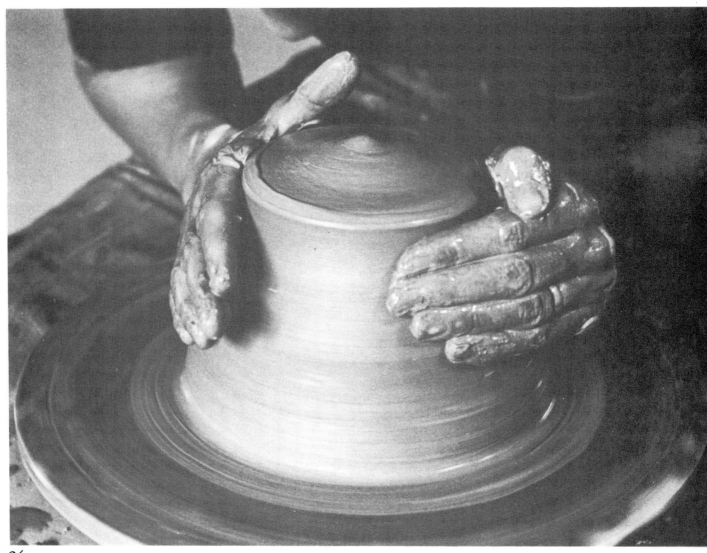

24

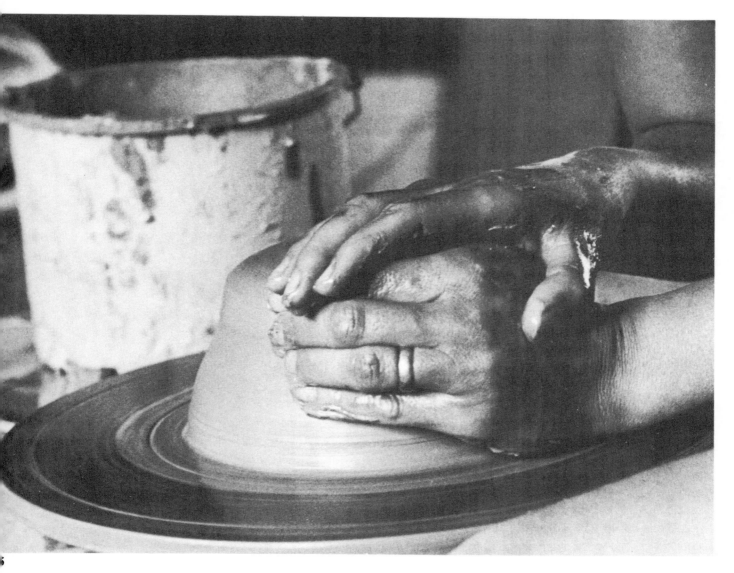

ward the top, tilt the hands inward to create a truncated cone shape [24]. Make sure that you press with the side edges of the palms only at the very bottom of the cone. As soon as you move your hands upward, switch immediately to the full width of the palm, that is the top edge of the palm.

Bring the clay down as described before [25]. This may be repeated as many times as is necessary. If the clay does not become centered, this is due to the fact that you are moving with the clay rather than controlling it. As explained in the

introduction, a layer of water should at all times act as a lubricant between the clay and the hands. Whenever the clay feels dry, stop gradually, lubricate, and pick up where you left off.

Depending on the amount of clay used, centering may seem to take a good deal of physical strength. It does, but to make it easier, use the weight of your body rather than your arms to hold the clay in place. Attitude is more important than physical strength. Do not be afraid to take charge of the clay and zero in on it mentally as well as physically.

Summary

- Place well-wedged, cone-shaped clay firmly on dry wheelhead. If you throw on a plaster bat, it will need to be dampened, otherwise it will draw too much moisture out of clay.

- Brace arms against body and hover over clay. Put fingers of left hand at right angles to palm and stretch fingers of right hand out [11].

- Move toward clay with wheel rotating counter-clockwise at fast rate, feeling tension throughout body.

- Move hands from bottom of cone (one quarter inch above wheelhead) toward top, pressing firmly toward center of cone with heel of left hand and top edge of palm of right hand [12–13].

- Release clay slowly when you reach top [14].

- Undercut clay [15].

- Place left elbow against rib cage and put weight on it. Extension of thumb of left hand is placed vertically against side of cone on top, thereby controlling diameter [16].

- Tilt left hand in slightly on top.

- With side edge of palm of right hand placed on top of cone from center toward you (not across center) [17], clay is pushed down, while the two hands are firmly interlocked with thumb of right hand braced against left hand [18–20].

- Move clay slightly up again by first undercutting with side edge of palms and then applying pressure with full width of palm, then tilting hands in on top [22, 23, 24].

- Bring clay down as before [25].

- Repeat as many times as necessary.

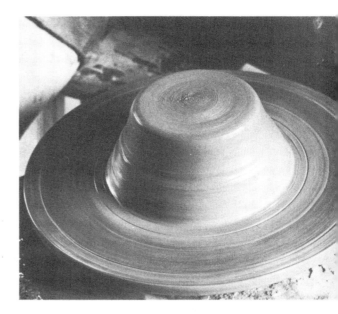

26

Dropping the Hole

Before proceeding to this step, the first penetration of the clay, it is essential to make sure that the block of centered clay is the right shape for the pot one intends to throw. For a cylindrical pot, the clay should be almost square, with the top slightly tapered in [26]. The bottom width of the block represents the maximum width of the bottom of the pot; therefore, for a pot with a wider bottom, the clay should be pressed down more.

Reduce speed of wheel slightly. Hold the left hand in the same position as when pushing the clay down in centering, but do not exert any pressure. Ride the fingertips of the right hand on top of the clay, while the right thumb interlocks the right hand with the left hand [27]. This gives the right hand enough strength to penetrate the clay without giving in to it.

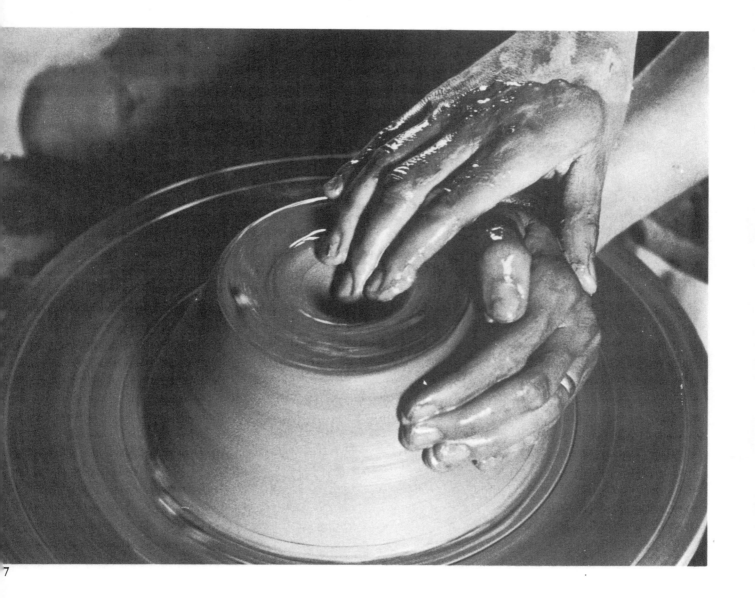

7

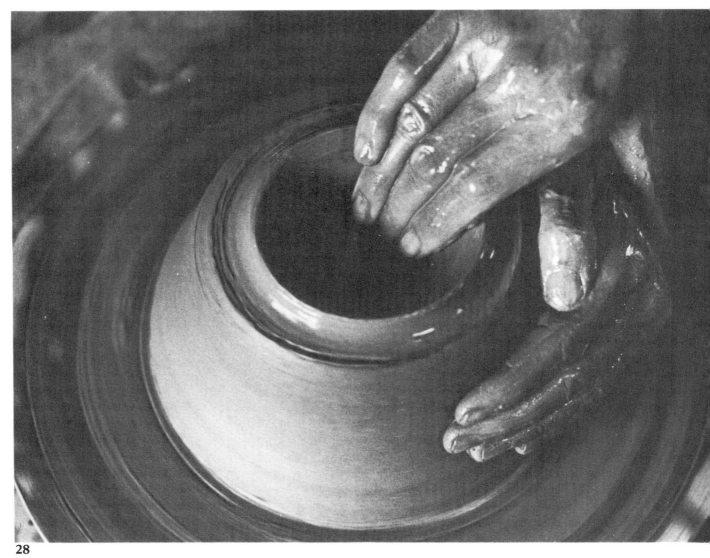

28

The fingertips of the right hand, in particular the middle finger, find dead center on the top of the clay. Insert your fingers down into the clay on your side of dead center. The middle finger is doing most of the work and the others brace it [28]. Avoid squeezing the clay between the left and right hand. The pressure area is only on the fingertips, mostly on the tip of the middle finger. The fingers do not penetrate the clay in a vertical position but at a slight angle away from you. This makes the hole wider on top, so that you can observe the depth of penetration; at the same time the contact area is limited to the inside of the middle finger.

While inserting the right hand, make sure you are holding it perfectly steady. Proceed slowly. Should the clay rock your hand, back up and firmly re-establish the diameter. Proceed to drop the hole until you have just enough clay left for the bottom of the pot [29]. To make sure you do not end up with a bottomless pot, stop the wheel and check the bottom thickness with a needle tool [30]. The function of the left hand during this step is twofold: it supports the right hand and it keeps the clay on center.

29

Summary

- Reduce speed of wheel somewhat.

- Place left hand against clay at six o'clock (just as in centering when bringing clay down) without exerting any pressure. Place fingertips of right hand on top of clay and thumb of right hand over left hand [27].

- Find dead center and insert fingers of right hand on your side of dead center. Tilt right hand toward you to enlarge hole on top [28, 29].

- Check thickness of bottom of pot with needle tool [30].

30

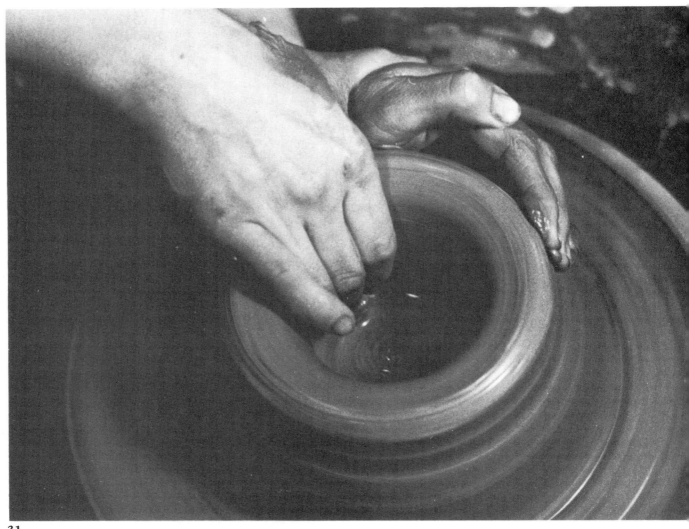

31

Opening Up the Clay

Opening up the clay establishes the inside diameter of the bottom of the pot once and for all. It is for that reason that the size and shape of the solid piece of clay prior to dropping the hole is of such importance to the final proportions of the pot. Needless to say, the clay can be opened only so far before threatening the structure of the pot with a weak spot at the bottom.

Opening up is done with the fingers of the right hand, and it creates a short cylinder with rather thick sides that taper inward on top.

Slow the wheel down from the previous speed. Keep the hands in the same position as in dropping the hole. The left hand should ride against the outside of the clay, and the fingers of the right hand are inserted into the clay. The thumb of the hand is braced against the left hand. Keeping the left hand firmly in place, the fingertips of the right hand, in particular the middle finger, move straight across the bottom of the pot from the center toward six o'clock, widening the opening at the bottom of the pot only [31]. The fingertips should slightly undercut the clay [32].

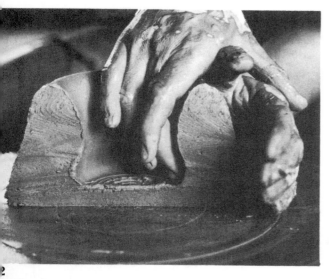

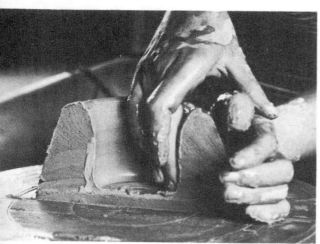

Once the undercut becomes too deep, straighten the fingers out [33]. This will remove the excess thickness above the undercut. This slight shift in pressure from the fingertips to the whole length of the fingers may be done several times while moving across the bottom of the pot [32, 33]. Please note that the outside shape of the clay does not change. The clay should also not be squeezed at the rim. Great care should be taken not to let the fingers of the right hand rise, since this creates a round rather than a flat bottom. The fingers should move steadily and very slowly across the bottom, proceeding only after the wheelhead has made a complete turn. Should the clay move your hand off center, back up a bit and re-establish a centered diameter before proceeding.

Summary

- Slow wheel down slightly.
- Keep hands in same position as in previous step.
- Move middle finger (backed by others) of right hand from center toward outside hand horizontally across bottom of pot, widening opening at bottom only [31].
- Alternate between undercutting with middle finger and straightening it out to reduce thickness of wall [32, 33].
- Release clay slowly when it is opened sufficiently.

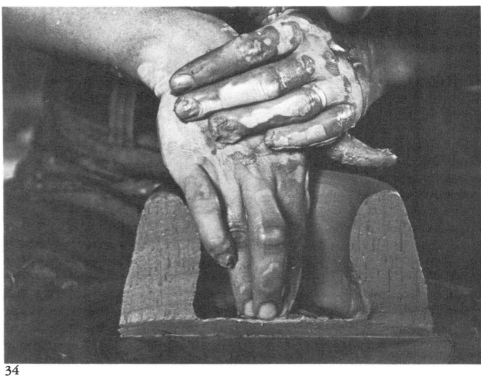
34

Cleaning the Bottom

It is almost always necessary to go over the bottom of the inside of the cylinder after opening up to make sure that it is flat. Bundle the index finger, middle finger, and ring finger of the right or left hand together. With the tips of these fingers, move across the bottom, either from the center out or the reverse, pressing down firmly until the bottom is perfectly flat [34].

Recentering the Rim

If the rim of the cylinder has been squeezed into a thin edge or thrown slightly off center, this is easily remedied. Create a channel between the thumb and the index finger of your left hand the same width as the clay and let the clay run through it at six o'clock without squeezing it [35]. Then lay the side edge of the palm of the right hand, exactly where the little finger starts, on top of the rim and interlock firmly with the left hand [36]. Press down gently until the rim is packed down to the same thickness as the rest of the wall.

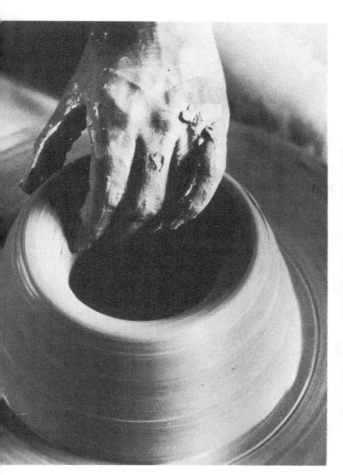
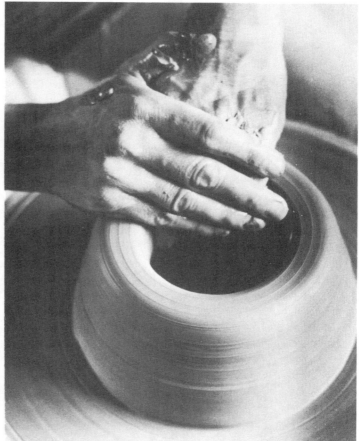

36

Raising the Wall

The walls of the short cylinder now have to be thinned and raised. This is achieved by applying pressure at one point on the circumference of the pot both from the inside and outside. The movement goes from the bottom up, and each movement is referred to as a pull. No more than three pulls should be necessary to achieve the desired wall thinness and height. The end result of this step should be a cylinder with evenly thin walls that taper in at the top.

Raising the wall requires a great deal of coordination of the two hands, subtle adjustments of pressure, and sensitivity to the clay.

Before raising make sure that the short cylinder is in the right shape. Adjustments can be made by recentering the rim as described above and by undercutting. This is done exactly like the undercutting of the solid piece of clay in centering. Remove the excess clay at three o'clock with the fingertips of the right hand, padded by a sponge and supported by the left hand. Take the excess clay off until you have made a slight indentation at the bottom of the cylinder [37].

The raising is achieved by squeezing the wall at the same point from the inside and from the outside. On the first pull this is done by placing the top edge of the right palm vertically against the cylinder at three o'clock and the fingertips of the left hand slightly cupped on the inside of the cylinder exactly opposite the right hand. Interlock the two hands using the left thumb [38, 39]. Move the fingertips of the left hand from the bottom up, squeezing the clay against the right hand where the wall seems to get thicker. As you approach the top, switch the pressure from the left hand to the right hand and press toward the center, so the cylinder will taper in on top. A cross section after the first pull should show a cylinder with slightly thinned walls that are well tapered in on top. This taper is extremely important: it counteracts the tendency of the rim to widen because of the centrifugal force and helps keep the pot on center. The objective of the first pull is not so much to thin the wall as to make sure that the wall is of even thickness, straight, and tapers gradually toward the top.

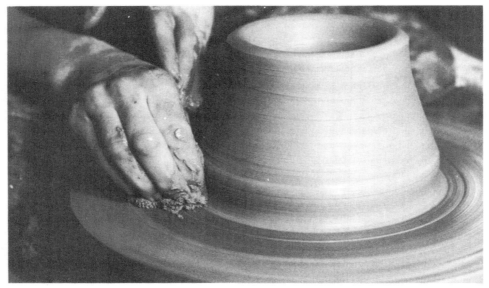

37

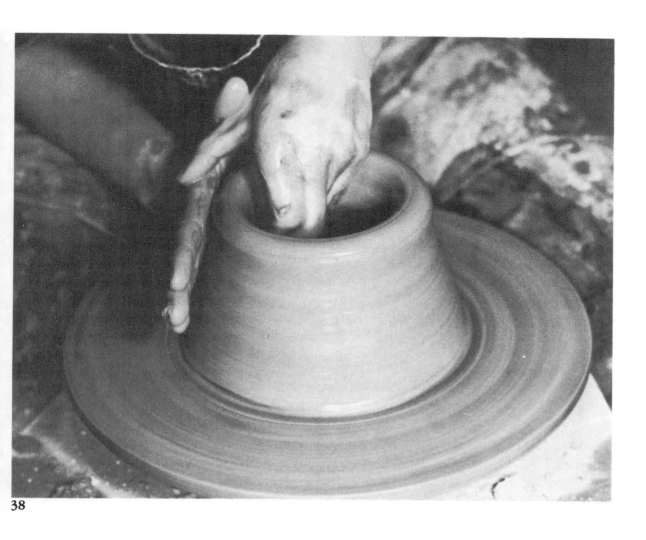

38

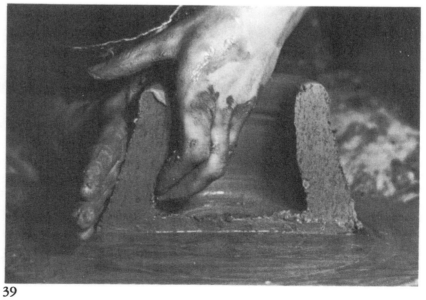

39

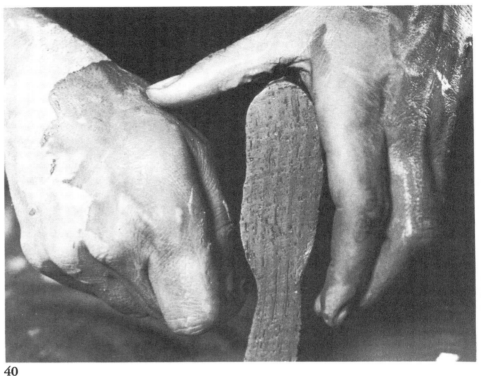

40

The second pull is the one that does most of the raising. First undercut the cylinder again at the bottom. The left hand remains on the inside of the cylinder. The fingers are slightly cupped (except for the index finger), so that the fingertips are on the same level horizontally. The pressure area is restricted to the fingertips. The slight bend in the fingers helps to gently lift the clay up and allows you to hold your hand vertically without increasing the contact area more than necessary [40].

On the right hand the index finger is bent over the straight thumb [41]. This gives enormous strength to the second joint of the index finger, which is the only pressure area and therefore does most of the work. Place this joint at three o'clock into the indentation created by the undercutting and press inward until you feel you have hold of the clay [42]. Then move the joint up until it is opposite the fingertips of the left hand, which are placed at the bottom edge of the cylinder on the inside. By pressing slightly out-

41

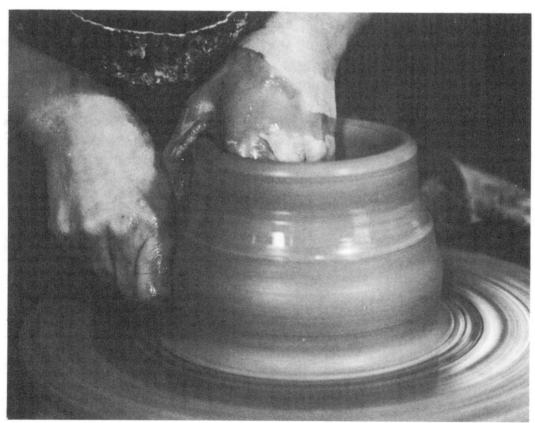

42

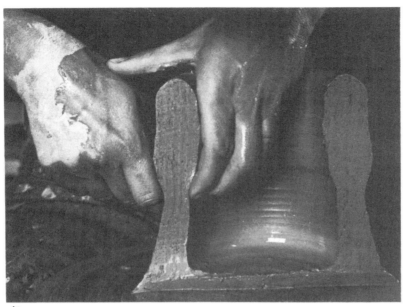

43

ward, create an undercut on the inside and then move both hands up together. In order to keep the hands exactly opposite on both sides of the wall, it is necessary to interlock them with the thumb of the left hand [43]. Come up slowly. The rotating motion of the wheel will create a tight spiral and the width of the throwing marks will indicate the speed of the hands in coming up [44, 45].

The wheelhead should always make a complete turn before you proceed up. Under no circumstances let the counterclockwise motion of the wheel pull your hands around the pot in that direction. In fact, as you come up, pull your hands slightly toward you so that your hands are at five o'clock when you reach the top. This helps to keep the taper on the cylinder and counteracts the pull of the wheel. In other words, you start at the bottom at three o'clock and finish at the rim at five o'clock.

As you come up the cylinder, adjustments in pressure have to be made. At the bottom there was slight outward pressure with the left hand in order to create the undercut that helps to bring the clay up from the bottom. In pulling up, gradually reverse the pressure until you press the clay mostly inward with your right hand. Since there is less resistance to the raising toward the top of the cylinder, you can decrease the pressure as you come up. Otherwise the wall will be a great deal thinner on top than at the bottom, a common mistake in beginners' pots.

While pressing in at the bottom with your finger joint to get hold of the clay, you should keep the joint parallel to the wheelhead. Once you have hold of the clay, twist the joint up slightly and pull up toward you [44].

During the whole operation, the arms up to the wrists are braced against the body. Hover over the clay with your nose two inches away from it and right above the rim at three o'clock. For additional support, the contact area of the right hand may extend over to the thumb and index finger and on the left hand over some of the index finger. This will also help to apply pressure in the right manner. Clay should never be forced; the pressure should be applied gently. This means holding the hands in an almost vertical position

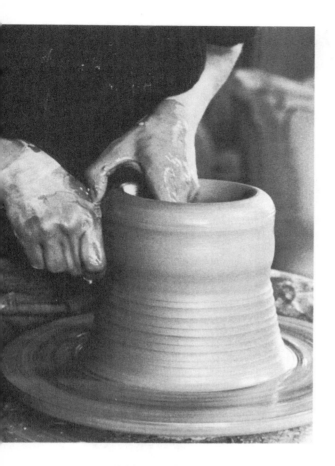

or, in other words, almost parallel to the wall.

After the second pull, take a good look at the cylinder. Since clay is an inert mass, the size and shape of the new cylinder will tell you exactly what you have done right or wrong. If the cylinder has not grown in size, not enough pressure has been applied to the wall. If there are thick spots and thin ones, the pressure was uneven or you have pulled up too fast. "Wide throwing" would be an indication of this. A twist in the clay indicates that there was too much friction, either from lack of water or from too much contact area. A flared rim indicates too much pressure with the inside hand.

The third pull is executed in very much the same fashion as the second one, except that (since the wall is much thinner now and therefore more fragile) the pressure has to be less and great care has to be taken not to twist the clay. Between each pull, the cylinder should be undercut to provide a place for the joint to get under and lift the clay, and the rim should be recentered.

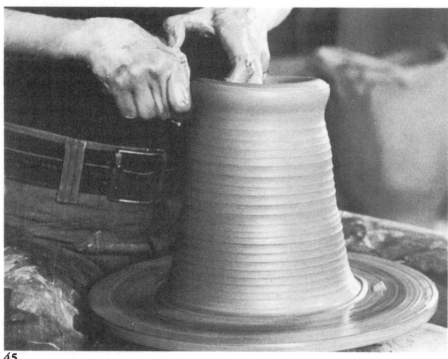

45

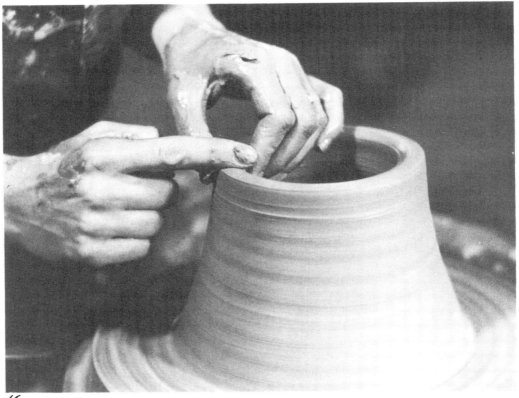

46

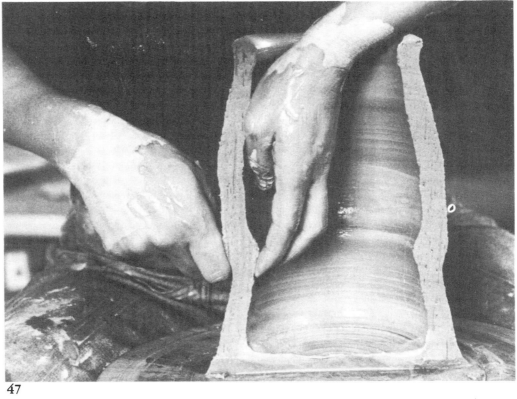

47

Since the rim is now thin, the first joint of the index finger of the right hand is used to pack it down [46]. Once the cylinder has grown too tall to be able to interlock the two hands with the thumb, the thumb goes inside the pot and may ride against the clay without exerting any pressure [47]. As soon as possible, however, the thumb should interlock again when the hand comes up. When the cylinder has become tall, the left elbow has a tendency to stick out into the air when one reaches deep inside the pot. Try to position yourself in such a way that your elbow can be braced against your body.

Remember that the hands and the walls should always be well lubricated with water. The water is best applied by squeezing it from the sponge onto the left hand, which is held over the rim with the fingers inside and the thumb on the outside of the pot [48]. This way both the inside and outside are lubricated in one action. During the throwing, particularly the raising, make sure that you do not collect water in the bottom of the pot. Take it out periodically with a sponge. Rotate the wheel while you insert your hand; then the pot is not thrown off center even if you touch the wall.

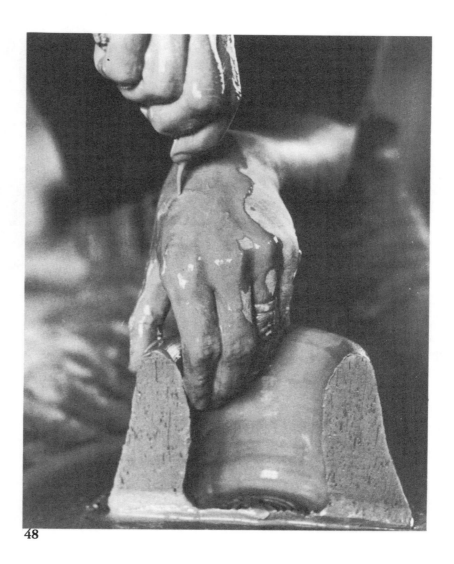

48

Summary

- Recenter rim.

- Undercut bottom [37].

- Place top edge of right palm vertically on outside of pot at three o'clock and fingertips of left hand on bottom edge of inside wall, exactly opposite palm [38, 39].

- Move inside hand up, pressing clay against outside hand where wall seems to be thicker.

- Toward top, reverse to pressure from inside hand to outside hand to keep wall tapered in on top [40].

- Undercut.

- For second pull, bend right index finger over thumb [41] and place in indentation created by undercut at three o'clock [42]. Fingertips of left hand are placed on inside against wall at very bottom. Pressure area for right hand is joint, for left hand fingertips. Contact area for right hand is thumb and index finger and for left hand index finger, thumb (if thumb is inside), and heel of palm [43, 47].

- Press joint of right index finger and fingertips of left hand into clay until bulge forms above the pressure areas on both inside and outside of wall [42]. Move outside hand up to meet inside hand and then move both up very slowly. Pull toward you as you come up and decrease pressure. Toward the top, press in more with right hand to keep taper of wall [43, 44, 45].

- Release clay slowly.

- Recenter rim [46].

- Undercut.

- Repeat procedure of second pull but with less pressure.

- Recenter rim.

- Undercut.

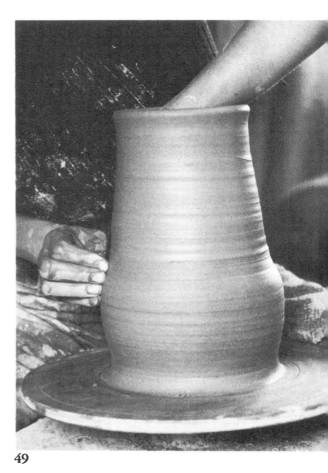

49

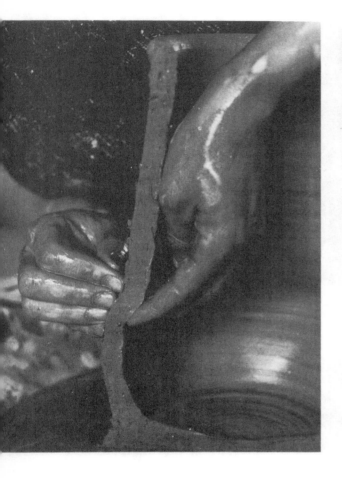
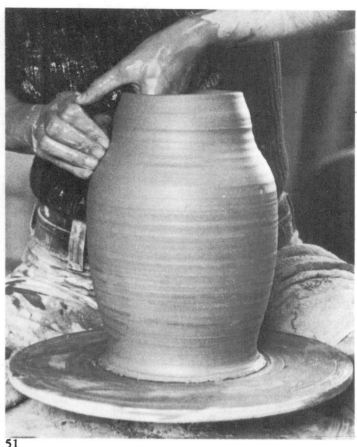

51

Shaping

Shaping is the process by which the potter gives the cylinder an expressive form. Technically, shaping should be thought of in terms of widening or narrowing the diameter of the cylinder. Widening is achieved by exerting pressure with the left hand from the inside outward [49–51]. The right hand supports the wall gently on the outside. The cylinder is made narrower by pressing with the

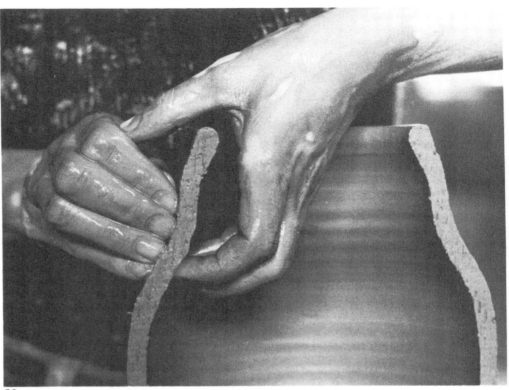

52

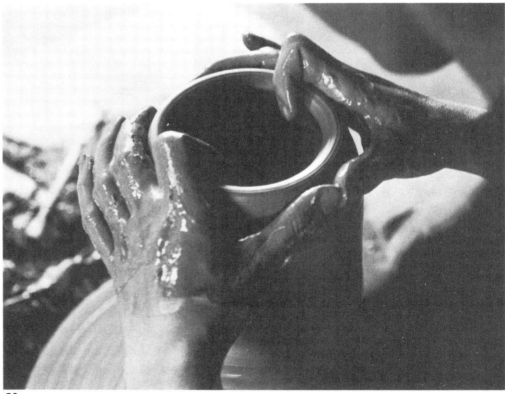

53

right hand inward toward the left hand, which in this case takes the supporting role [52]. In shaping, several factors have to be kept in mind.

1. A vertical clay wall will support itself quite well, but when one tries to cantilever clay out into space, great care has to be taken. This also means that extreme and abrupt changes in direction should be avoided until one has developed a good feel for the process.

2. Narrowing the cylinder at the bottom tends to throw the top part of the cylinder off center.

3. Widening the diameter always results in thinning the wall, and if an enormous increase in diameter is planned, additional thickness should be left when the wall is pulled up. Narrowing the diameter thickens the wall; this has to be corrected by alternate shaping and raising.

4. What makes a shape beautiful and interesting is not necessarily the complexity of the shape but the relationship of width to height—where the widest part of the pot is in relation to its height—and the finish of the lip and the certainty of the outline, plus the quality of the clay surface.

The position and contact area of the left hand stay the same as in raising. The contact area of the right hand changes. Since relatively little pressure is needed to change the shape, the fingertips of the right hand are used on the outside. It is essential that the fingertips be opposite each other. If the pot goes off-center during shaping, the fingertips are probably misplaced. Keep the fingertips of the inside hand in a horizontal position while the outside fingertips are in a vertical position, braced by the thumb resting against the index finger [49–51].

Start at the bottom and work your way up, pressing outward with the left hand if you desire to widen the diameter and pressing inward with the right hand if you wish to make it more narrow [52]. If the pot is small enough, interlock the hands with the left thumb; otherwise the thumb may ride against the inside of the pot for additional support [50]. If you bend your left arm in such a way that it just touches the rim, it helps to keep the pot on center [49]. The final shape should be arrived at in several movements. You may adjust the shape without starting at the bottom. Be careful not to overwork the shape; it will usually result in a weak form. The eyes should be over the pot at one o'clock, observing the outline of the pot rather than the hands.

The pressure needed to adjust the shape may be minute, nothing like the pressure used in raising. There are times when your hands can be barely floated on the clay and still effect a change. The pot is sometimes so fragile that it seems like a raw egg without the shell. For this reason the contact area has to be kept to a minimum and very little lubrication is necessary. It is often enough simply to wet your hands.

The process by which the diameter of a pot is narrowed sharply is called collaring. Different positions can be used to speed this collaring process. Only a cylinder of sufficient height can be divided into a belly and a neck. First, the bottom part of the pot is formed in the usual fashion, while the top is kept just wide enough to get the hand in. If necessary, the rim can be narrowed in the following manner: the outstretched thumb and middle finger of both your hands form a ring around the rim and contract it gently, while you hook your index fingers over the rim to keep it on center [53].

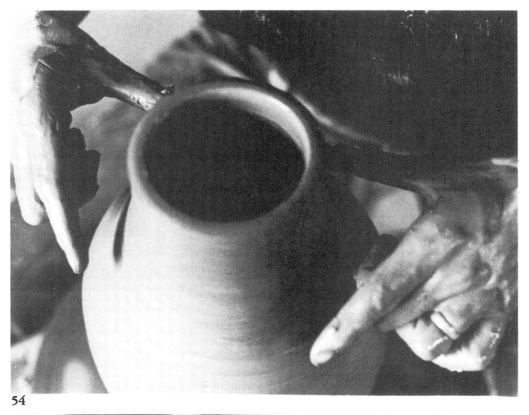

54

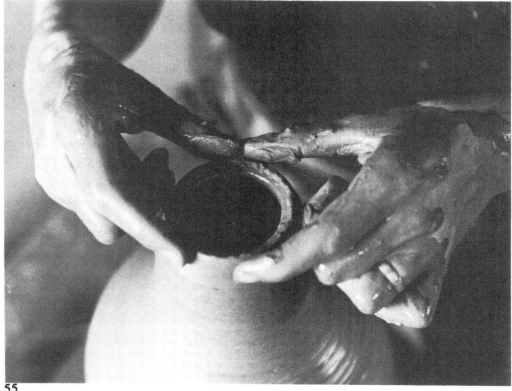

55

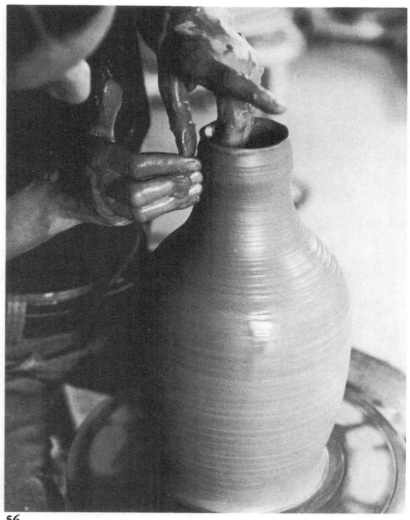

56

Then the collaring is done with a six-point system, namely, by the use of the thumb, index finger, and first knuckle of the middle finger of both hands placed on the outside of the neck. By distributing these pressure points around the circumference of the neck and moving them inward, you can narrow the neck very rapidly [54]. Start at the shoulder and press horizontally. Never press down—the shoulder will inevitably collapse. Come up to the lip with the wheel going somewhat faster than it usually does in shaping [55]. The thinner the wall is when you collar, the more rapidly the clay will contract.

You will feel that the wall is thickening. If it starts to ripple, you have applied too much pressure. The thickened wall must be thinned with pressure from the fingertips of the right hand on the outside and as many fingers as can be inserted on the inside [56]. Then the six-point system may be used again until the neck is as narrow as desired. As long as the diameter of the neck allows, the wall should be thinned after each collaring. The transition from belly to neck is one that is often difficult to control. Minor adjustments can

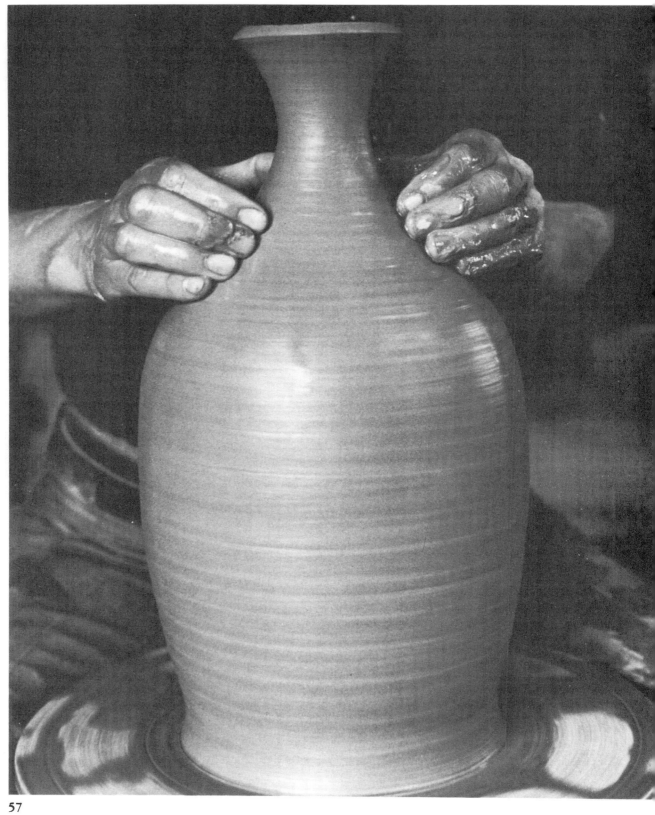

57

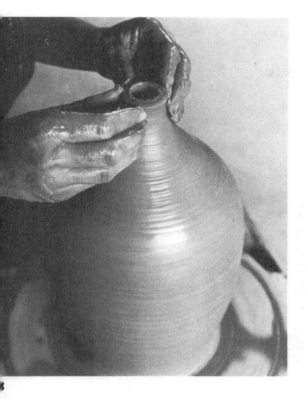
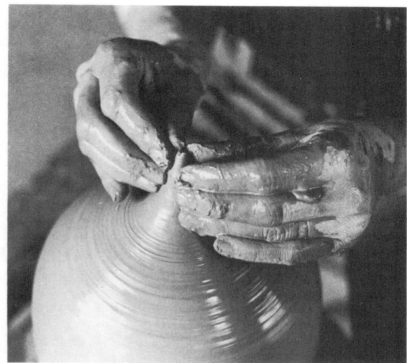

59

be made by using the fingertips and thumb of both hands on the outside and pressing in very carefully [57]. The collaring of the neck can of course be carried to the point of completely closing the pot [58, 59].

Summary

- To shape, place fingertips of left hand in horizontal position on inside at three o'clock and fingertips of right hand in vertical position, backed by thumb on outside of cylinder wall exactly opposite inside fingers [50].

- To widen diameter, press out with inside hand and support wall with outside hand [49].

- To narrow diameter, press inward with outside hand, while supporting wall on inside with left hand [52].

- Extension of thumb, heel of palm, and arm, at rim of pot, may touch on inside to give additional support [50].

- To collar, divide cylinder into belly and neck. Collar rim by forming ring around it with extended thumb and middle finger of both hands squeezing gently inward while index fingers are hooked over rim to keep it on center [53]. Collar rim so that hand can just barely pass through. Then shape belly of pot.

- With six-point system of thumb, index finger, and first knuckle of middle finger of both hands narrow neck further [54, 55].

- Thin wall [56] and repeat collaring. Alternate between thinning and collaring as often as necessary.

- Final adjustments can be made with fingertips of both hands on outside of pot [57–9].

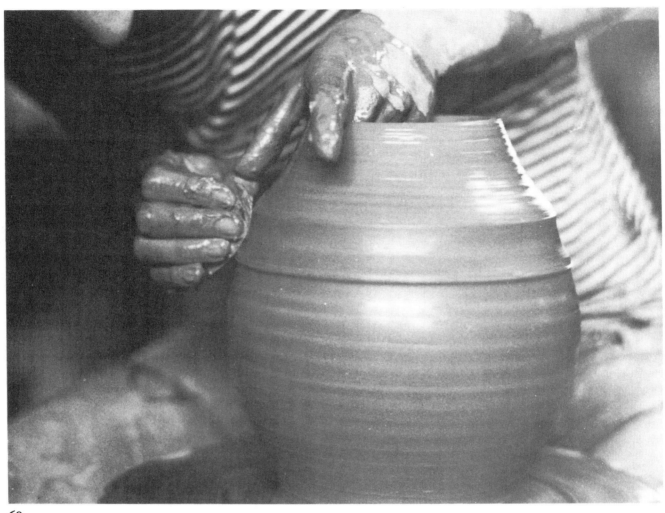

60

Notes on Finishing a Pot

As I have pointed out before, a simple pot can be as beautiful as a complex one. Attention has to be given to proportion and detail.

Tools can be used in shaping. A flexible rib removes unwanted throwing marks and helps to define curves. Be sure that the tool is not held at right angles to the pot but at a tangent, almost parallel to it [60, 61].

Pencils, textured tools, and modeling tools can be used on the freshly thrown pot to incise lines and to make indentations or textures [62, 63].

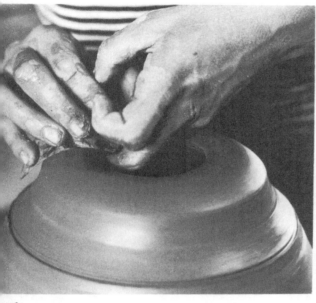

61

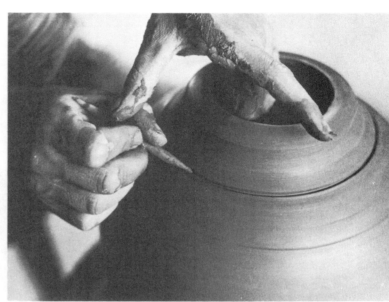

62

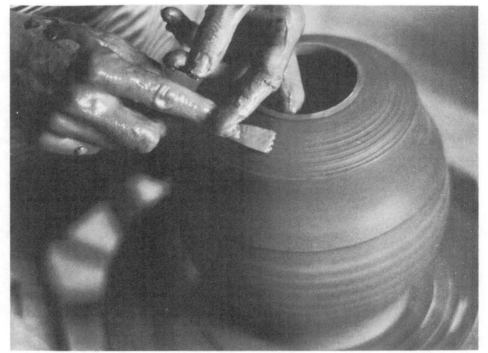

63

The importance of the rim cannot be stressed enough. It does a great deal in determining the overall impression of a pot. After each pull the rim should be recentered and somewhat thickened [64]. This strengthens the pot structurally as well as aesthetically. Work on the rim should be done extremely carefully with as small a contact area as possible and always with both hands. An uneven rim may be cut with the needle tool [65], and a sponge or a dampened piece of paper towel, bent over the rim or the flexible rib can improve the rim and change its character [66].

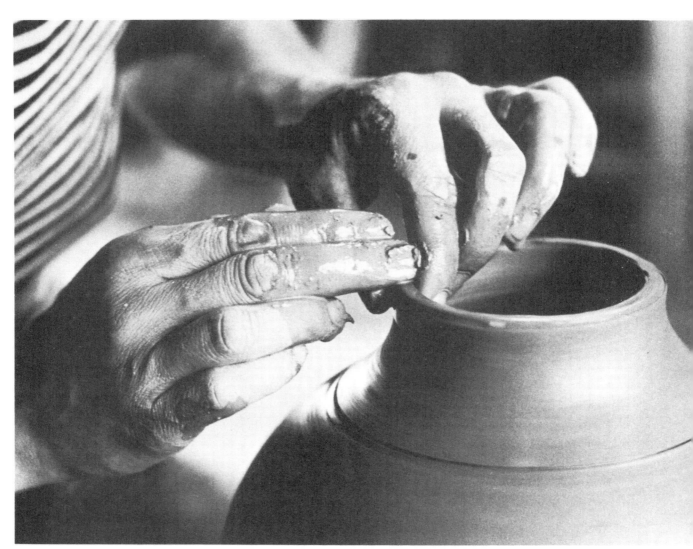

64

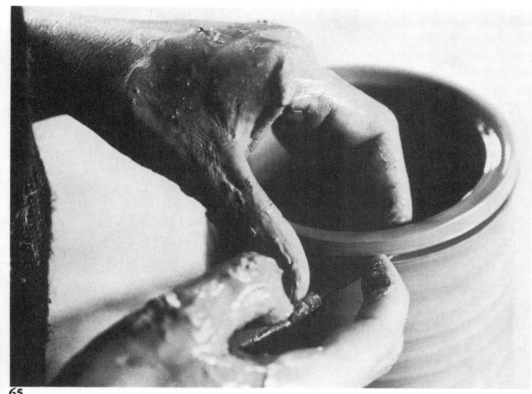

65

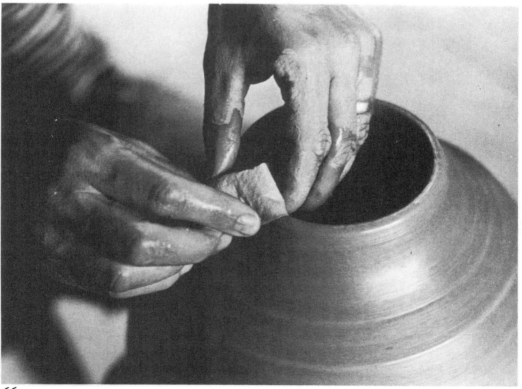

66

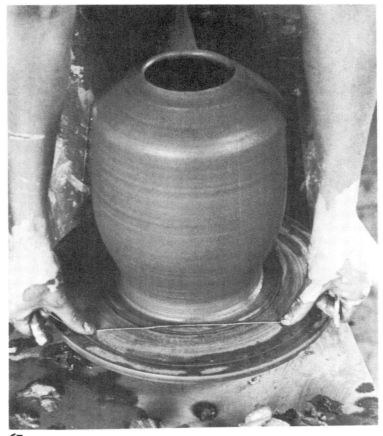

67

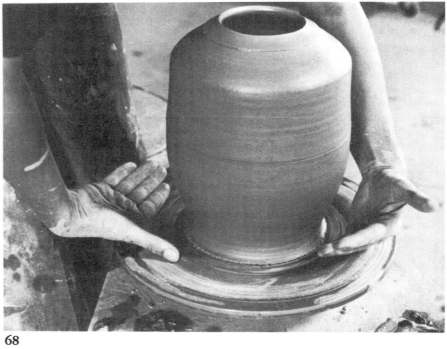

68

Cutting and Lifting the Pot Off

The pot is cut off the wheelhead using two thin wires twisted together. The wheel should be going extremely slowly. Hold the wire taut between the two hands and press it down against the wheelhead with the thumbs. The distance between the thumbs should be slightly more than the widest diameter of the pot. Start at twelve o'clock and come to six o'clock [67].

Most cylindrical forms, especially those with fairly narrow rims, can be thrown directly on the wheelhead and lifted off immediately.

The prerequisite for lifting a pot off the wheelhead is that it be thrown rather rapidly, with thin and even walls. This ensures that the clay is not too wet and soggy and that the walls are firm. Thin, even walls mean there is no unnecessary weight, particularly at the bottom of the pot; otherwise, it might be necessary to use too much pressure lifting the pot off the wheelhead. The advantages of throwing directly on the wheelhead are obvious: bats, though unavoidable for some shapes, are a nuisance. They slow down the throwing process and there are never enough available.

To lift the pot off the wheelhead, remove all water and slip from the pot. Dry your hands. Form a ring along the bottom of the pot with the thumb and fingers of one outstretched hand on your side of the pot and the edges of your other hand and arm on the far side [68]. Gently lift the pot from the far side into the hand nearest you [69]. Try to distribute the pressure evenly around and keep your hands as far down toward the bottom of the pot as possible. Have a board ready nearby to receive the pot. Only minor distortions should result from this process. Never touch the rim of a freshly thrown pot. A rim that has become oval in lifting off can be brought back to the round shape by pressing at the bottom of the pot on the short sides of the oval.

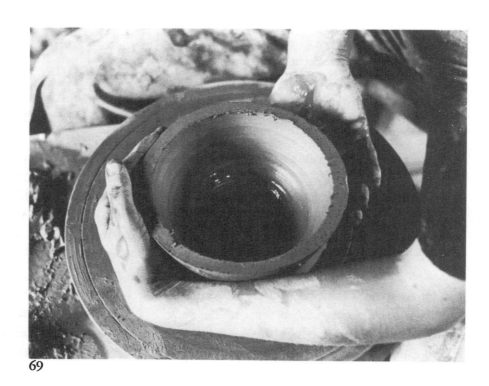

69

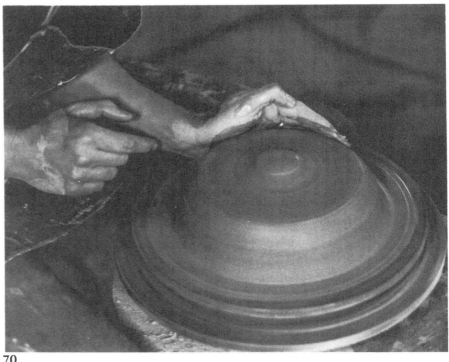

70

Throwing Open Shapes

The process of throwing open shapes, such as bowls, plates, planters, and casseroles, follows the same principles and sequence of steps as throwing cylindrical forms, but it also differs in all steps from centering to raising and shaping. The emphasis here will be on the differences.

The principles of throwing open shapes apply to a deep bowl as well as to a flat plate. It is very important to throw all open shapes on a bat, a second wheelhead, so to speak, so the pot can be removed from the wheelhead on the bat without being touched.

A round plaster bat, the most common kind, is sealed to the wheelhead by smearing some slip on the wheelhead and roughly centering the bat, letting the plaster absorb some of the water from the slip. Wooden bats are sealed to the wheelhead by a more complex process. This process is described on page 65.

Centering

Center the clay on the bat as described under cylinder shapes. Should the bat not be level, take care that you do not ride your hands on the bat; keep them just above it.

Once the clay is centered, but not before, spread the clay. Keep the clay on center with the heel of the left hand, which is placed at the side of the clay [70], while the right hand presses the clay down [71]. Remember that the pressure areas of both hands are limited. Should the diameter need some adjustment, use the fingertips of the right hand, braced by the left hand [72].

The flatter and wider the clay is spread, the flatter and wider the form will be.

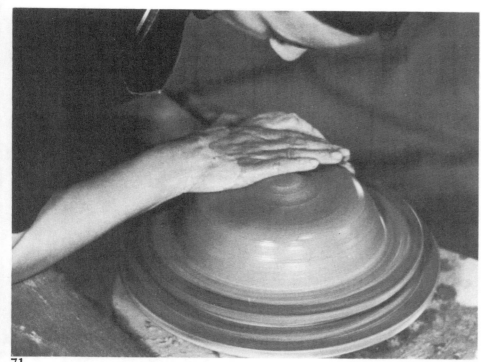

71

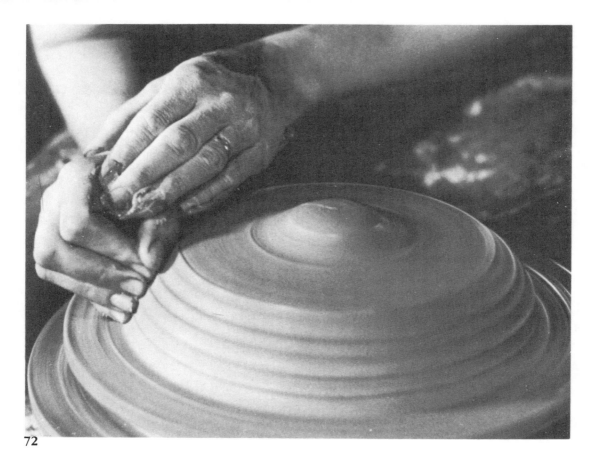

72

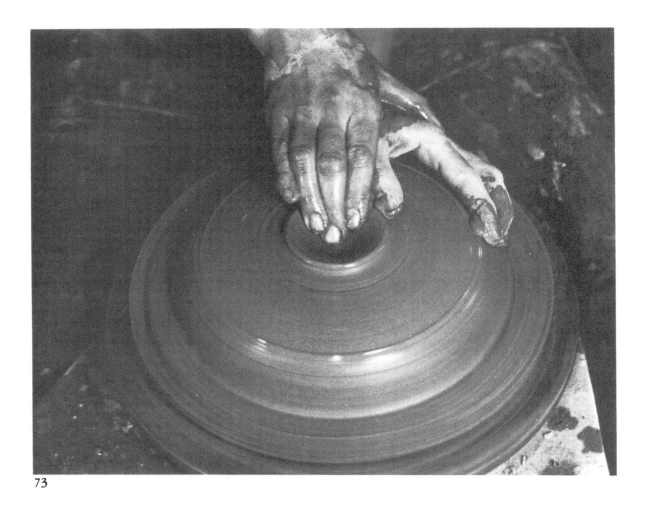

73

Dropping the Hole

In an open form, the hole is dropped as in a cy-
lindrical form with the following adjustments:

1. The thumb of the left hand rides on top
of the clay and near the center so that it can sup-
port the fingers of the other hand, which are in-
serted into the clay [73]. Remember that only
parts of the left hand ride against the clay and
that no pressure is exerted with that hand. The
right-hand fingers are inserted at an angle to keep
the hole wide on top.

2. The hole is dropped less deep, so that the
bottom of the bowl is thicker, usually slightly
less than double that of a cylindrical pot. This
allows for a foot to be carved.

Opening Up the Clay

Two things are radically different in this step: the position of the hands and the path of the fingers across the bottom of the pot.

The fingers of the left hand are placed on the inside of the hole, while the thumb is placed against the outside diameter of the clay [74]. The clay is opened up by pulling the fingers toward the

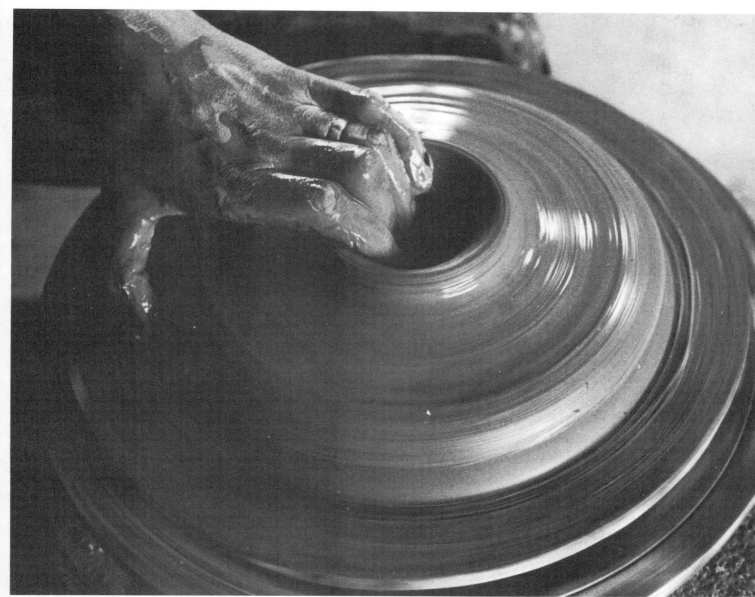

74

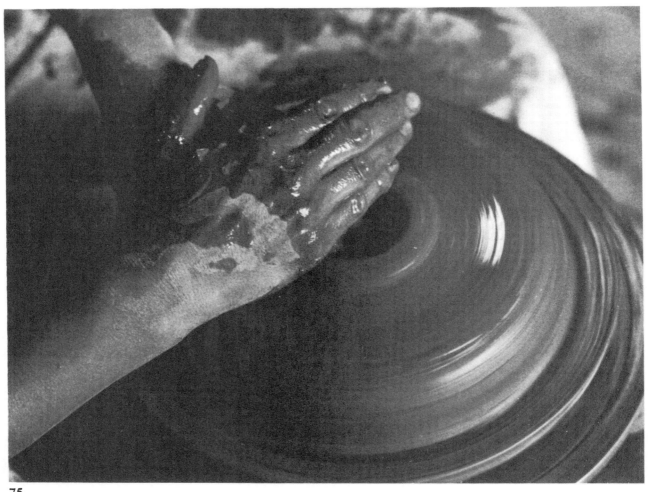

75

thumb. This may take quite a bit of strength. The clay, when pushed outward, has a tendency to rise and form a ring that will split as the diameter is increased. This is controlled by the edge of the right hand, which interlocks with the left hand and packs this clay down [75–80]. While packing the clay down, the right hand also helps to open the clay up, since the fingers of the right hand may be clasped over the fingers of the left hand [78].

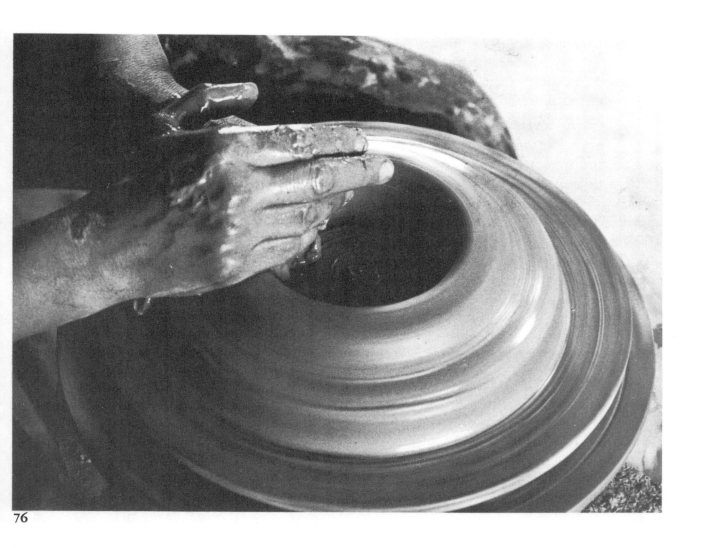

76

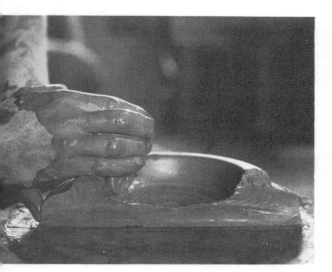

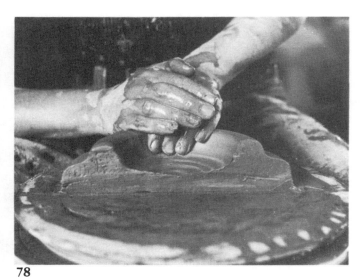

78

The path that the inside fingers take when pushing the clay outward is important. The fingers should rise so that a curving bottom is developed. With cylindrical forms we made sure that we moved horizontally across the bottom, but now the fingers are allowed to rise, so that the curve of the final form is already established. Also, the clay is generally opened wider than in the cylindrical form, with the walls flaring outward. A comparison between the shape of an open form and that of a cylinder at this stage readily indicates the differences [81].

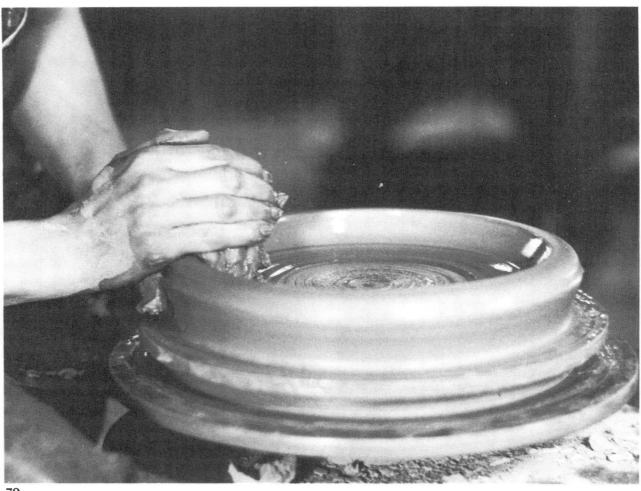

79

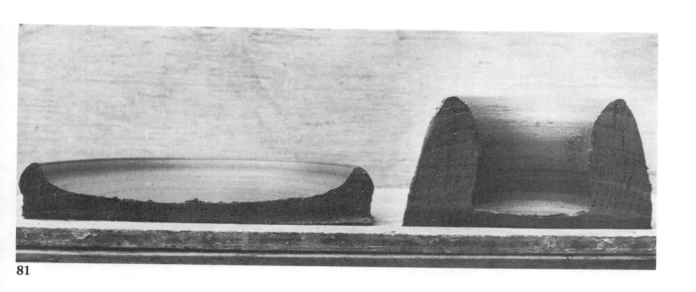

81

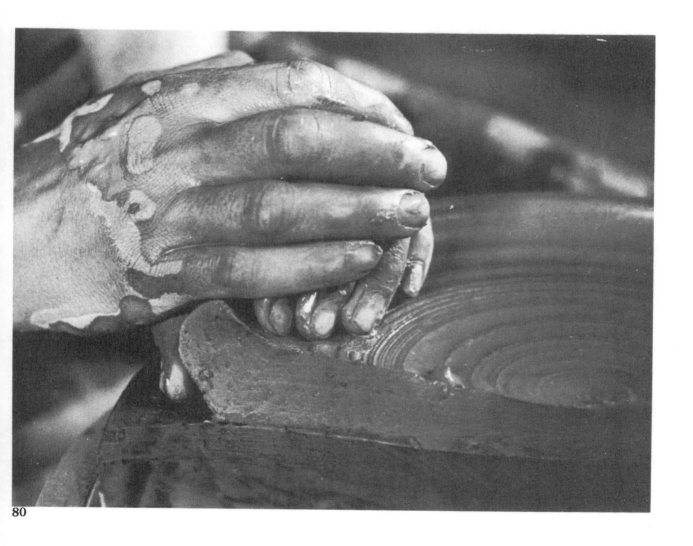

80

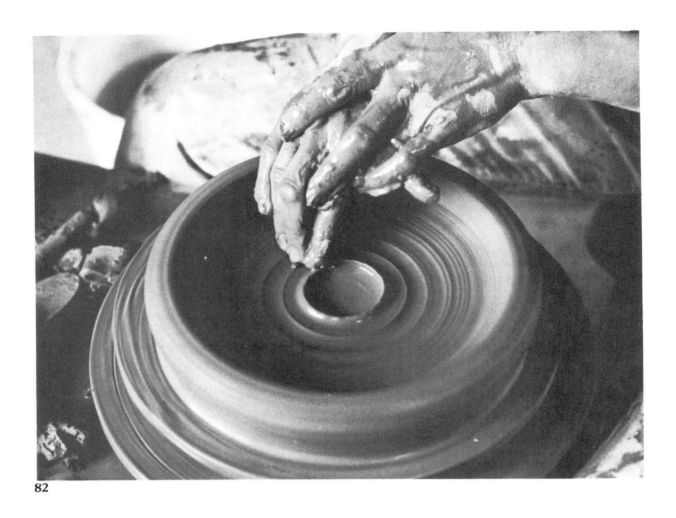

82

Packing the Bottom

This step is of utmost importance, since it compresses the clay in the bottom and strengthens it at the same time as it refines and clarifies the curve. It is done by moving with the fingertips of the right hand across the bottom from the edge to the center. This motion is repeated until the inside is an even curve with no shoulders and the clay feels dense. Only the very tips of the fingers touch the clay, and the fingers are arched for more strength. As always, the right hand is supported by the left hand and the elbows are braced [**82**]. Please note that this motion takes place in the bottom of the bowl and does not include the sides. The curve in the bottom will remain the same throughout the throwing process. It is therefore important that it reflect the intentions of the thrower. Later adjustments, though possible, are difficult to make.

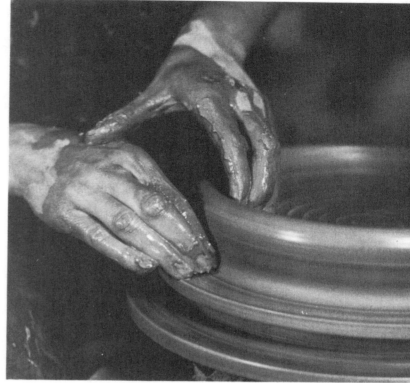

83

Raising the Wall

Before raising the wall, the clay should be undercut on the outside with the fingers of the right hand. The left hand keeps the clay in place on the inside [83]. This makes room for the second joint of the index finger of the right hand, so that it can get under and move the clay up.

Raising is done as in cylindrical shapes with three differences: first, on the inside, the fingers of the left hand are not arranged horizontally but more vertically, so that they are placed partially on the wall and partially on the bottom [84]. Great care must be taken not to indent the clay at the bottom of the inside, since this would make a continuous curve from the center of the bowl to its rim impossible.

The second difference is that the wall is raised tapering outward rather than inward [85]. This is achieved by pressing out with the inside hand toward the top.

Third, since the rim will undoubtedly be extended, extra thickness has to be left in it. In open forms in general, the walls are kept slightly thicker.

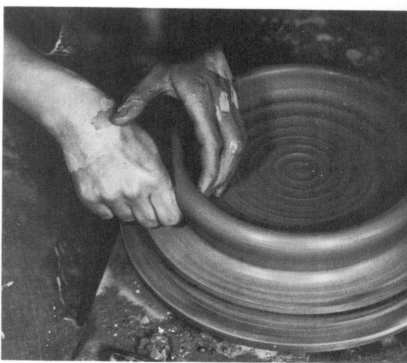

84

Shaping

Shaping consists of continuing the curve of the bottom into the sides. The position of the hands is the same as in shaping a cylinder—that is, the fingertips of the left hand are arranged horizontally on the inside of the pot and the fingertips of the right hand vertically on the outside, except for the area of transition between the bottom and side of the open form, where the fingers of the left hand are in a vertical position [85, 86]. Shaping a bowl or plate is done from the inside; thus the push is invariably from the inside and it may be done from the center outward or from the rim to the center. The eyes, instead of observing the shaping on the outside of the pot, do so on the inside, at nine o'clock. Three factors have to be taken into account:

1. The centrifugal force of the wheel has a greater effect on pots with wide diameters. Therefore, the speed of the wheel has to be finely controlled. An abrupt change, particularly an in-crease, can throw the pot off center.

2. If the diameter is increased to any great extent, it has to be done by thinning the clay, rather than by stretching it like a rubber band. In other words, the clay has to be squeezed between the inside and the outside hand, but in such a way that an increase in diameter, rather than in height, is achieved. If the clay is stretched like a rubber band, small cracks will appear at the rim either immediately or in the firing.

3. In an open shape, the idea is to cantilever the clay out. The tension in a bowl or plate reflects the boldness with which this is done. But such cantilevering has to be done very gently, with the speed of the wheel very slow and the clay well supported with the hand from below. The contact area should be held to an absolute minimum, which means fingertips only, and any change in pressure and direction should be made very carefully. Once a bowl has sagged and therefore gone off center, it is almost impossible to rescue it.

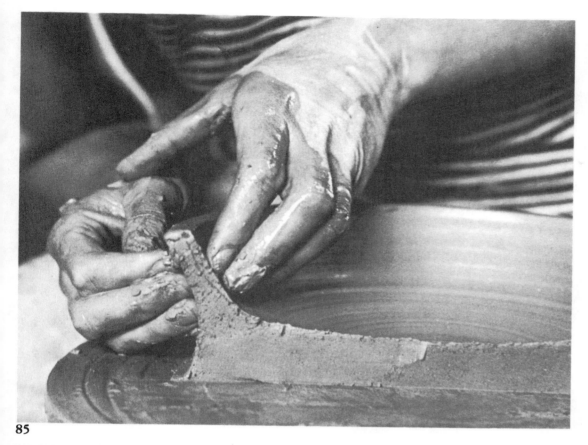

85

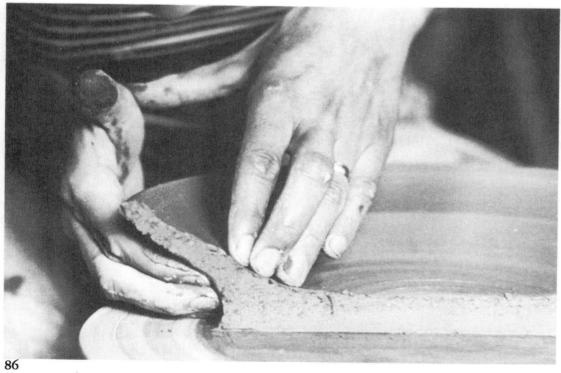

86

Finishing

A flexible rib can be used for finishing touches, particularly if a smooth surface is desired. Bend the rib to adjust to the shape of the clay and hold it at an acute angle, using both hands to hold on to it [87]. If you are working on the rim, support it from underneath [88].

Open forms require some reinforcement at the rim to keep it from warping in the firing. This can be done either by thickening the rim and/or by changing the direction of the rim. A combination of both and numerous variations of these two often adds not only to the structural strength of the pot but also to its aesthetic appearance.

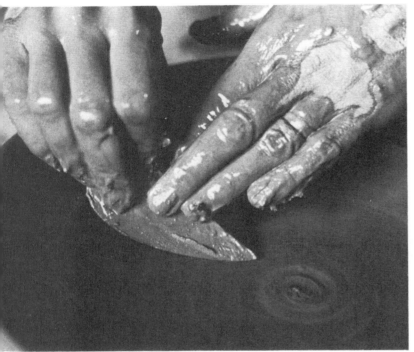

87

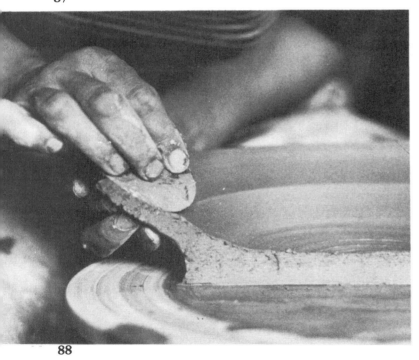

88

Wooden Bats

To attach a wooden bat—a round piece of exterior plywood, masonite, or chipboard—to the wheelhead, center a handful of clay on the wheelhead. Drop the hole all the way through to the wheelhead and open the clay in the same way as for open shapes [89]. Do not pull up, but open horizontally, so a ring of clay is formed somewhat smaller than the bat. In this ring make an indentation [90]. Place the bat gently on this indented ring, as much on center as possible; then press firmly on the center of the bat by putting your weight on it [91]. Do not press on the side of the bat as it will pop up on the opposite side. If the bat is attached properly, suction will hold it in place. Some wheels come equipped with keys to hold the bat; others have indented wheelheads with matching bats. On the latter type of wheel, a bat must be used for all pots.

Even though you do not remove the form from the bat until it is leather hard, it is always better to cut the finished pots off the plaster bat with a twisted wire before letting the pot dry, and it is imperative that the pot be cut off wooden bats after finishing to allow the pot to shrink without cracking as it dries. This is especially important with large pots.

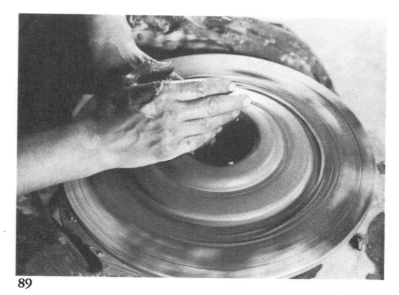

89

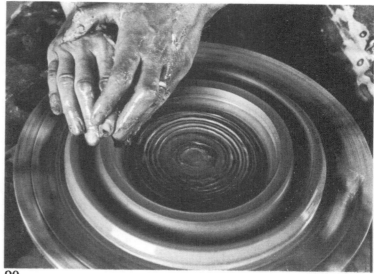

90

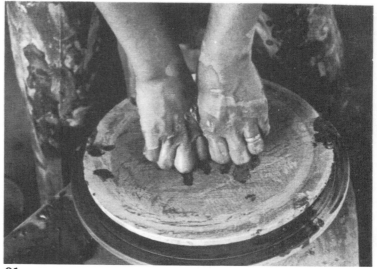

91

Summary

- Attach bat [**89, 90, 91**].
- Center clay as for a cylinder.
- Spread centered clay by applying pressure with right hand from top of truncated cone while controlling diameter with left hand [**70, 71**].
- Adjust diameter with right hand [**72**].
- Drop hole in same manner as with cylindrical forms, but move thumb of left hand toward center to support right hand and leave almost double thickness in bottom, so foot can be carved later [**73**].
- Open clay by pressing with fingers of left hand from inside toward thumb of left hand, which rides against outside [**74**]. With edge of right hand pack down and control clay that is rising from inside [**75**]. While moving outward, let fingers come up to establish curve of bowl [**76–80**].
- Open clay more than when throwing a cylinder and let wall taper outward on top [**81**].
- Carefully pack bottom of form and remove all shoulders by compressing clay with fingertips of right hand as they move from outside to center. Repeat as often as necessary [**82**].
- Undercut and raise wall, tapering it outward on top [**83, 84**]. Leave wall and in particular rim thicker than on a cylinder.
- Shape as with cylinders but consider speed of wheel because of additional effect of centrifugal force and lack of tensile strength of clay [**85, 86**].
- Increase in diameter should be effected by thinning wall.
- Finishing touches may be applied with flexible rib [**87, 88**].
- Rim should be thickened or direction of wall changed near rim in order to avoid warping when fired.

2

Trimming

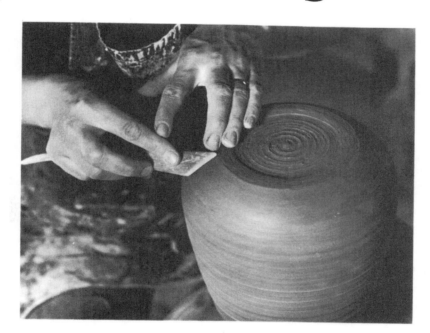

Trimming is done when the pot is leather hard. It has three functions: to cut off the excess clay that all but the most experienced potters leave in the lower part of the pot; to smooth and finish the lower edge left rough by the cutting wire; and to carve a foot when the form demands it and the bottom of the pot is thick enough to allow it.

What should be uppermost in your mind when trimming is that you are adjusting the outside shape of the lower third of the pot to the inside shape so you will have a uniform wall throughout the pot. Trimming should be held to a minimum since you deal with the clay at a stage where you cannot use its most advantageous characteristic—its plasticity—but must deal with it rather like wood on a lathe. Trimming is basically a corrective measure.

Pots may be trimmed two ways: upside down or right side up. They can be placed upside down on the wheelhead only if the rim is strong enough to support the weight of the pot and if the diameter of the pot is large enough so the pot sits firmly on the wheelhead. When the pot is placed upside down, it can be trimmed either with or without a foot.

Pots are placed on the wheelhead right side up particularly in the case of narrow-necked pots and pots with weak rims. In this case, the bottom of the pot cannot be touched and therefore should have the proper thickness from the beginning. If that is not the case, it has to be trimmed upside down inside a chuck.

The tools needed for trimming are two or three different-size trimming tools, several modeling tools, a flexible rib, an elephant-ear sponge, a needle tool, and a knife [92]. Trimming tools come in many different sizes and shapes. I have found the shapes shown in the pictures to be the most versatile and useful. Whatever shape you choose, be sure the cutting part is not flexible; it

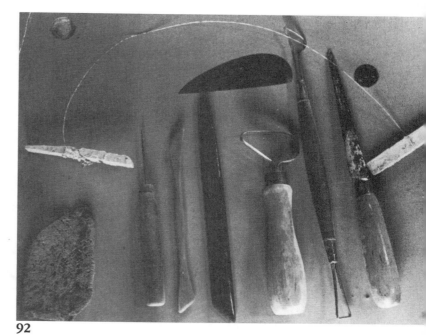

92

93

should never be made of a thin band of metal or a round wire with a thinner wire wrapped around it. Half-round steel or a heavy steel band with a sharp cutting edge makes the best trimming tool [93]. A serrated edge is necessary only for texturing. If you trim the clay at the proper consistency, you can expect a long life for your trimming tool; trimming almost-bone-dry clay will quickly dull it.

Trimming Upside Down

Cylindrical Shapes

Since the prime objective of trimming is to remove excess clay and adjust the outside shape to the inside, you have to take a good look at the pot to determine how much clay needs to be taken off and from where. This is best done by determining how wide the bottom of the pot is on the inside and comparing it to the outside.

The thickness of the bottom is established by measuring it with a needle tool. Most experienced potters have only to glance quickly at the inside of the pot to know where and how much to trim, but the beginner must take time for this step.

The pot has to be recentered prior to trimming. This is done by placing the pot as near the center of the wheelhead as possible, using the concentric rings on the wheelhead as guides. A needle tool is held in a fixed position while the pot rotates slowly. The needle tool is moved toward the pot until it touches the pot in at least one spot and makes a mark [94]. The wheel is stopped and turned until the mark is brought to six o'clock. The pot is then moved slightly toward the center of the wheel away from the potter,

since the mark represents the spot farthest away from the center. Think of the pot as a circle within the circle described by the needle tool. Repeat this recentering until the needle tool marks the pot evenly all around. It is impossible to be exact, since the pot might have become slightly distorted in moving or in drying.

Three small lumps of clay serving as keys are usually sufficient to lock the pot to the wheelhead. Great care should be taken in the consistency of the clay and the manner in which the lumps are attached. The clay for the keys should be neither too wet nor too dry. If the clay is too wet, it will stick to the pot and mess up the lip, and if it is too dry, it will not stick to the wheelhead and will indent the pot.

The manner in which the keys are applied is as follows: press the clay down on the wheelhead and then push it gently against the pot [95]. Do this while firmly holding the pot in place with one hand to avoid pushing it off center. Test whether the pot is firmly attached to the wheelhead. It is also a good idea to stop the wheel periodically during trimming and see whether the pot has loosened.

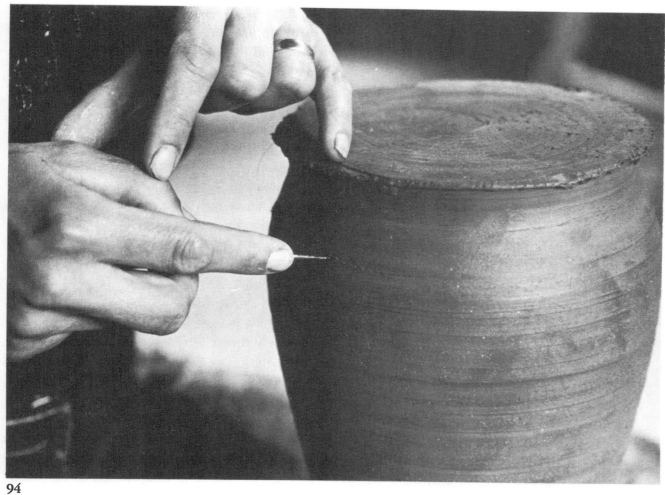

94

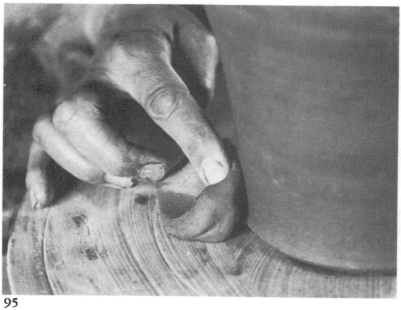

95

The excess clay is removed by shaving it off with the trimming tool. The manner in which the trimming tool is held is very important. Do not hold it like a pencil, but lay your index and middle fingers on top of it and your thumb underneath. The fingertips should be almost at the tip of the tool. Brace your right hand with your left hand, which is also placed on top of the pot (actually, the bottom) [96]. Your arms are, as always, braced firmly against your body, and you should hover over your pot as close as possible. With the wheel turning as fast as in centering, move the tool slowly toward the clay at three o'clock. Holding the trimming tool like a tangent on the circle, work the side of the pot first, from the top down. Remember to shave the clay off, do not dig in; just as in throwing, move your tool slowly and only after the wheel has made a complete turn. Tilt the tool to follow the curve of the pot [97].

After the side of the pot is completed, a decision has to be made: if the bottom of the pot is as thin as it should be and level, all that needs to be done is to smooth the texture left by the trimming tool with a wooden modeling tool or the flexible rib.

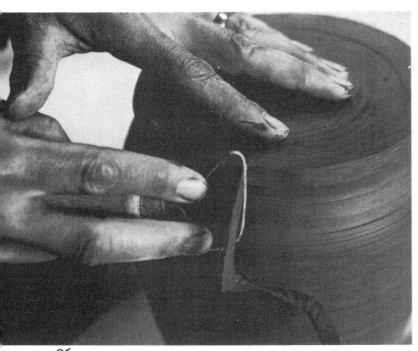

96

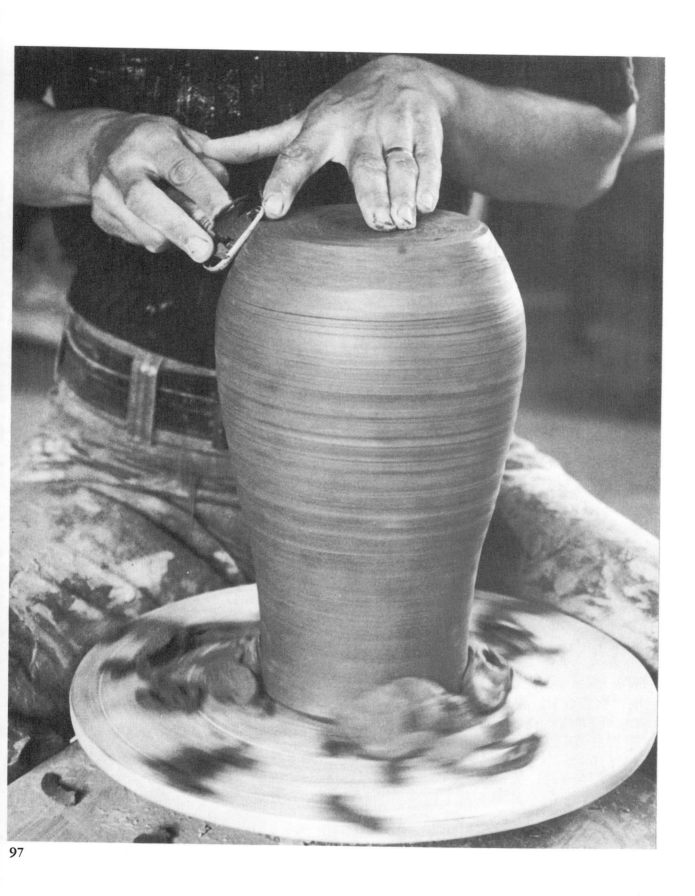

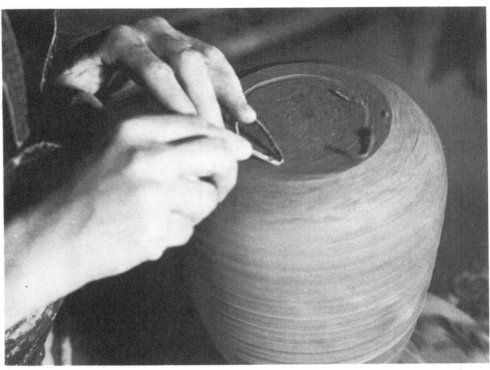

98

Carving a Foot

In case of a bottom that is too thick and/or not level, a foot can be carved in the following manner. First finish the side of the pot as described above. Then indicate the inside diameter of the foot by making an indentation with the tip of the trimming tool, holding it firmly with both hands [98]. Be careful that you do not make the foot too narrow. The depth of the indentation depends on the thickness of the bottom. Then remove the clay from the indentation to the center by moving in that direction, using the tip of the trimming tool [99]. If clay more than one eighth of an inch deep has to be removed, go over the bottom several times, always from the outside toward the center in order to avoid slipping and carving into the foot.

Round off the foot with the trimming tool. In the case of a pot that is not level, level the foot by holding the trimming tool firmly [100].

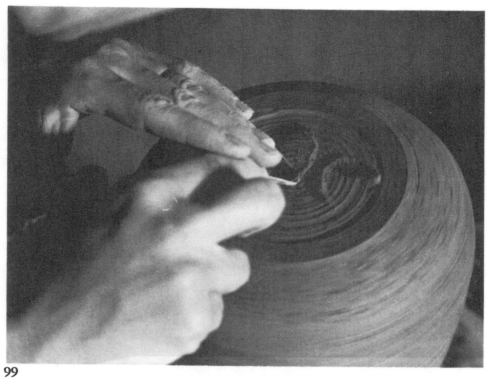

99

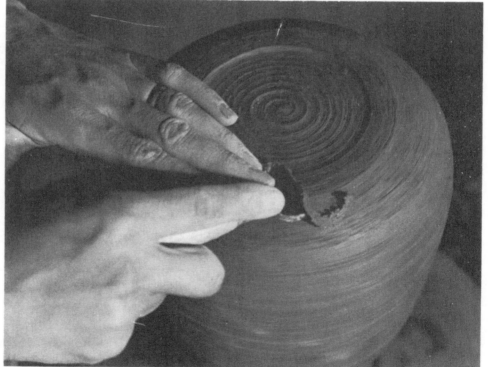

100

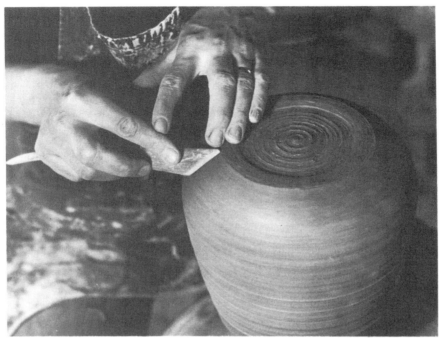

101

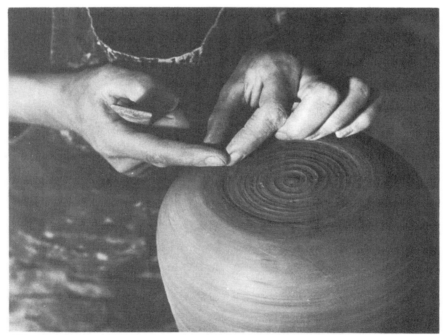

102

The trimming texture may then be smoothed out with a wooden modeling tool [101] and the foot smoothed with your finger to give it a more plastic appearance [102].

Open Shapes

Open shapes, such as bowls and plates, are always trimmed upside down and should almost always have a foot, for both structural and aesthetic reasons.

Trimming open shapes is done as described above with some variations: great care has to be taken in turning over an open shape. Undue stress on the rim may result in cracking or distortion. After checking the thickness of the bottom, the pot can be best put upside down by placing a bat on top of it and flipping it [103] and then lifting it to the wheelhead using the undercut [104].

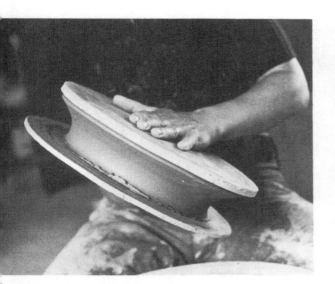

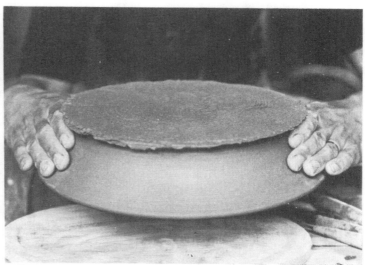

104

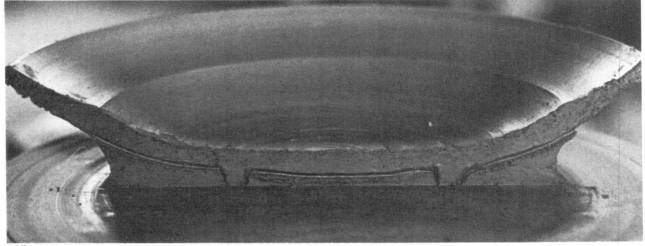

105

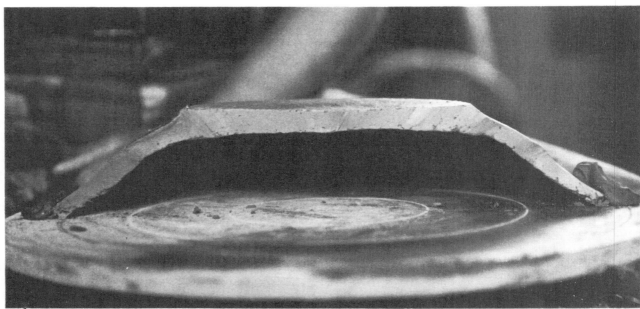

106

107

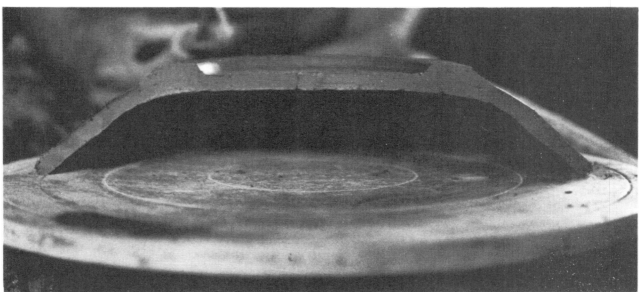

On open shapes, like plates, the foot is usually a separate ring and the side of the shape should be trimmed in such a way as to form the ring [105, 106]. The center of the bottom is taken out as with cylinders and the foot is finished in the same manner. When trimming excess clay out of the bottom, one must make the outside curve conform to the curve on the inside of the shape in order to ensure a uniform wall thickness [107].

The placement of the foot is critical. If it is set in too far, the pot may warp in firing because it lacks the proper support. If it is set out too far, the pot may look awkward and heavy.

Summary

- Determine manner in which pot should be trimmed, as well as how much and where it needs trimming.
- Recenter pot by finding spot farthest away from center of the wheelhead with needle tool and moving pot toward center [94].

Trimming upside down

- Seal pot to wheelhead in three places, using clay that is first pushed to wheelhead and then against pot [95].
- Lay index and middle finger on top of trimming tool with thumb on bottom. Interlock with left hand which rides on top of pot (actually bottom) [96].
- Shave excess clay off by moving up and down slowly with trimming tool while wheel turns as rapidly as in centering [97].
- If foot is needed, finish side of pot and mark inside diameter of foot by making indentation with tip of trimming tool [98].
- Remove excess clay in bottom by moving from outside to center [99].
- Round off and level foot [100].
- Remove trimming texture with wooden modeling tool or flexible rib [101].
- Smooth foot with finger [102].
- Open shapes almost always need to be trimmed upside down and should have a foot.
- Flip open shape over with help of second bat placed on top [103].
- Move pot to wheelhead using undercut [104].
- Trim side first, clearly setting up foot as separate ring [105, 106].
- Remove excess clay from bottom. Should inside be curved, make corresponding curve on outside [107].

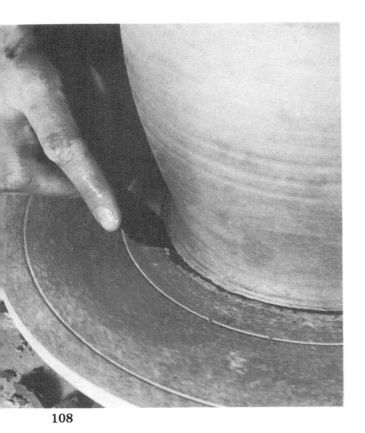

108

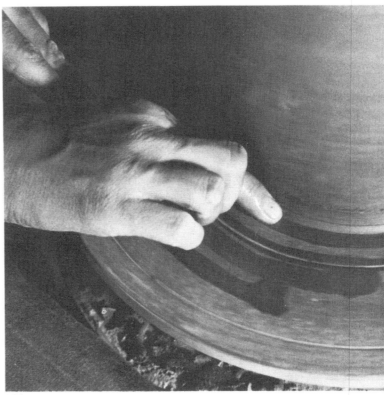

109

Trimming Right Side Up

As explained before, trimming right side up has to be done when the rim cannot support the pot or the diameter of the lip is too small. The prerequisite for trimming in this manner is that the bottom of the pot need no adjustment. The pot is centered as described above. Then, while the wheel is rotating slowly, a small amount of water is seeped underneath the pot with the flexible tool [108]. The small edge that was formed when the pot was cut with the wire is then sealed to the wheelhead by pressure with the finger [109].

Be careful that the pressure is downward so you do not move the pot off center. Then the pot is trimmed as described above, except that a one-eighth to one-quarter inch rim is left at the bottom in order that one does not cut off the seal [110–12]. It is possible to trim the pot quite effectively since the tip of the trimming tool can undercut quite well. Should the clay that seals the pot to the wheel get in the way, trim it down, always leaving at least an eighth of an inch.

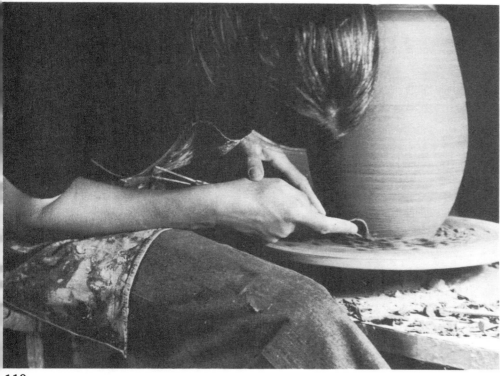

110

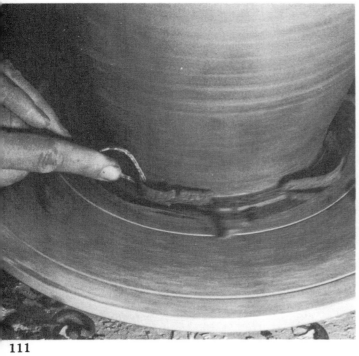

111

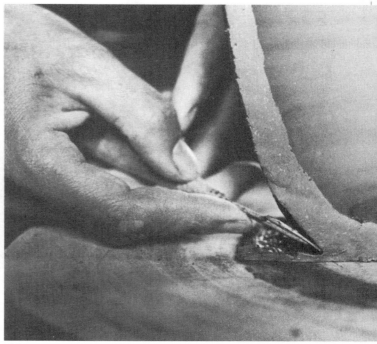

112

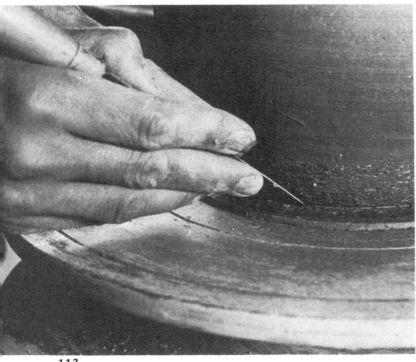

113

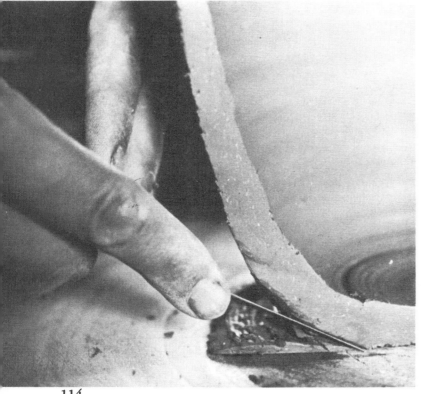

114

When the trimming is completed, take a knife with a long pointed blade and separate the pot from the clay ring by cutting along the pot to the wheelhead [113, 114]. You must have a firm grip on the knife in order to avoid cutting into the pot. Wet the blade to minimize the friction. The wheel should rotate very slowly. If the clay ring is thicker than an eighth of an inch, this step is difficult. Lift the pot off. If the cutting has been done well, the clay ring should stay on the wheelhead [115]. The edge of the pot can be smoothed with your thumb [116] and the center of the bottom should be tapered in lightly to counteract any warping that may bulge the bottom outward [117].

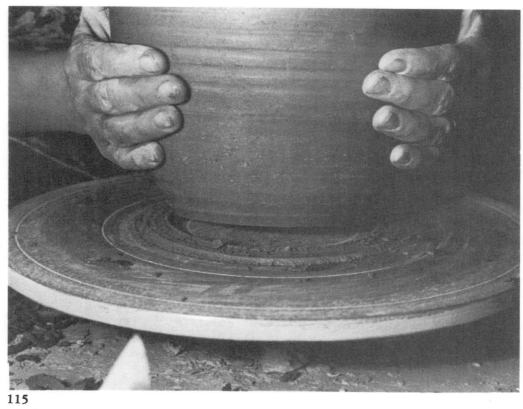

115

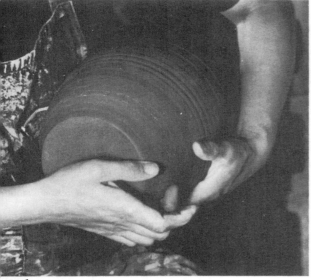

116

117

Summary

- Recenter pot.

- Seal pot on wheelhead by seeping water under pot [108].

- Press edge of pot to wheelhead [109].

- Trim downward, leaving one-eighth to one-quarter inch of clay for seal [110–12].

- If necessary, trim ring that seals pot to wheelhead.

- After completing trimming, break the seal by cutting off ring with tip of pointed knife, while wheel rotates extremely slowly [113, 114].

- Lift pot off wheel [115].

- Smooth bottom edge of pot with thumb [116].

- Tap slightly on bottom of pot [117].

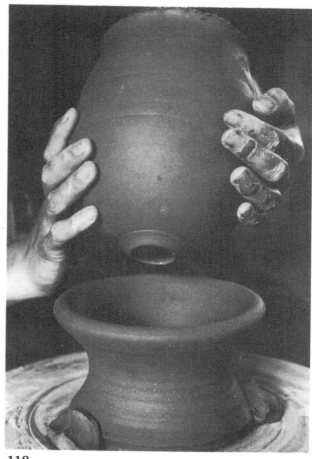

118

Trimming in a Chuck

For pots with narrow necks and thick bottoms, use a chuck.

The use of a chuck is very awkward but may be unavoidable at times. Various-size chucks can be thrown. They consist of an open-ended cylinder with the rim flared to hold the pot [118], and they may be used in the leather-hard, bone-dry, or bisque stage. However, almost anything can serve as a chuck, as long as the pot fits into it without distorting it. Center the chuck and seal it with clay to the wheelhead. Put the pot upside down into the chuck. Some cushioning, like newspaper, may be necessary to avoid indenting the pot. Center the pot in the chuck and also make sure the bottom is level. If you have not lost your patience by then, trim the pot in the same manner as described for trimming pots upside down.

Summary

- Center chuck.
- Place pot in chuck and center [118].
- Level pot and center.
- Trim pot as described in trimming upside down.

3
Specialized
Throwing Techniques

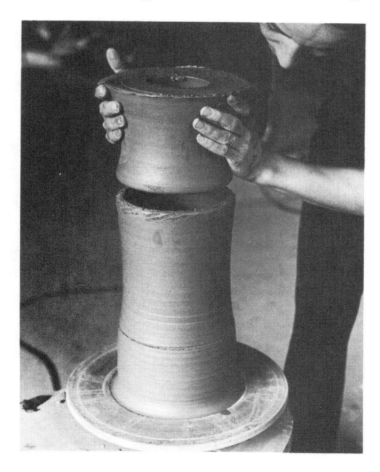

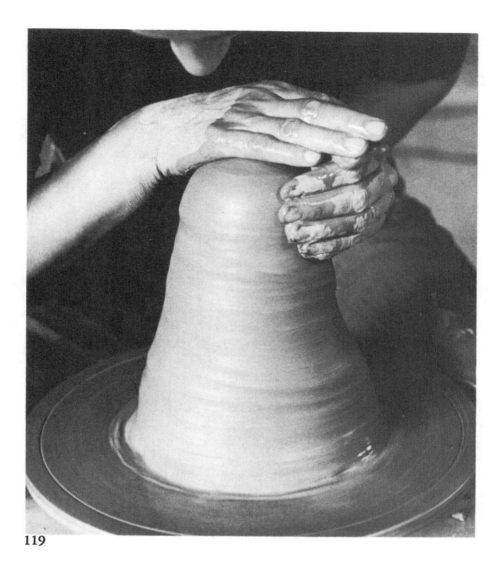

119

Throwing off the Hump

Throwing off the hump means throwing several small pots off one big chunk of clay. This technique is especially useful for throwing many small items, such as cups, and if the items are so small that it is difficult to center the small lumps of clay. The size of the pot one can throw off the hump is limited to the size and shape that can be lifted off without much distortion.

A large amount of clay is wedged into the cone shape, put on the wheel, and pushed up once into a thinner, taller cone. Then, just as described in centering, start to push the clay down, but only as much as you intend to use for the pot [119]. Keep the left hand in the same position as in pushing the clay down, but move the right hand from on top of the cone to the side. Under-

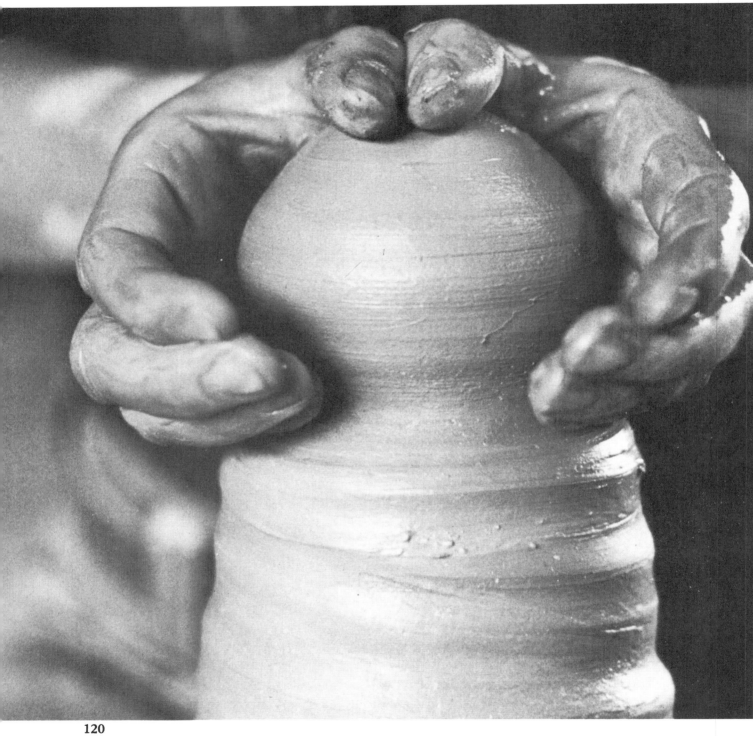

120

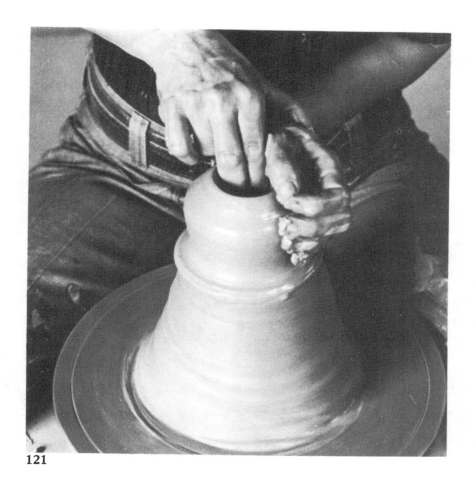

121

cut with the edge of both hands, while keeping
the thumbs on top, and slightly, very slightly, lift
the clay up. Cradle the clay in both hands until it
is centered and clearly delineated from the un-
centered portions of the clay [120]. The clay
should be centered in that one motion of pushing
the clay down [119], slipping the right hand to
the side, undercutting, and then cradling the clay
in both hands with the thumbs on top [120].

The steps of dropping the hole and opening
up the clay are exactly the same as described be-
fore, except that one has to imagine that the
wheelhead is at the lower edge of the centered
portion of clay [121]. Needless to say, one can-
not measure the thickness of the bottom.

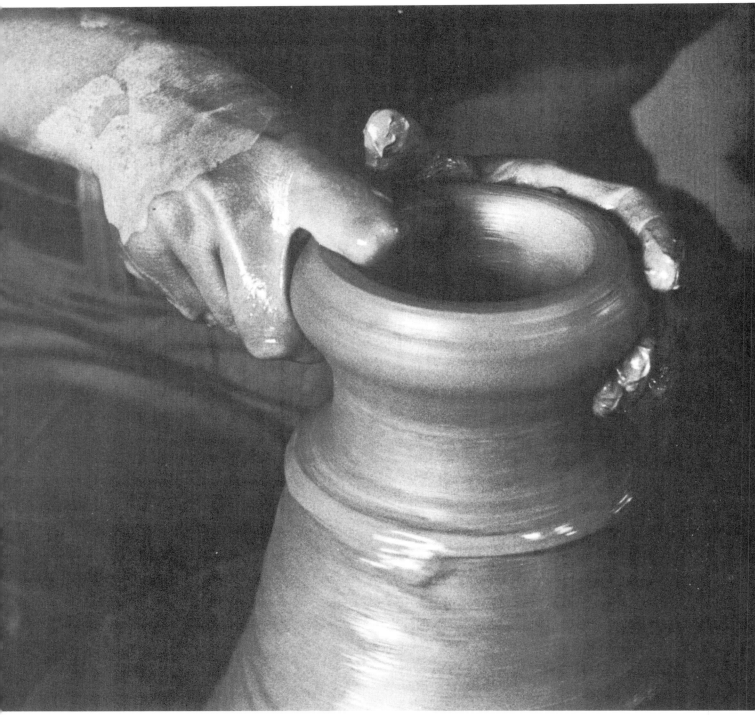

122

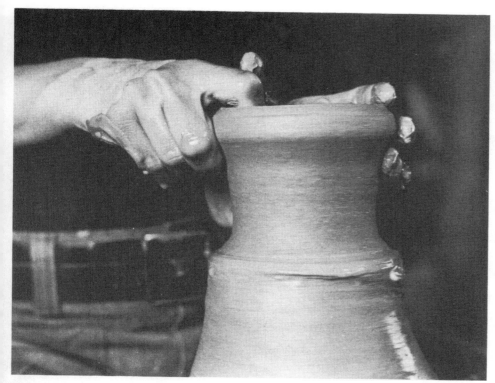

123

Raising the clay can be done in two ways. Since one deals with small amounts of clay, it can be clawed, which means that the clay is raised by squeezing it up with the right hand, using the index finger on the inside of the pot and the middle finger on the outside, while the left hand gently supports the wall on the outside and keeps it on center [122, 123]. Note that the second joint of the right middle finger is somewhat underneath the clay. Clawing can be done only once. The wall is then thinned further and shaped with the use of the fingertips of the right and left hands [124].

The wall can also be raised in the traditional method or, since small amounts of clay are used, by squeezing the clay between the fingertips of the inside and outside hands. Raising and shaping may be accomplished at the same time [124].

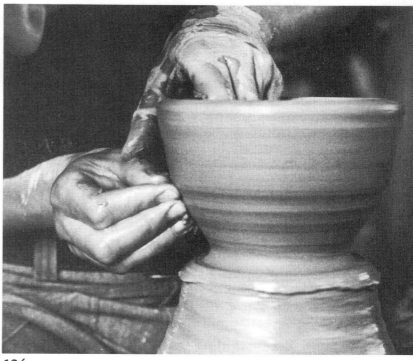

124

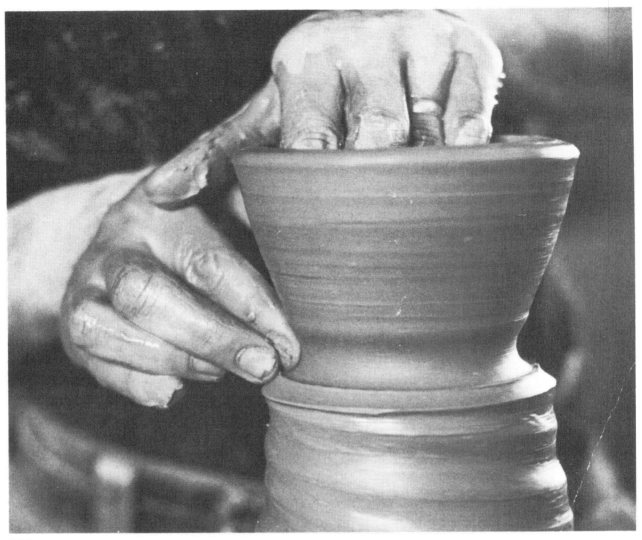

125

An important feature of this technique is to keep at all times a clear delineation between the centered clay or pot and the unused and uncentered clay. This delineation has to be re-established from time to time by running the index finger, backed by the middle and ring fingers of the right hand, against the lower edge of the centered clay on the outside, while counteracting this pressure with the fingertips of the left hand on the inside of the pot [125, 126].

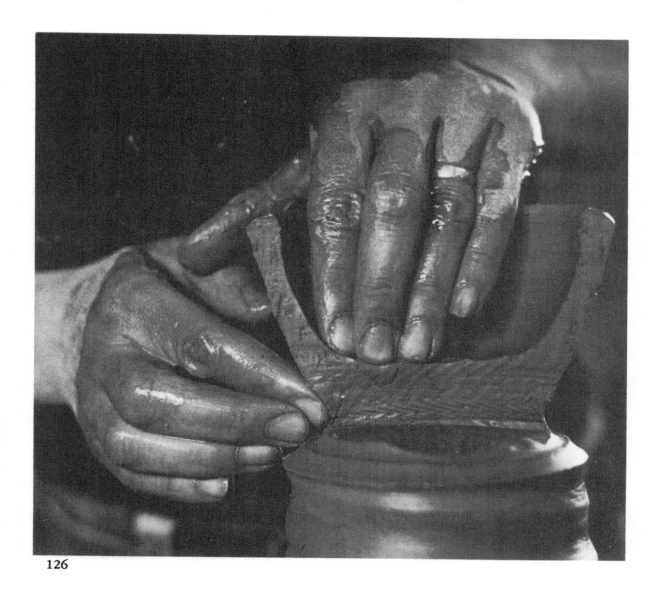

126

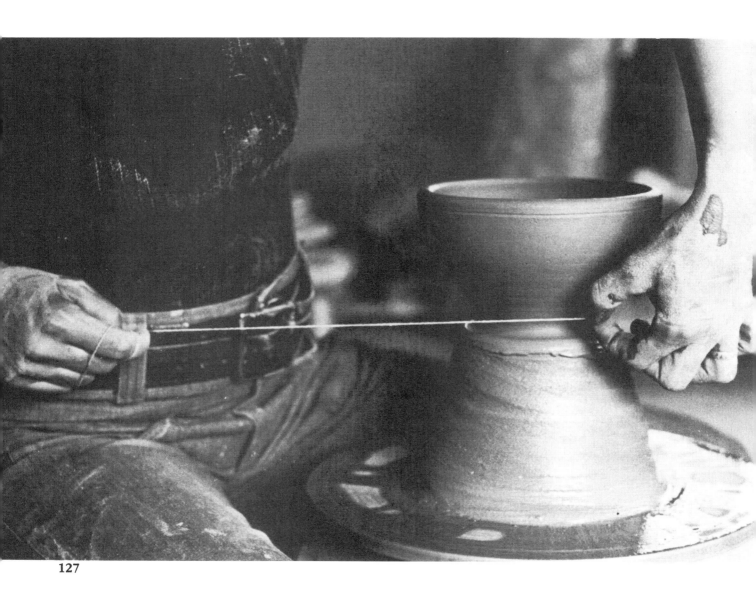

127

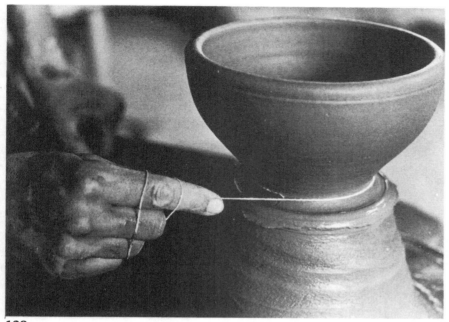

128

Cutting off the pot can present some prob-
lems. If trimming is to be kept to a minimum,
the pot should be cut off at the proper level, so
that the bottom of the pot is neither too thick nor
too thin. The pot also has to be cut off perfectly
horizontally.

To do this the following procedure is best, al-
though it may take some practice to master it. A
textured but fine string (braided nylon fishing
line is best) is held firmly by the right hand, while
the loose end is placed at three o'clock [127]. The
string between three o'clock and the right hand
should be taut. With the wheel going extremely
slowly, the string is allowed to wrap around the
bottom by moving the right hand toward the pot
[128]. When the string has been allowed to
wrap around once, gently pull back with the right
hand, keeping the string firmly in that hand, and
the pot is cut miraculously.

The pot can also be cut by wrapping the
string around the pot, crossing it over, and pull-
ing [129].

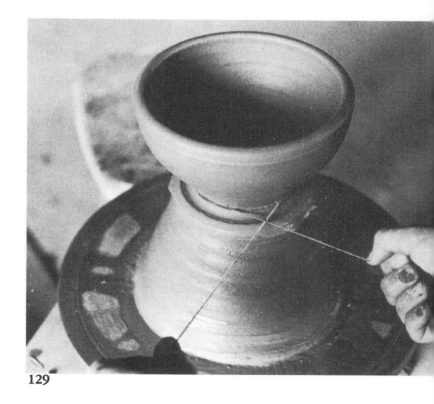

129

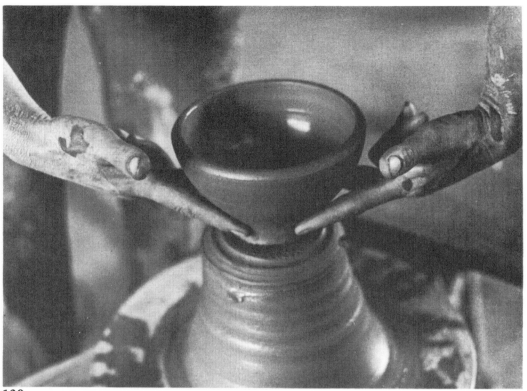

130

To lift the pot off the clay, use the index and middle fingers of both hands [**130**] or the six-point system of thumbs, index fingers, and joints of the middle fingers [**131, 132**]. Press in at the very bottom of the pot, where the clay is solid.

Before starting to center a new section of clay, it is essential that the whole amount of clay be pushed up again into a new cone. The clay for the next pot is then centered by pushing the clay partially down, as described above.

This technique should actually be called throwing off the cone rather than the hump. The uncentered clay should never be allowed to take the form of a flat block of clay. The pot should always be thrown on top of a cone. This way you can keep your hands off the uncentered clay, and it is easier to get at the bottom of the pot to lift it off.

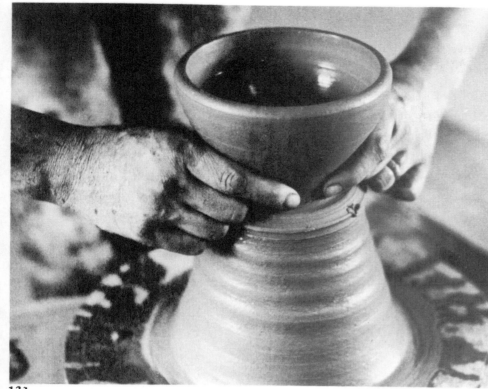

131

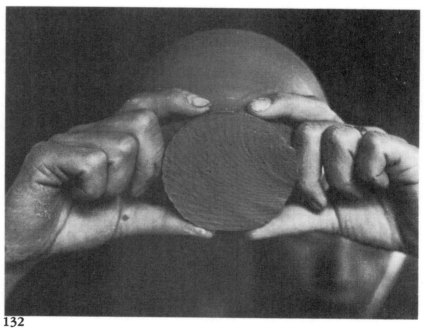

132

Summary

- Push uncentered clay into high cone [119].

- Push clay partially down.

- Slip right hand to side of clay and undercut slightly with edge of both hands, lifting centered clay off uncentered part [120].

- Cradle section of clay that should be centered between both hands with thumbs on top [120].

- Drop hole and open clay up in traditional manner [121].

- To raise clay, claw fat ring by squeezing clay between right index finger on inside of pot and second joint of right middle finger on outside [122, 123].

- Complete thinning and shaping at same time by using fingertips on both hands [124].

- Re-establish separation between centered clay or pot and uncentered clay by using index finger of right hand, while supporting inside with fingertips of left hand [125, 126].

- Cut off pot by letting loose end of a string wrap around foot of pot and then pulling back string with right hand [127, 128].

- Lift pot off, using index and middle fingers of both hands like tongs [130] or using six-point system of thumbs, index fingers, and joints of middle index fingers [131, 132]. Apply pressure at very bottom of pot, where clay is solid.

- Push whole amount of clay into tall cone shape before centering clay for next pot.

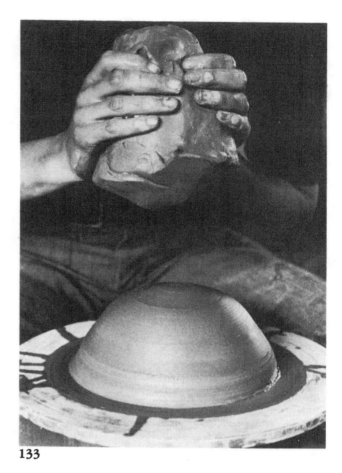

133

Throwing Large Pots

I have made an attempt to explain the process of throwing as it applies to the average-size pot. The necessary modifications for throwing very small pots were discussed under throwing off the hump and consisted of throwing many pots from one piece of clay, minimizing the contact and pressure areas, and taking short cuts, such as raising the wall at the same time as one shapes it.

The problems of throwing with large amounts of clay are the exact opposite. They center around the fact that a great deal of strength may be required to deal with more than fifteen pounds of clay. In most instances lack of strength can be overcome by breaking up one step into several, by increasing the contact and pressure areas, and by using one's body both to add support and to put weight behind one's strength.

Since it is very tiring to wedge more than ten pounds of clay at a time, large amounts can be wedged in two parts (or even three). Wedge each part and divide it in two. Then take one half of one part and one half of another and wedge them together. This way you are assured that the two parts are the same consistency. Center one part and shape it into a mound. Remove the slip on the surface of the mound with the flexible rib and push the second part on top of it [133].

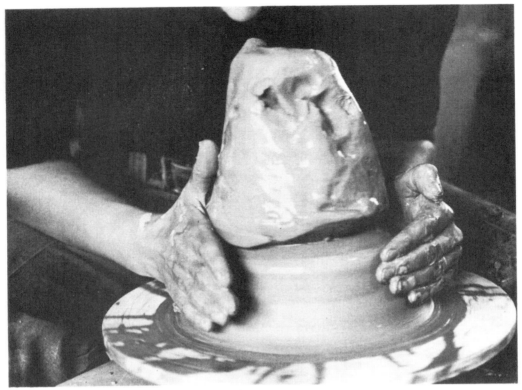

134

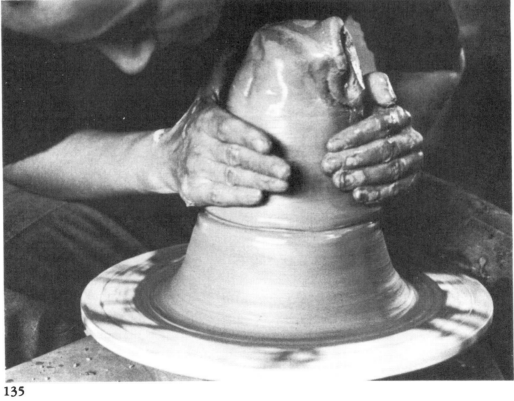

135

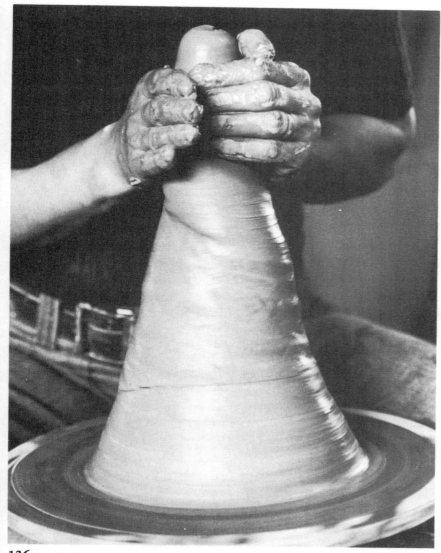

136

Start to center the whole amount by pushing up the first centered part into the second cone [134] and the top cone downward into the bottom cone [135]. Then proceed to center the entire amount [136].

If you want to center the whole amount of clay at one time, it is helpful to first slap the clay into a cone shape with your dry hands from either side while the wheel rotates slowly [137].

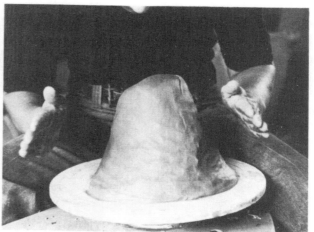

137

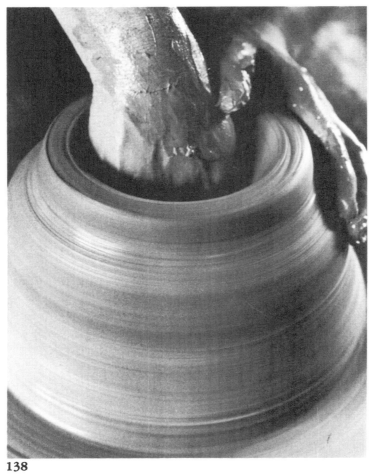

138

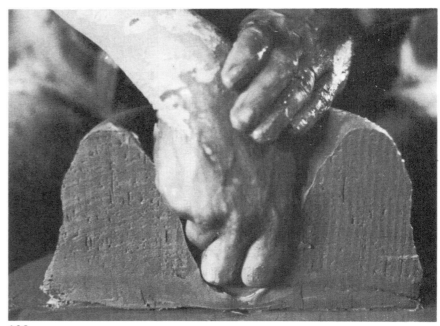

139

Dropping the hole into a large amount of clay requires more strength than the fingertips of one hand can supply. You can drop the hole either by inserting a fist [138, 139] or by pushing the fingers of both hands in, while the thumbs ride on top of the rim [140, 141]. In the first case, put the weight of your body behind your fist and brace it with your left hand.

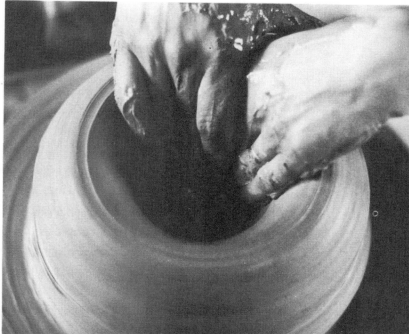

140

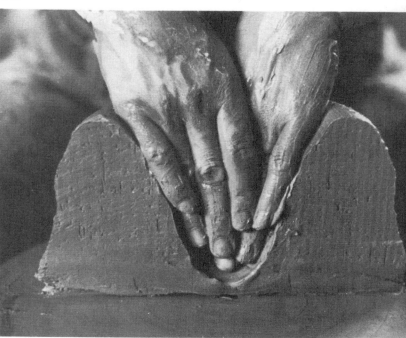

141

In raising the walls, the knee can supply the extra push and support needed by the right hand to take charge of the clay. Push the knee directly against your hand when you take hold of the clay at the bottom. This way the clay has absolutely no leverage and it therefore does not require any strength in your arms to keep the hand steady [142].

The pulls can be done in the usual manner, but once the cylinder becomes a foot or more in height, it is better to stand up. Put your legs as close to the wheel as possible. This way you can brace your right arm and hand on your leg and then your body as you come up with your hands on the cylinder [143]. It also allows you to keep your left arm close to your body and braced instead of sticking out into space. If you are tall, bend your knees and keep your back straight. Standing back from the wheel and bending your back will not only result in a backache, since it puts all the stress on your back, but will put you in a position where your arms are away from your body and cannot be braced. Shaping large pots presents no problems. The additional weight of the clay, however, has to be kept in mind.

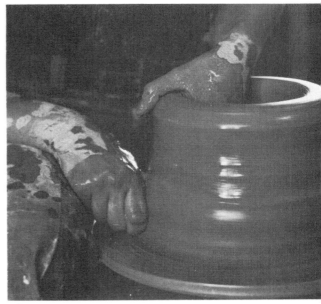

142

Summary

- Wedge clay in two or three parts.
- Divide each part and wedge two different halves together.
- Center one part and push it into a half-round mound.
- Put second part on top [133].
- Push lower part into second part [134] and top part into lower part [135]. Then center entire amount of clay [136].
- Drop hole, using fist [138, 139] or both hands on inside [140, 141].
- Raise clay by pushing with knee against right hand [142].
- Stand up as close to wheel as possible, keeping back straight and bracing both arms against body [143].

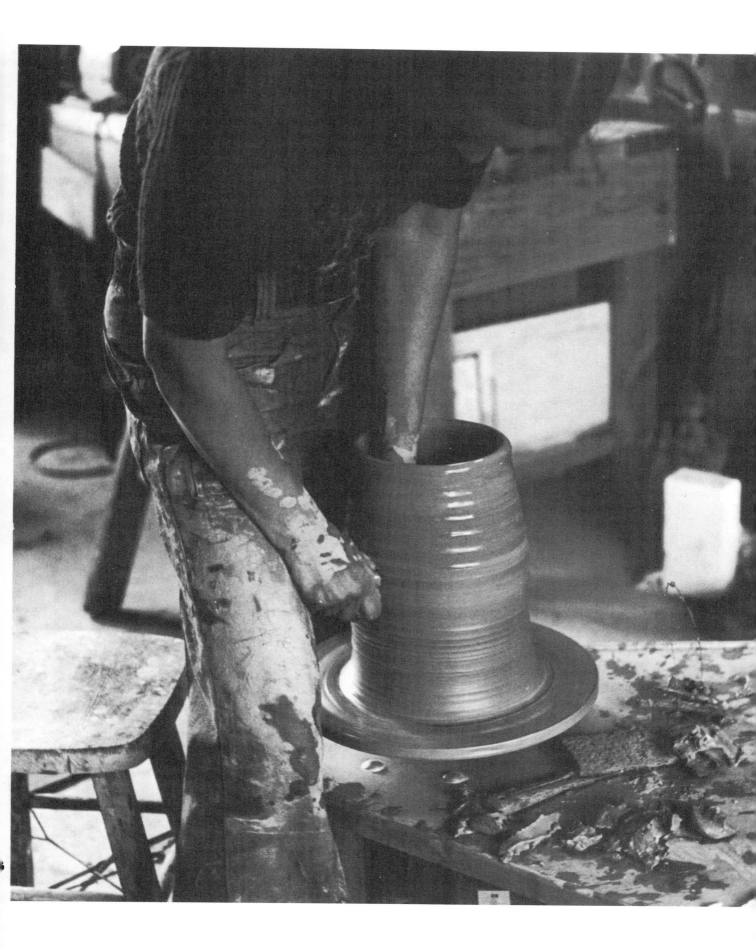

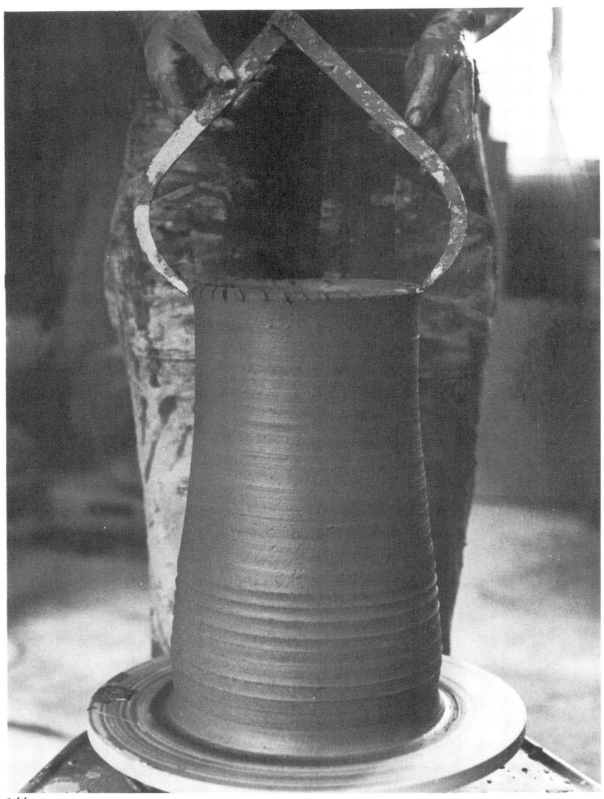

144

Section Throwing

Section throwing is a technique that greatly facilitates the throwing of large pots. Rather than form a thirty-inch pot from a solid lump of clay, you can throw a pot in two or three sections. This can be done in two ways: one, the sections may be thrown separately and joined when all sections are leather hard. This technique requires a great deal of measuring and planning, since the sections cannot be easily modified and it is often difficult to conceal the joints and give the pot a unified appearance. In order to avoid this, the sections can be thrown successively on top of one another. This way, even though the bottom section cannot be altered, the top section can be adjusted and formed to continue the flow of the bottom section. The principles and steps of section throwing apply to large pots as well as to putting knobs on covers and throwing pedestals on bowls. It involves attaching a freshly thrown cylinder with heavy walls upside down on a pot that has been allowed to dry to a soft leather-hard stage. The attached cylinder is then thinned out and shaped very much like any other pot. This process can be repeated as often as desired. The great disadvantage of this technique is that unless a wheel with an arrangement for self-centering bats is available, it is necessary to have two wheels.

This technique should be employed for large, tall pots with relatively narrow diameters. A large, wide-open pot is better thrown using the coil method.

The bottom section of the pot is thrown and shaped. Great care should be taken not to create thin spots, particularly near the rim, since the wall has to carry the additional weight of the next sections. Round off the rim to provide as large a seat as possible for the next section. Allow the section to dry to a soft leather-hard stage. Since pots dry from the top down, it may be necessary to cover the rim after a while so that it does not get too dry. As mentioned earlier, if your wheelhead is provided with a self-centering bat, throw the bottom section on such a bat and remove it for drying. Otherwise, leave the bottom section on the wheel to dry. It is essential that the bottom section is perfectly on center when you continue. Perfect recentering of a pot is almost impossible.

When the bottom section has sufficiently dried, measure the outside diameter of the rim with calipers [144].

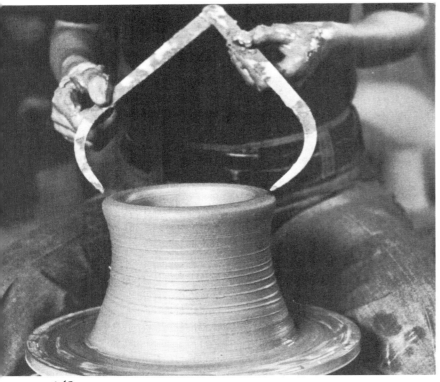

145

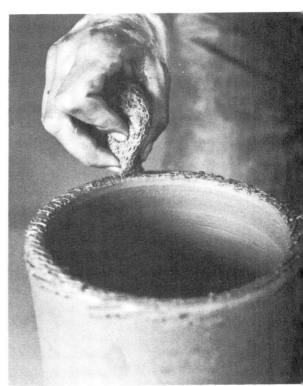

146

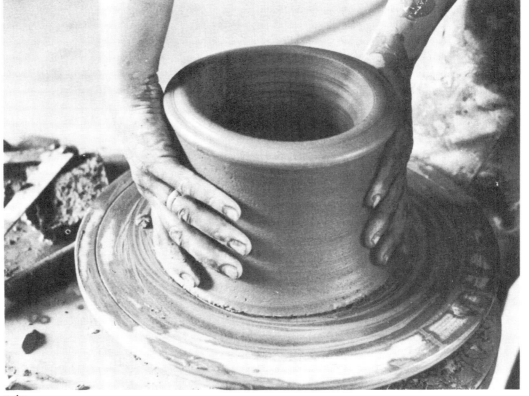

147

Center slightly less clay than used in the bottom section on another wheel. The top diameter of the centered clay prior to opening up should be two to three inches less in diameter than the top diameter of the bottom section.

Drop the hole all the way to the surface of the wheelhead or bat, open up, and make one pull to raise the wall. Adjust the outside diameter of the rim to one quarter of an inch more than the measurement taken from the bottom section [145]. The new cylinder should have rather heavy, concave walls. The rim should be thicker than the rim of the bottom section. Score the rim of the bottom section and down the side for one quarter to one half inch. Wet the rim with a sponge, but under no circumstances let water run down the side of the pot [146]. Then grasp the second section with both hands [147] and put it upside down on the bottom section [148]. The reasons for turning the second section upside down are that it is easier to make adjustments in diameter at the rim of a thrown pot than at the bottom and, also, the heavy part of the cylinder is on top, where it can be thinned with less pressure.

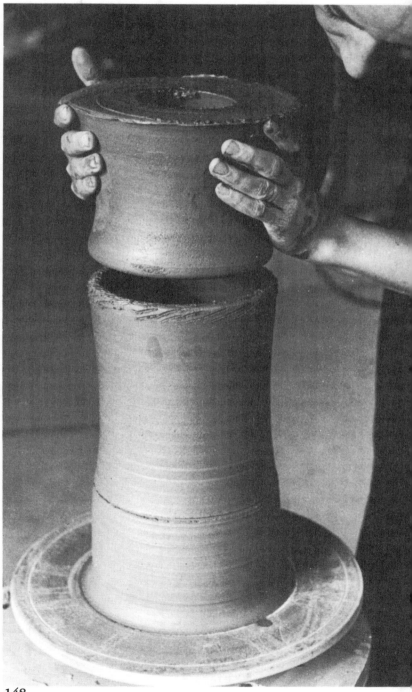

148

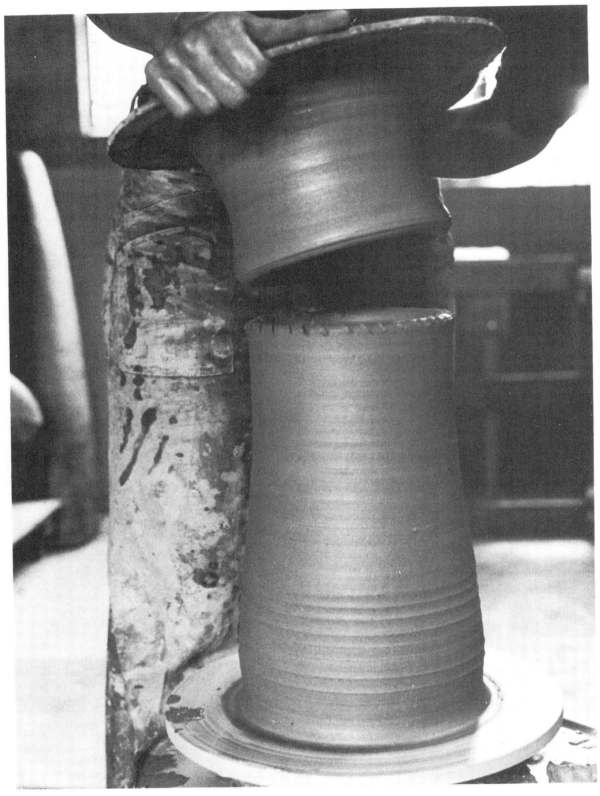

149

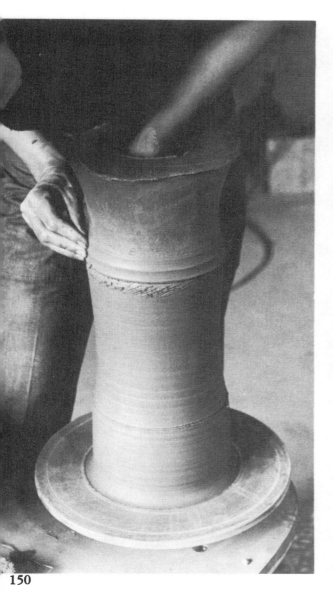

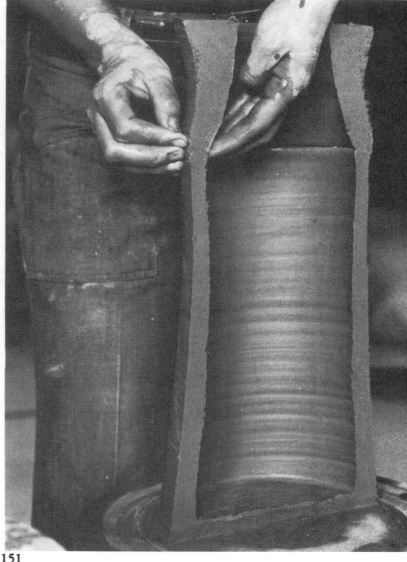

150 151

When moving the second section over to the bottom section, try to avoid distorting the cylinder. Cylinders with wide diameters distort a great deal more than narrow ones; therefore, they should be thrown on a bat and moved over to the bottom section with the bat [149].

Adjust the top section to sit well on the bottom section by pushing the top section in or out. Bracing yourself firmly by pushing your knee against the wheel and standing as close to the wheelhead as possible, with your arms held firmly against your body, recenter and attach the top section to the bottom section with the fingertips of the right and left hand held as in shaping on the outside and inside of the pot. Go from one inch above the joint downward to one inch below it with the wheel going at a moderate speed [150, 151]. When the sections are joined, proceed from the joint upward, thinning the wall and shaping it at the same time with the fingers held

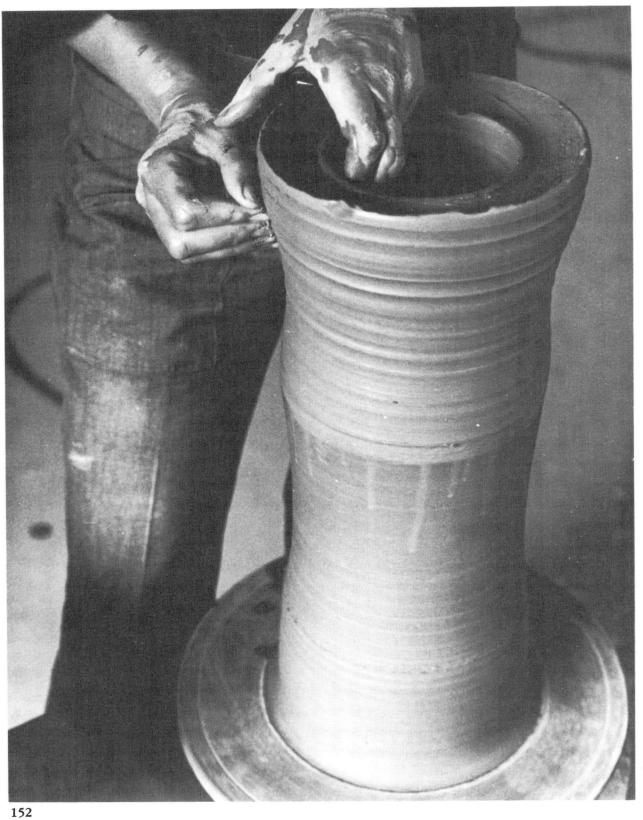

152

in the same position [152, 153]. Two things are absolutely essential in successfully completing this: water has to be used extremely sparingly, since it should never be allowed to drip down the side of the lower section. At the same time, the friction has to be kept to a minimum in order to avoid twists. It is, therefore, better to use the fingertips rather than the joint in raising. Since less pressure should be applied, many pulls may be necessary to thin the walls. In general, when raising and shaping, one has to be extremely gentle and responsive to the clay.

The rim of the top section is then prepared to form the seat for the next section and the process begins again [154]. The sky or the height of the kiln is the limit. If more than two sections are used, it may be necessary, while letting the top section dry, to cover the bottom section with plastic. Should the first section come loose from the wheelhead or bat, reseal it by seeping some water under it and pushing some of the clay from the bottom of the pot onto the wheelhead.

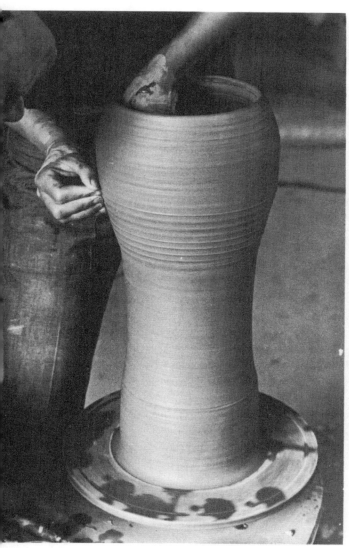

153

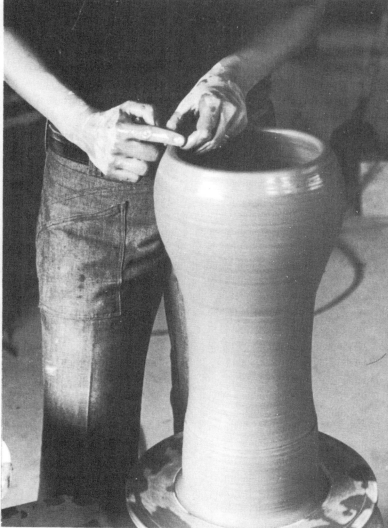

154

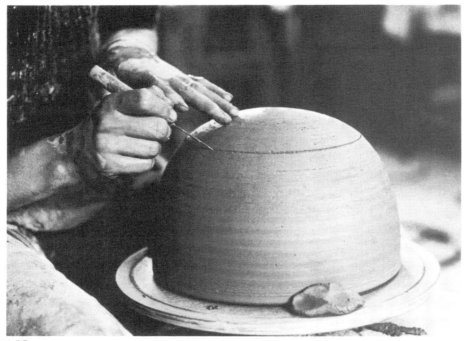

155

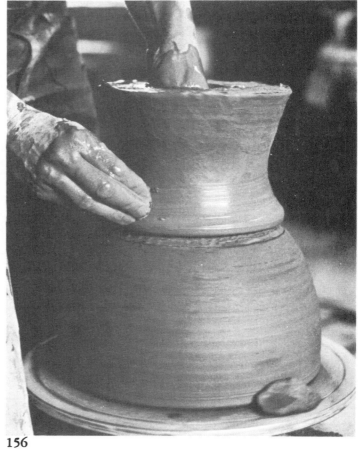

156

Footed bowls follow the same procedure. The bowl is thrown and trimmed to follow the inside shape. This acts as the first or bottom section. On this trimmed bowl determine where the second section should start and draw a circle [155]. This determines the diameter of the rim of the second section. Flare the second section quite wide in order to be able to make a smooth transition from the bowl to the foot. The second section is placed upside down on the bowl, using the circle as a guide. The section is first sealed to the bowl by moving downward on the first pull, and then the cylinder is thinned and shaped as described above [156]. Special attention has to be given to the rim so that it does not become too thin. This is because, when you turn the bowl right side up, it becomes the bottom edge of the foot and carries the full weight of the pot. No water should ever be allowed to accumulate on the inside of the second section. This would inevitably result in a crack through the bottom of the bowl.

The transition from the bowl to the foot can be worked with the flexible rib until it becomes totally obscured [157, 158]. The footed bowl should not be turned right side up until the foot has become leather hard, and the drying should be retarded by draping a piece of plastic over the foot. Goblets and knobs on lids can be thought of as miniature footed bowls; the procedure is the same.

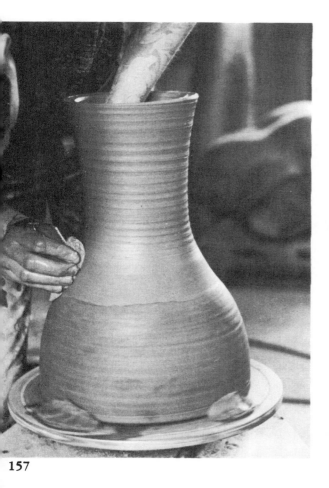

157

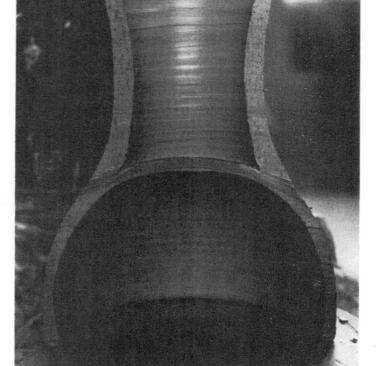

158

Summary

- Throw and shape bottom section without thin spots and with moderately heavy, rounded rim [144].

- Let bottom section get to leather-hard stage.

- Measure top diameter of bottom section [144].

- Throw short cylinder with heavy concave walls for second section [145].

- Adjust diameter of rim of second section to diameter of rim of bottom section [145].

- Score and wet rim of bottom section [146].

- Put second section upside down on first section using both hands or lifting it with bat [147–9].

- Seal joint, pushing downward with fingertips of both hands and going from one inch above joint to one inch below joint [150, 151].

- Raise and shape second section with fingertips of both hands, using as little water as possible and minimizing friction as much as possible [152, 153].

- For footed bowl, trim bowl following inside curve.

- Draw circle where foot should start [155].

- Throw short cylinder with heavy concave walls and with diameter of rim equal to diameter of circle.

- Place cylinder upside down on bowl using circle as guide [156].

- Seal cylinder to bowl, and raise and shape foot, making sure there are no thin spots and walls are heavy enough to carry weight of whole pot [156–8].

- Let pot stand upside down until it is leather hard.

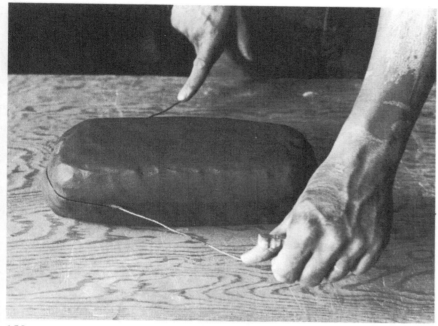

159

Coil Throwing

Coil throwing is a technique in which pots are formed from coils rather than from a solid piece of clay. It therefore enables even a slightly built potter to produce large pots. In fact, its use makes sense only if one desires to throw a large open pot.

The technique involves rolling out fat coils of clay, attaching them to each other, and raising and shaping the wall with the wheel turning at a moderate speed. No water is used for lubrication.

Wedge some clay and pound it into an oblong shape. Cut it in half lengthwise using a wire [159]. Prepare the coil by squeezing this oblong form into a heavy coil. This is done by holding

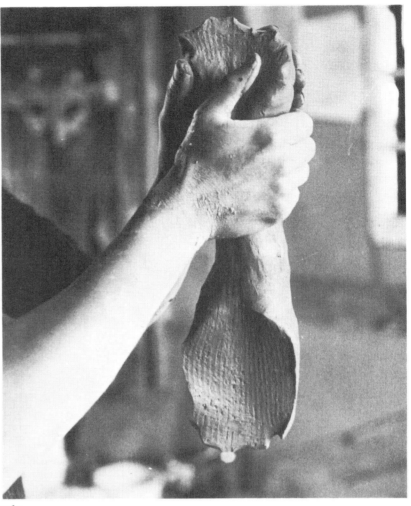

160

it up and slapping it gently from the middle up-
ward with one hand while rotating it with the
other [160]. Then turn the coil, starting again
from the middle, and move up [161]. This way
the weight of the clay helps to thin the coil. Roll
this fat coil on a flat, slightly absorbent, clean
surface, such as plywood, to thin it out and make
it as even as possible [162]. When rolling the
clay make sure that your hands do not press
down. They should only supply the rotating mo-
tion. If the coil makes two or three complete ro-
tations, the table surface rather than the hands
will thin the coil. Start with your hands in the
center and move them apart toward each end.

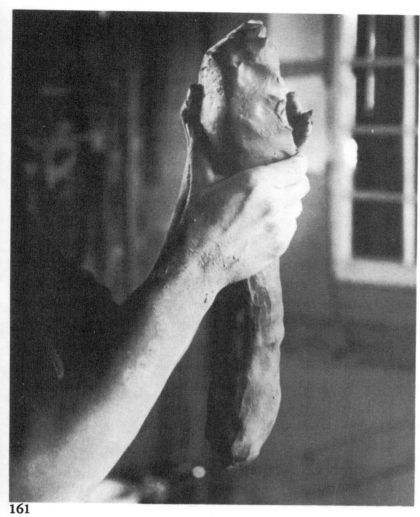

161

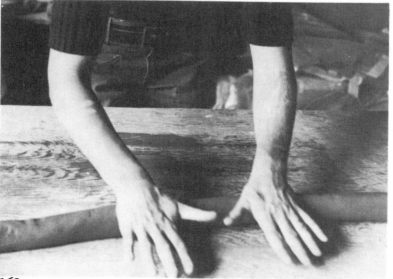

162

Place a fairly thin slab of clay on the wheel; run your fingertips from the center outward, pushing down gently, while the wheel rotates. This seals the clay to the wheel and evens out the slab. Center the slab by simply cutting the excess off with a needle tool [163]. Place the first coil on the slab. Proper and careful placement is essential. Cut the overlapping coil at an angle to have as much contact as possible for joining the coil [164, 165].

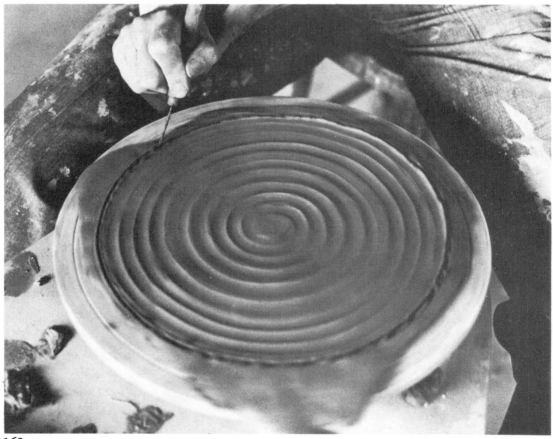

163

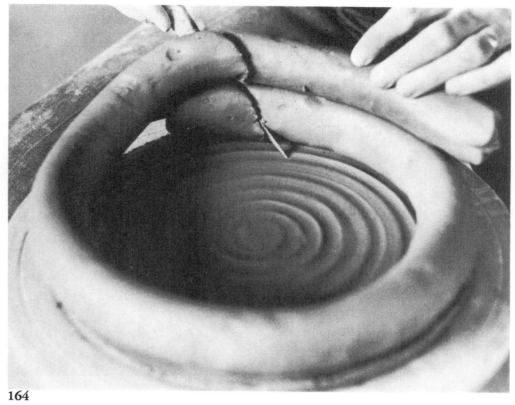

164

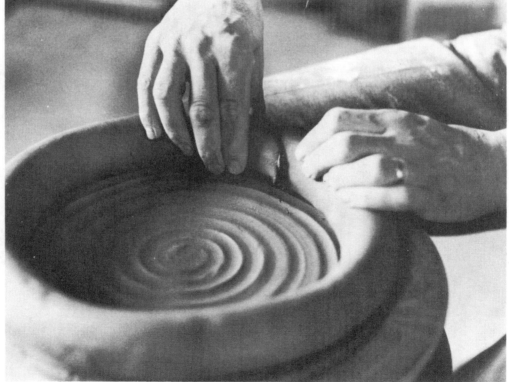

165

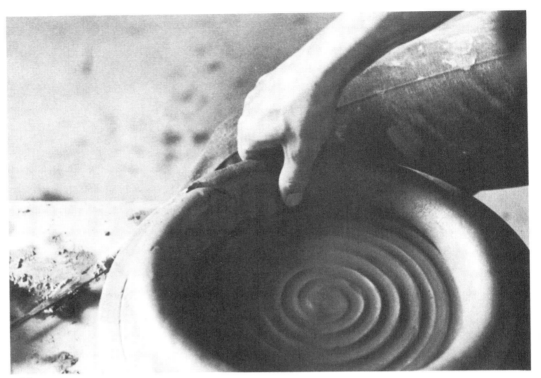

166

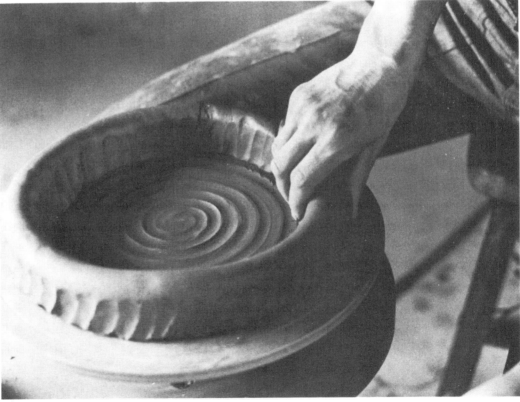

167

With your thumb, seal the inside of the coil to the slab [166] and then the outside [167]. The other fingers counteract the pressure of the thumb on the opposite side of the wall and help in making sure that there is a good contact of the whole coil to the bottom. Then the coil is raised and shaped at the same time by squeezing it between the fingertips of the right hand on the outside and the fingertips of the left hand on the inside [168]. The wheel should go at a moderate speed and no water is used; it would only weaken the structure and the process would have to be interrupted too often to let the walls dry out.

With the first coil, place your fingers one inch above the wheelhead and go down to seal it well to the bottom slab. Then move the fingertips up. Since no water is used, the contact area has to be limited to the fingertips and the pressure should not be too great. Since you are also centering the clay at the same time, it is essential that your arms be well braced. Several gentle pulls will be necessary. The tendency at first is to thin the

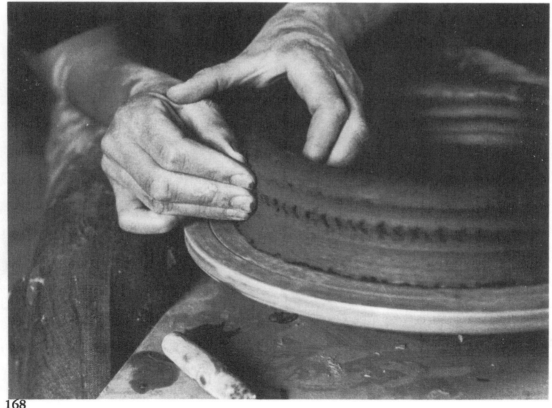

168

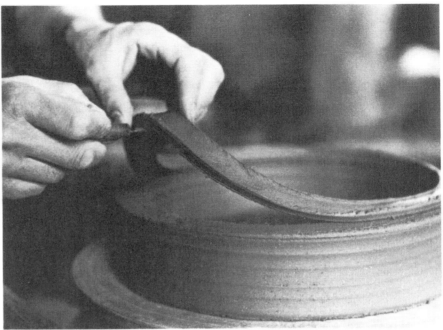

169

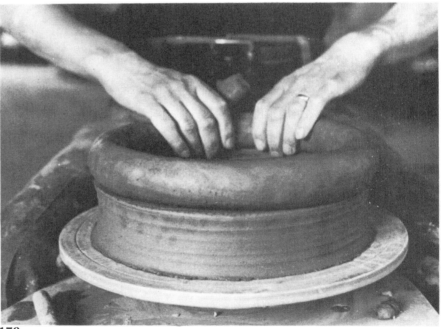

170

coil too much. In general, one has to leave the wall thick, since a large pot is to be thrown. The top edge is always uneven and has to be cut off with a needle tool [169] before the next coil is placed on top of it [170]. The placement and seal-ing of the second coil is exactly the same as the placement and sealing of the first one. In throw-ing, start with the fingers of the right hand cover-ing the join and then move up [171, 172]. Again the rim is cut and the next coil placed. And so on

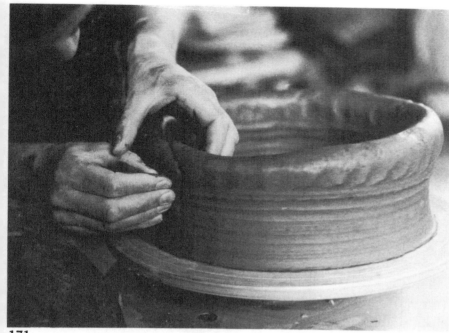

171

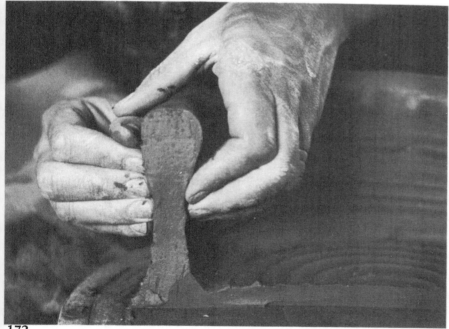

172

and so on [173].

The main part of the actual throwing should occur mostly on one coil. From time to time you can go back over a few coils to adjust slightly the shape, but only minor adjustments are possible. Even without the use of water, it is necessary to let the pot dry and harden somewhat after three or four coils, particularly if there is a change in diameter. Then, before placing the next coil, it is necessary to score and wet the top edge of the preceding coil.

When the diameter of the pot becomes wide, it may be necessary to put the coil on in two pieces. The two lengths of coil have to be made from one piece of wedged clay to ensure that they are of the same consistency [174, 175].

At first this technique seems to be rather tedious and the progress slow, but once you have gone beyond the point you can reach with a solid piece of clay, coil throwing becomes very exciting. It is possible to throw the first section from a solid piece of clay and then proceed with the coil-throwing method; the thrown section has to be dried to the soft leather-hard stage and should be absolutely free of thin spots.

From time to time the bottom should be checked to see whether it is still sealed to the wheelhead. Once the pot has become quite large, it will be held in place by its own weight. Unfortunately, the bottom has a tendency to crack, so it may be better to start with a slab that has been allowed to dry to a soft leather-hard stage.

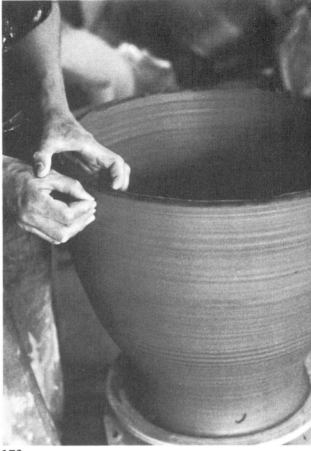

173

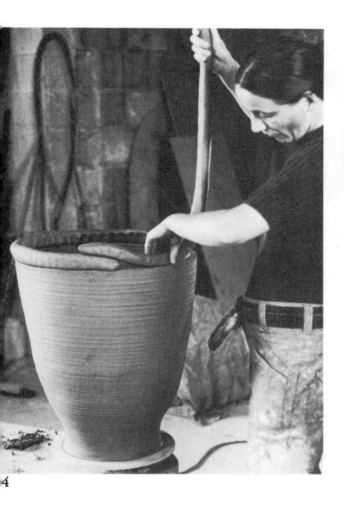
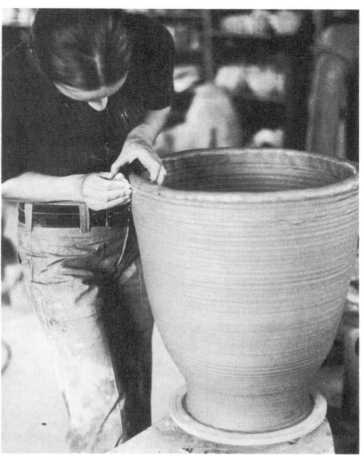

174

175

Summary

- Pound wedged clay into oblong shape.

- Cut it in half lengthwise [159].

- Form rough thick coil by holding clay up with one hand and slapping it with other [160]. Rotate coil while you start from center and move up. Turn coil over and start again from center [161].

- Roll coil on flat, slightly absorbent, clean surface. Start with hands in center and move them to each end [162].

- Place thin slab on wheelhead and seal it by running fingers of right hand from center outward with wheel rotating.

- Center slab by cutting off excess with needle tool [163].

- Place first coil, overlap it, and cut at angle [164].

- Join coil to form ring [165].

- Seal inside with thumb, then outside [166, 167].

- Thin and shape by squeezing with fingertips of right hand on outside against fingertips of left hand on inside of pot. The wheel speed should be moderate. On first coil, move downward and then up [168].

- Cut rim [169].

- Place second coil [170].

- Repeat sealing as before, and start raising and thinning from join upward [171, 172].

- Repeat procedure with three or four coils.

- Let pot stand to become soft leather hard.

- Score and wet top edge and place next coil.

4

Throwing
Specific Forms

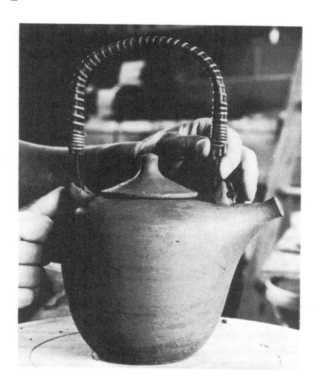

176

177

Jars and Covers

To throw a covered jar means to throw two pots that fit precisely and interlock firmly. The problems of precise fit are obvious when one considers that the amount of shrinkage of the clay varies with the consistency of the clay and with the type of shape. To overcome these problems, certain precautions should be taken. 1. The clay for the cover and the jar should be wedged in one lump. 2. Precise measurements have to be taken immediately after one finishes throwing the pot. Calipers that convert from inside to outside calipers are the best tool for this purpose. 3. It is always a good idea to throw more than one cover for each jar. 4. Cover and jar should be put to-

gether as soon as the cover is trimmed so that they can dry and be fired as a unit.

In regard to the interlocking of the pot and cover, provisions for a seat or rim that holds the cover in place can be made on the jar and the cover can be equipped with a seat and, sometimes, with a socket as well. There are numerous variations and combinations of covers and jars. I will discuss here only six traditional types of covers [181, 209] and five types of seats for the covers on the jars [176], and their possible combinations [177]. These covers can be divided into two groups—those that are thrown right side up and those that are thrown upside down.

Seats for Covers

A rounded or squared-off rim (type 1) and a horizontal shoulder (type 2) are two of the simplest ways to provide a seat for the cover. In either case, the cover hangs from the rim or shoulder and the cover socket reaches inside the pot.

The horizontal shoulder can also be provided with a short vertical ring which holds the cover in place (type 3). Make sure that there is a clear delineation between the shoulder and the ring for measuring [178]. The width of the shoulder can vary a great deal and may be as narrow as the thickness of the rim of the cover.

The rim of the jar may be flared out (type 4); it is the inside of the flared wall that provides the seat for the cover.

Type 5 provides a ring on the inside of the pot on which the cover can sit and a ring around it to keep it in place. This type of seat has to be carefully planned and executed as follows: leave almost double thickness in the rim of the jar. Complete the jar; then let the rim ride between the thumb and middle finger of the left hand. Do not squeeze. These fingers only support the wall. With the index finger of the same hand, move the inner half of the rim down to form the seat [179]. The right hand supports the left hand. The rim and seat can be squared off with a wooden modeling tool for precise measuring [180]. This type of seat holds most covers very securely, particularly if the seat is moved down sufficiently and is wide enough.

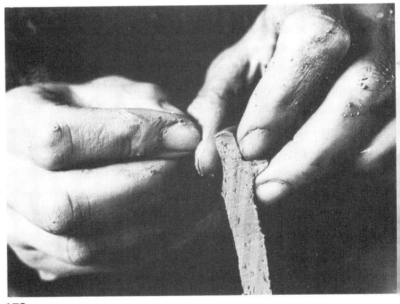

179

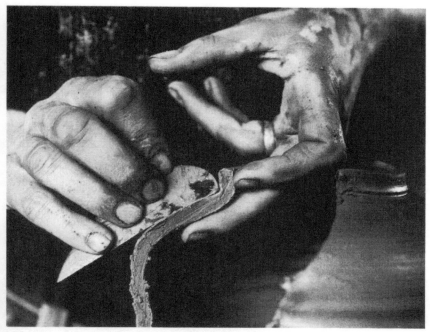

178

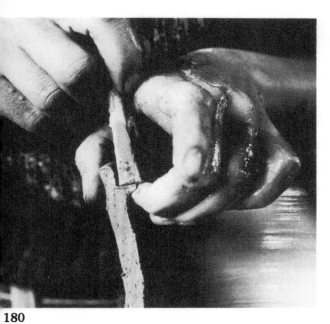

180

Summary

- Type 1: rim of jar rounded or squared off [176].
- Type 2: shoulder of jar [176].
- Type 3: shoulder with rim [176, 178].
- Type 4: flared rim [176].
- Type 5: rim with inside seat [176]. Leave double thickness in rim. Move excess down inside wall with left index finger while left middle finger and left thumb support inside and outside of wall [179]. Right hand supports left hand. Squared off seat with wooden modeling tool [180].

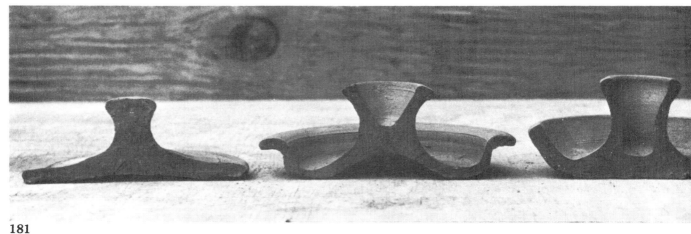

181

Covers Thrown Right Side Up

In this group [181], cover and knob are thrown at the same time. Usually these types of covers need little or no trimming. In measuring, the calipers have to be converted from inside to outside calipers, since in almost all cases the inside diameter of the rim is equal to the outside diameter of the cover. Measure the outside diameter with the calipers and mark the distance between the points on a convenient piece of wood or paper. Then reverse the arms of the calipers and adjust them to the distance you have marked [182, 183].

182

183

184

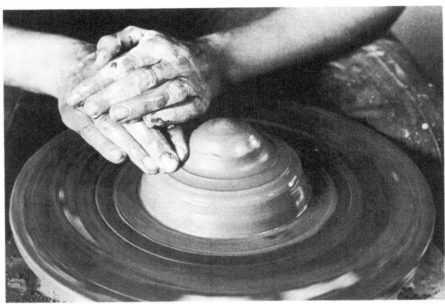

185

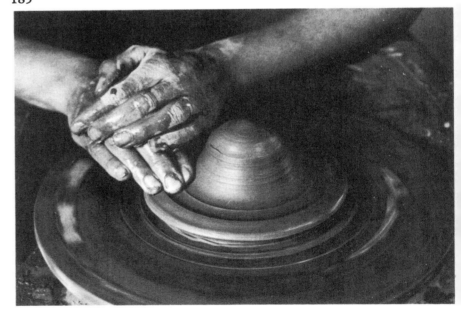

186

The FLAT COVER is the simplest of this group [184]. Spread the centered clay one to two inches less in diameter than the final diameter of the finished cover and approximately one to one and one half inches thick. With the fingertips of the right hand, braced with the left hand, push the clay down, starting about one half to one inch from the center and going out to the edge at three o'clock [185, 186]. Spread the clay to the desired diameter, making sure that the cover does not become too thin. Remember that when you cut it off the wheelhead with the wire one eighth to one quarter of an inch of clay remains on the wheelhead.

The mound of clay left in the center then can be thrown into a knob by dropping the hole, opening up the clay, and raising and shaping it like a small pot [187]. The cover may be finished with the help of a flexible rib [188] and the edge should be slightly raised with a model-

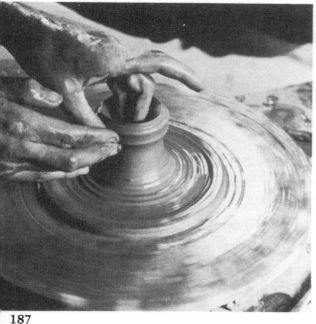

187

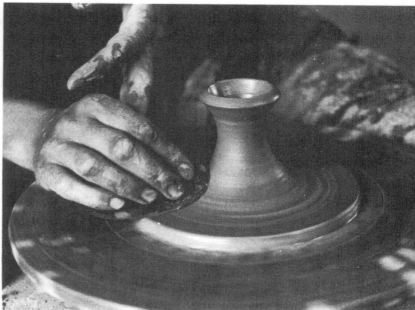

188

ing tool, so that when one cuts it with the wire the edge keeps its thrown, plastic look [189]. To lift the cover off the wheelhead, slip the flexible rib under the edge of the cover at twelve o'clock. Lift it just enough to put the fingers of both hands under it at twelve o'clock [190, 191]. Move the hands to nine and three o'clock and lift the cover off [192]. When placing it on the board, reverse the process precisely. Start by setting the cover down at six o'clock. Then move both hands to twelve o'clock and let go, dropping the cover ever so lightly.

This type of cover is practical for small sizes, as well as large ones (over six inches should be thrown on a bat). It is totally finished and needs no trimming, particularly if the hole is dropped far enough when making the knob. Adjustments in diameter are easy to make, if one is generous and uses more clay than necessary and has made the cover too large. The excess, in that case, is cut off with a needle tool, and a sponge is run over the edge for a well-rounded look.

This type of cover, however, always needs an inside seat, as in type 5.

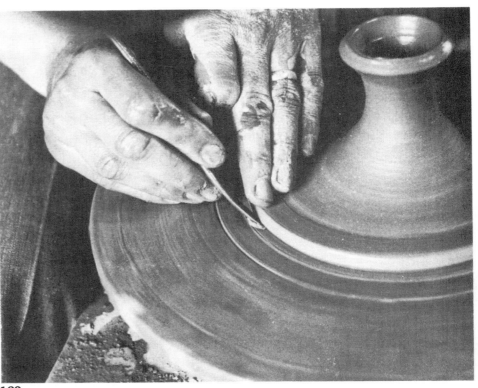

189

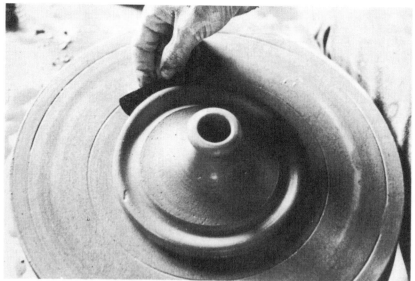

190

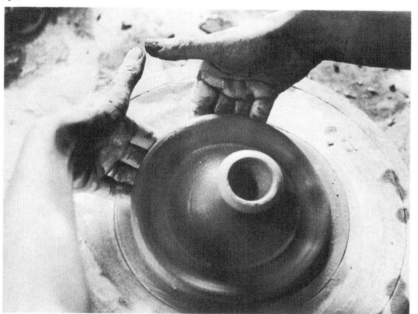

191

192

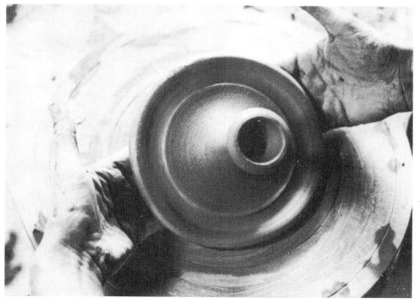

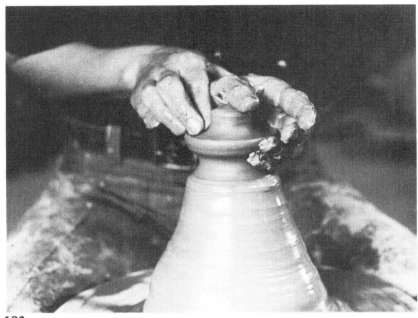

193

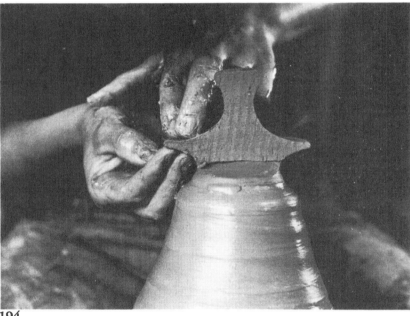

194

Small flat covers may be thrown off the hump. After centering the clay, push it down with the fingertips of the right hand while the left hand cradles the clay with the small finger underneath the clay and the thumb on top [193]. The cover can be squeezed to the desired diameter with the fingertips of the right hand underneath and the fingertips of the left hand on top of the clay [194]. On covers of this small size, the knob may be formed as a solid piece of clay with pressure from the fingertips of both hands [195]. The advantage of throwing the flat cover off the hump is that the rim can be easily smoothed with the sponge to give it a full, plastic look [196].

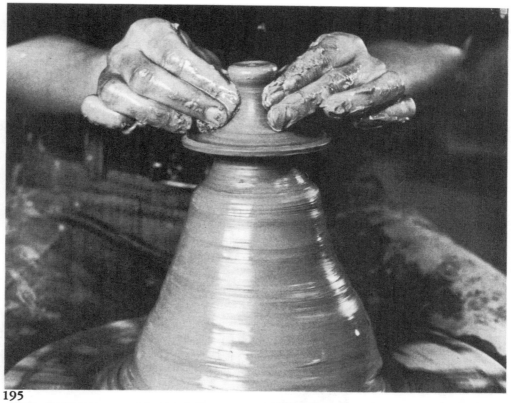

195

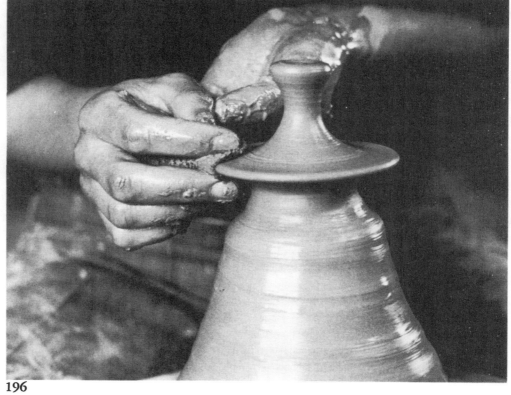

196

The FLAT COVER WITH A FLANGE [197] is also thrown right side up. On this type of cover two measurements may have to be taken: the outside diameter of the bottom or socket, which is equal to the inside diameter of the opening of the pot, and the outside diameter of the cover. To make this cover, spread the centered clay on the wheelhead to a width slightly less than the diameter of the socket. Drop the hole off center, creating a mound of clay in the center [198]. Open the clay up [199] and raise the outer wall vertically [200]. The outside diameter of the socket should now be exact [201].

197

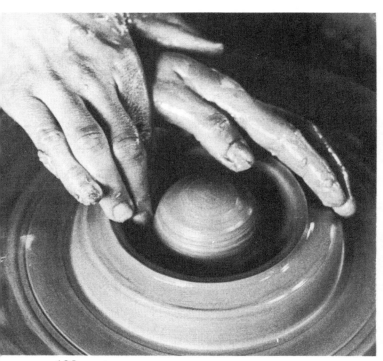

198

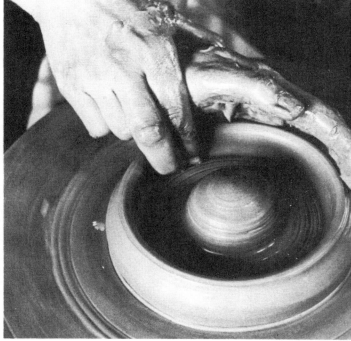

199

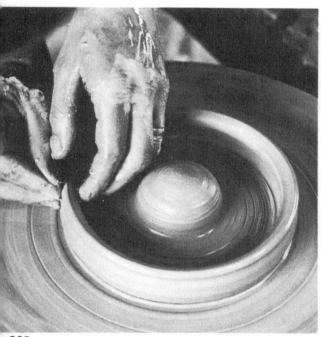

200

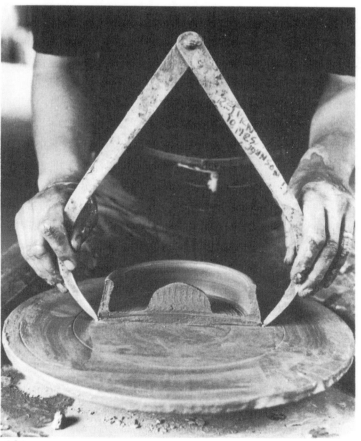

201

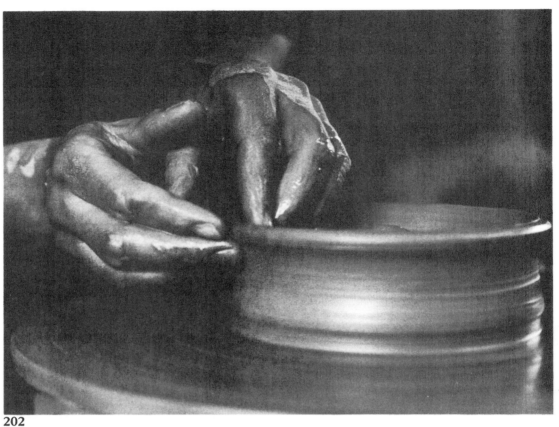
202

Then bend the wall over the middle finger of
the right hand with the fingertips of the left
hand [202, 203]. You can also use the sponge
to bend the wall over the index finger of the left
hand [204]. Care must be taken not to change
the diameter of the socket, particularly just below
the flange. If this type of cover is used on a type
1 or type 5 jar, the width of the flange may also
need measuring. The knob is thrown exactly as

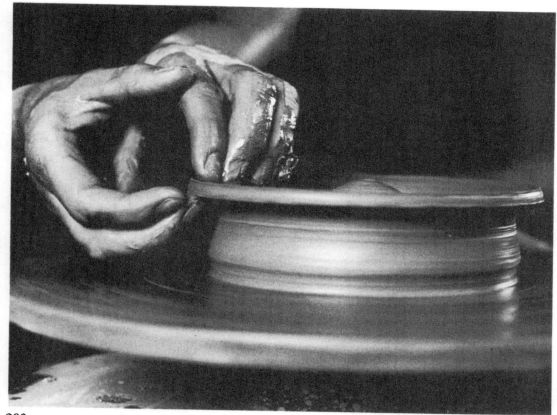

203

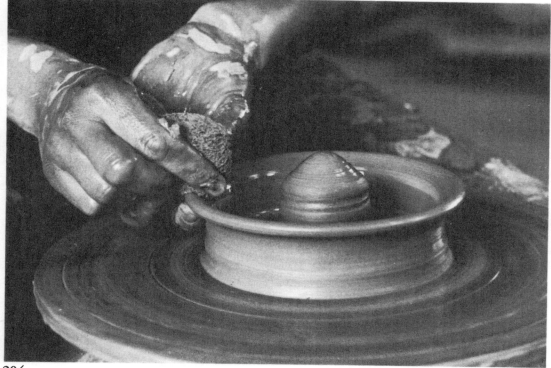

204

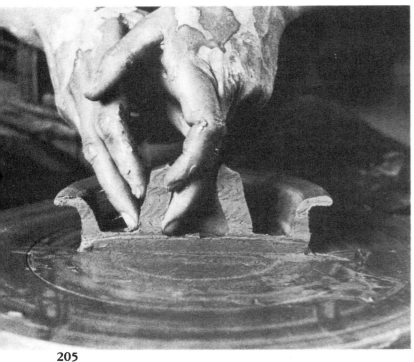

205

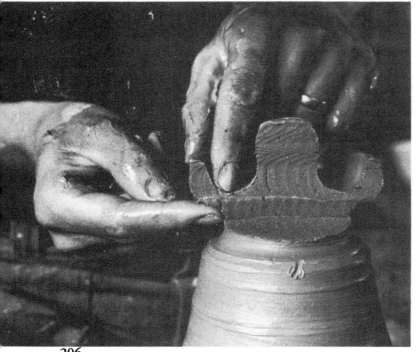

206

on the flat cover previously described [205]. The obvious disadvantage of this cover is that two measurements have to be taken. The advantages lie in its many different applications: it can be used for jars of types 1, 2, and 5. If it is thrown with a deep socket, the cover sits very securely in place. As with the flat cover, no trimming should be necessary. The flat cover with the flange can also be thrown off the hump, and adjustments in the diameter of the socket part can be made by squeezing the clay in the bottom of the cover from above and below [206].

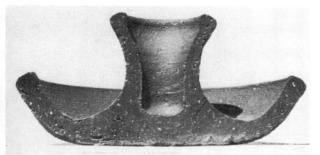

207

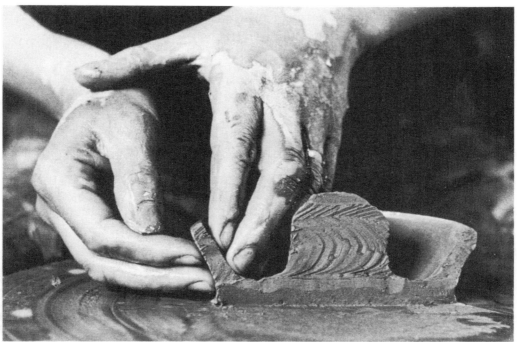

208

A similar cover, thrown right side up, with the hole dropped off center is the one that fits jar type 4 with the flared rim [207]. The angle of the flare of the jar has to be repeated by the flare of the cover, and for this a trained eye and hand are necessary [208]. The outside diameter of the FLARED COVER is equal to the inside diameter of the rim of the jar at the very top. Measuring must be precise, since it is unappealing to the eye if the cover is too large and protrudes beyond the rim of the jar. If the cover is thrown too small, it may end up in the bottom of the jar.

Summary

- No trimming needed on covers thrown right side up. Knob is thrown at same time as cover [181].

Flat cover [184]

- Center clay and spread it into block one to two inches narrower than desired diameter. With fingertips of index, middle, and ring fingers of right hand, push clay down, starting half to one inch off center and going to edge at three o'clock [185].
- Spread clay to desired thickness of cover and desired diameter [186].
- Throw knob from mound of clay in center [187].
- Clean lid off with flexible rib [188].
- Lift edge of lid with wooden modeling tool [189].
- Cut lid off wheelhead.
- Lift edge of lid at twelve o'clock just enough to slip fingers of both hands underneath [190, 191].
- Move hands apart to nine and three o'clock [192].
- Lift cover off wheelhead.
- Place cover on board, reversing steps exactly.
- Fits jar of type 5.
- Off hump: push clay down with fingertips of right hand while cradling clay with left hand [193].
- Achieve desired diameter by squeezing clay between fingertips of left hand on top and fingertips of right hand below clay [194].

 Shape knob from solid piece of clay left in center with pressure from fingertips of both hands on outside [195].
- Smooth edge with sponge [196].

Flat cover with flange [197]

- Spread clay to almost desired diameter of socket.
- Drop hole one half to one inch off center [198].
- Open up clay [199].
- Raise outside wall vertically [200].
- Make sure outside diameter of socket part fits opening of pot [201].
- Bend part of wall over middle finger of right hand with left hand without changing diameter, just below flange, or with sponge, bend flange with right hand over index finger of left hand [202–4].
- Throw knob from the mound of clay left in center [205].
- Lift off cover in same fashion as flat cover.
- Off hump: Proceed as described above except lid can be brought to desired diameter by squeezing clay from on top and below with fingertips of both hands [206].
- May use with jars of types 1, 2, and 5.

Flared cover [207]

- Throw in same manner as flanged cover, but instead of raising wall vertically, flare it at same angle [208] as rim of jar of type 4.

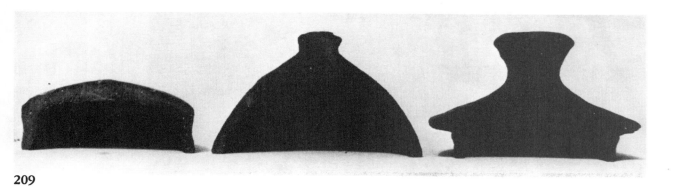

209

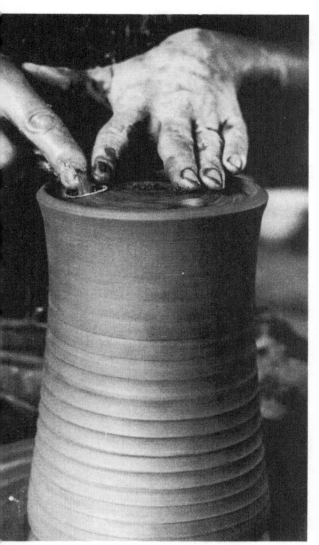

210

Covers Thrown Upside Down

The second group of covers [209] is thrown upside down. The top is usually trimmed using its jar as a chuck [210]. The knob can either be carved out of the excess clay left in throwing [211, 212] or it can be thrown on top of the cover after it has been trimmed following the procedure outlined in the discussion on section throwing [213–15].

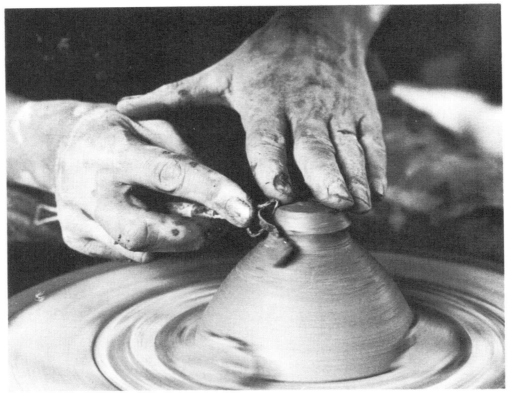

211

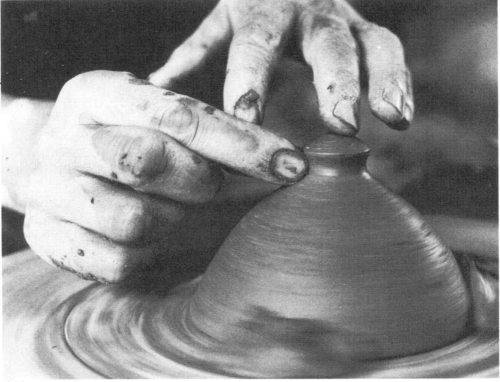

212

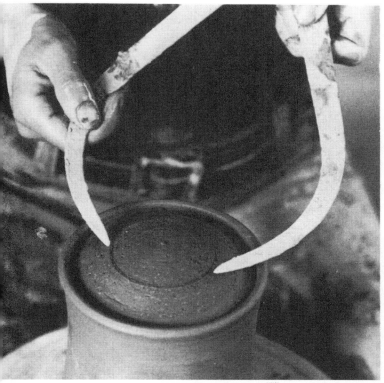

213

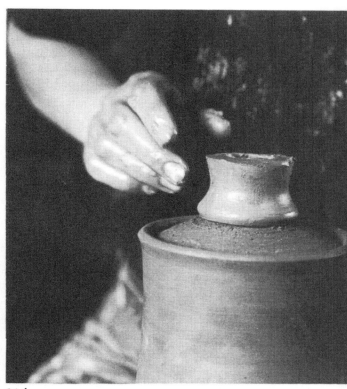

214

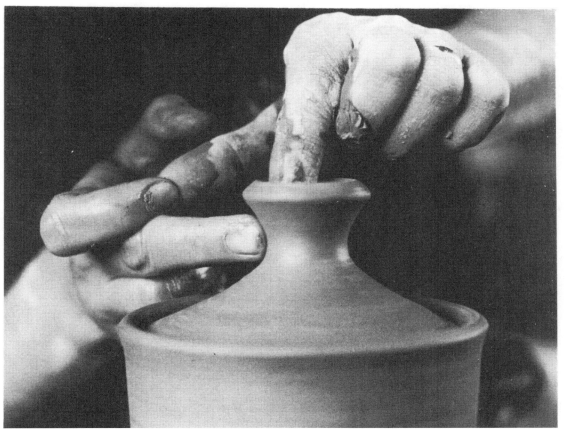

215

216

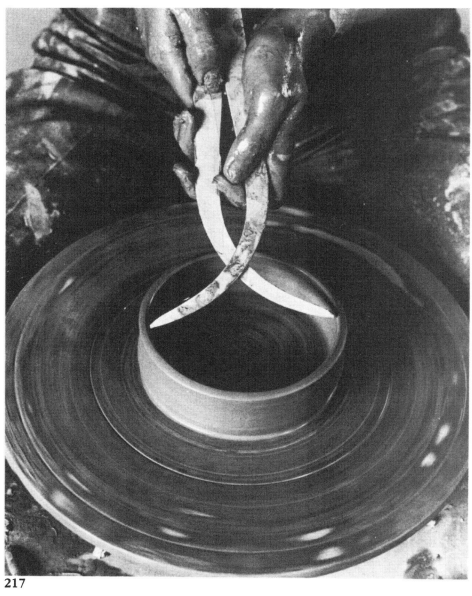

217

218

The simplest of the second group is the ORIENTAL COVER [216], so named because of its frequent use by Japanese and Chinese potters. It consists of a flat dish with straight sides [217]. It usually sits on the shoulder of a pot, where the ridge keeps it in place (type 3). If the cover is hand-size, no knob is needed. The top of the cover (that is the bottom, when it is being thrown) may be curved or flat, and often lends itself to decoration. With this type of cover, the outside diameter of the ring on the shoulder of the pot is equal to the inside diameter of the cover.

BOWLS, either flat or deep, lend themselves well as covers. This type of cover [218] almost always sits on an inside seat, as in type 5, but it could also be used in conjunction with type 3. A shallow, almost plate-like cover of this type is especially well suited for casseroles [219].

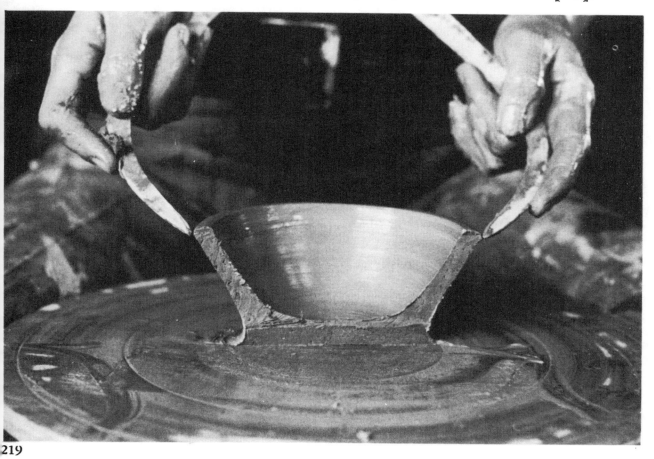

219

220

The last type of cover to be discussed is the CLASSICAL TEAPOT COVER [220]. It is thrown upside down in the form of a bowl, either shallow or deep, and equipped with a flange on the outside. Since it consists of a seat and a socket, two measurements may have to be taken: the diameter of the socket, corresponding to the opening that it goes into, and the diameter of the seat, if it sits inside a pot as in type 5.

Throw a bowl with the outside diameter slightly more than the diameter of the socket and a rim that is thicker than the wall [221]. Push this additional thickness down on the outside of the bowl to form the seat by using the index finger of the right hand, while the wall is supported by the thumb and middle finger of the left hand [222, 223]. The wooden modeling tool is used to square off the seat for precise measuring [224] and the sponge is used to thicken the edge [225]. This type of cover, though difficult to throw, is extremely versatile and can be used sitting on a rim (type 1), on a shoulder (type 2), and on an inside seat (type 5). To adjust the diameter of the seat, squeeze the flange out to make it bigger or cut off the excess to make it smaller. Adjustments can also be made by moving the wall of the bowl in or out after the seat has been made, but remember that both the diameter of the seat and that of the lid socket will change.

221

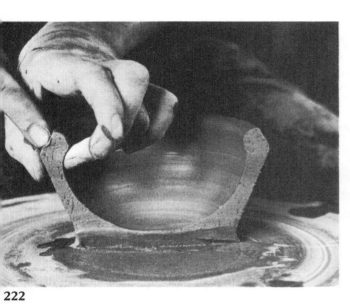

222

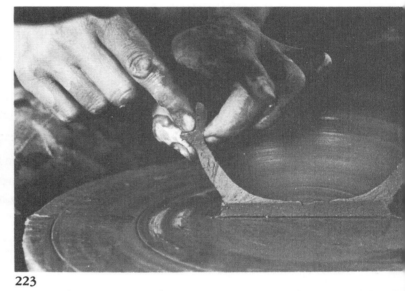

223

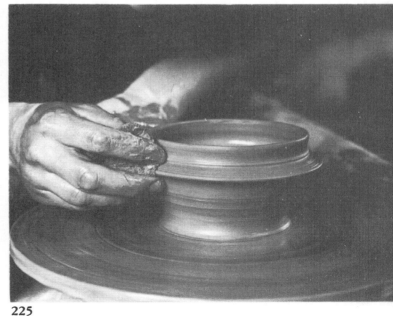

224

225

Summary

- Lids thrown upside down [209]; lids may be trimmed using jar for chuck [210]. Knob can be carved from excess clay or thrown on top using section-throwing method [211–15].

Oriental cover [216]

- Throw small dish with vertical sides and flat or curved bottom [217].

- This cover fits type 3 jar.

Bowl-shaped cover [218]

- Throw bowl, either deep or shallow [219].

- This cover needs inside rim and fits type 5 jar.

Classical teapot cover [220]

- Throw flat or deep bowl, leaving rim extra thick [221].

- Move excess thickness of rim down with index finger of right hand while the wall is supported with thumb and middle finger of left hand [222].

- With this excess clay, form seat on outside of bowl [223].

- Square off seat with wooden modeling tool [224].

- Finish edge with sponge [225].

- Fits jars of types 1, 2, and 5.

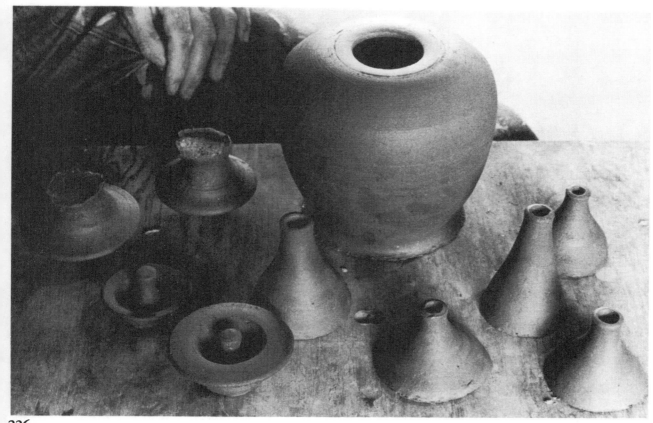

226

Teapots

A teapot consists of many parts that have to be thrown separately and assembled when they are leather hard. Composite forms are in general difficult to shape into a cohesive whole, and a teapot is probably one of the most difficult. The shape and placement of the parts are dictated not only by aesthetic considerations but also by their function. The teapot holds a liquid and therefore should not be top-heavy; the spout has to pour evenly, without dripping, and has to be placed in such a way that the teapot can be filled to the top. The cover should fit precisely to seal in the aroma of the tea and to remain on the pot when it is tilted for pouring. The handle should be comfortable and placed to facilitate pouring. Moreover, the teapot should reflect the special ceremony and the mood of those who use it.

A pot, cover, and spout have to be thrown and set aside until they become leather hard [226].

The type of cover chosen should be one that

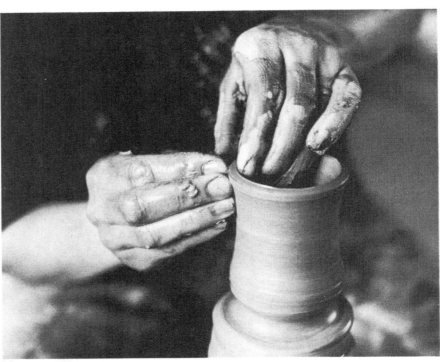

227

sits very firmly on the pot, even when it is tilted. The spout is usually thrown off the hump, following the principles of collaring. First throw a narrow cylinder with very thin walls [**227**]. Collar this cylinder with the six-point system, keeping a wide base [**228**]. Alternate collaring and thinning as long as the diameter allows you to get one finger inside. The final taper can be achieved by using the fingertips of one hand at three o'clock and the fingertips of the other hand at nine o'clock with the thumbs at six o'clock [**229**]. Spouts may vary a great deal in shape; they can be long and thin or rather squatty. They should always have a narrow pouring end and a wide base in order to make a gradual transition from the pot to the spout. Trumpet-shaped spouts have a tendency to spurt out the liquid rather than to let it flow evenly. When learning to throw teapots, it is a good idea to throw several covers and spouts, so you can experiment with different combinations.

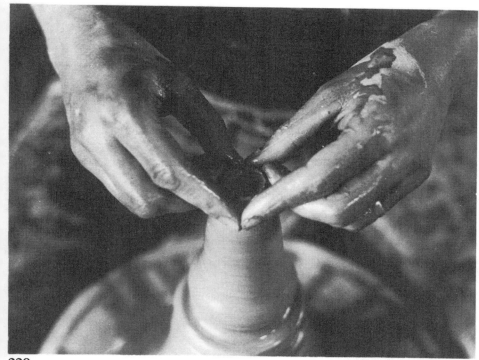

228

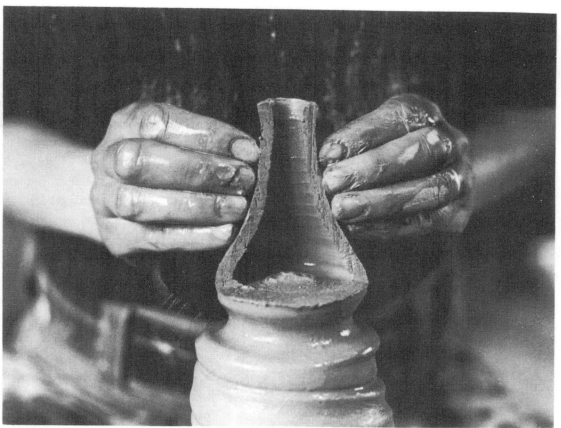

229

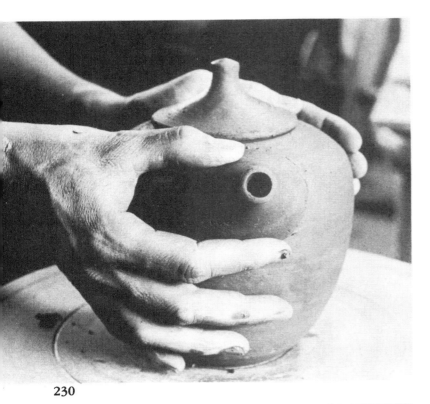

230

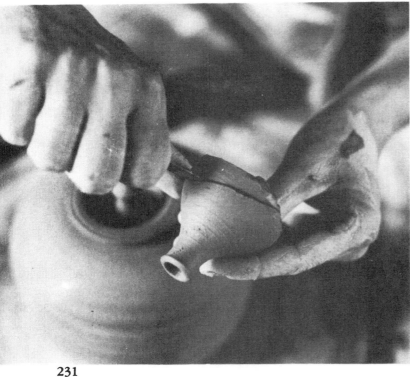

231

In assembling the pot, make sure that the spout is a little wetter than the other parts. Trim the pot first and place the cover on it. Then select the right spout [230]. Some of them, depending on the shape of the pot and the spout, may need to be cut at an angle at the base so that they fit the pot better [231]. The bottom edge can also be adjusted to the form of the pot by squeezing it. Remember that the lip of the spout should be higher than the top of the pot.

Once the selections of the spout and the place of attachment have been made, outline the spout on the pot; score and slip where the walls of the spout will be attached. Make the holes for the tea to pour through [232]. They should not be too small; otherwise they may clog up with glaze and impede the flow of the tea. Score the bottom edge of the spout and attach [233]. Work the transition of the spout to the pot by smoothing it with your fingers or tools or by paddling it [233, 234]. Sometimes the transition from spout to pot is kept

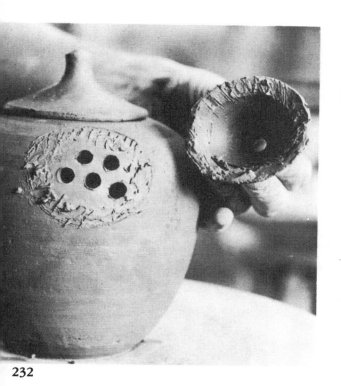

232

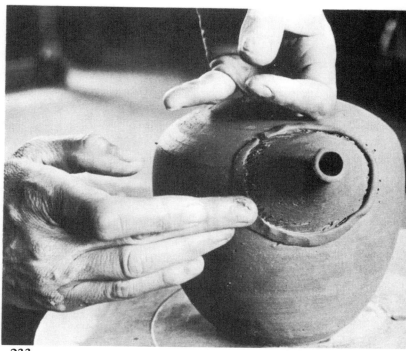

233

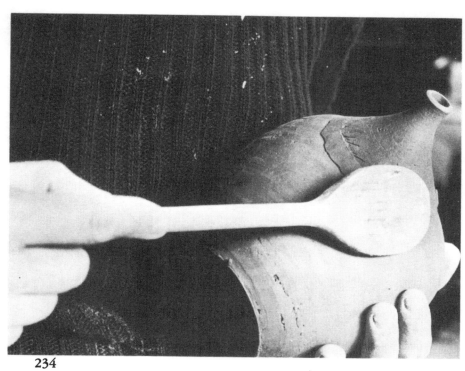

234

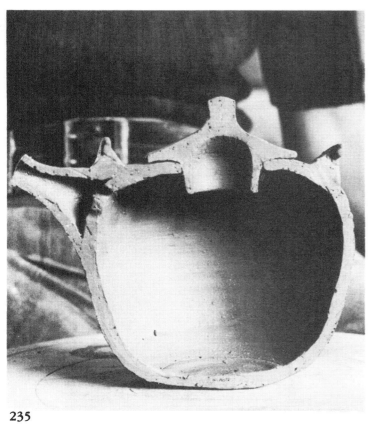

235

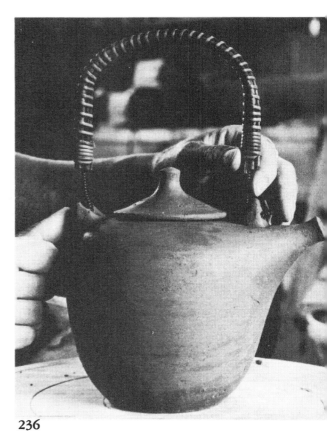

236

deliberately delineated and a decorative pattern is used to mark it. In either case, make sure that there is good contact between the spout and the pot for a permanent and crack-free bond [235].

Handles can be provided for by attaching knobs for a bamboo handle [236] (available in many art-supply stores and Oriental gift shops) or by pulling a handle at the side or over the top of the pot (see page 169).

Summary

- Throw pot with matching cover that interlocks firmly with pot even when tilted [226].

- Spout is thrown off hump using collaring technique [227–9].

- Make sure spout has wide base and tapers to narrow opening.

- Let all parts become leather hard, except for spout, which should be somewhat wetter.

- Trim pot and cover.

- Select spout [230] and adjust its shape to pot either by cutting bottom edge of spout at angle [231] or by squeezing it to make smooth transition to pot, or both.

- Outline spout on pot and score and slip [232].

- Attach spout, making sure tip is at same level or higher than top inside edge of pot [233–5].

- Pull handle either over top of pot or at side. Or attach knobs to hold wire of bamboo handle [236].

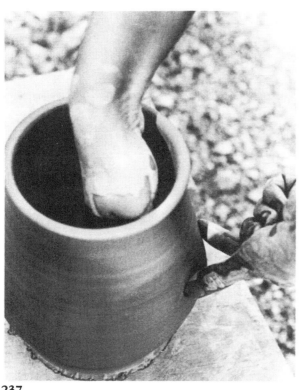

237

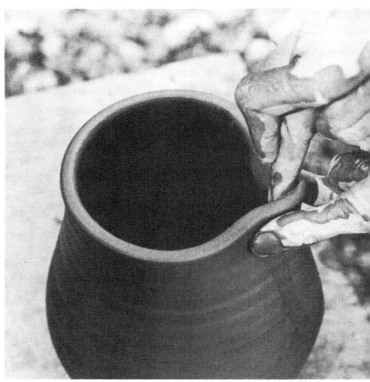

238

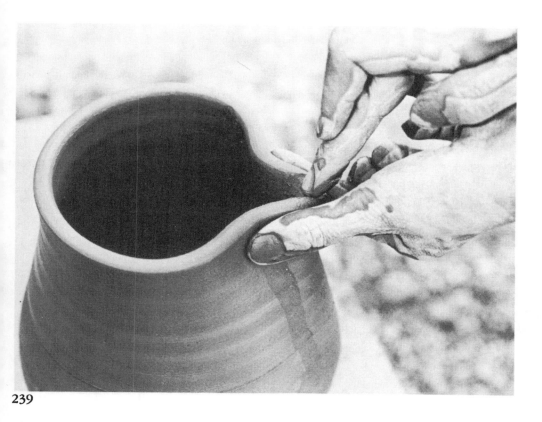

239

Pitchers

The pouring spout on a pitcher is formed right after the pot has been thrown. Insert the right hand deep into the pot and, with the tip of the middle finger, create a channel on the inside by pushing outward while coming up. This pressure is counteracted on the outside, where the thumb and index finger press in lightly on either side of the middle finger [237].

At the rim the middle finger gently pulls the rim over without tearing it [238]. The fingers have to be well lubricated. At the very tip the spout should have a sharp edge to break the liquid [239].

To balance the form made by the top edge, the rim may be slightly pushed in on either side of the spout.

After trimming, the handle is attached as described on page 169.

240

Handles

Handles can be made in a variety of ways. A strip of clay can be bent to the proper shape and smoothed with a damp sponge, or a wire-loop can be passed through soft clay to cut the handle from the clay; then the handle is bent and attached to the pot.

The pulled handle is structurally sounder and aesthetically more appealing. It is formed by pulling and stretching it from a larger piece of clay and it is more akin to the throwing process in looks and structure. The handle is pulled into a tapered form which makes a curve when bent into shape that cannot be imitated by any other method.

Depending on the size of the handle to be pulled, wedge three or four times the amount of clay needed for one handle. It is extremely important that the clay be well wedged, since any unevenness in the consistency of the clay will make it impossible to pull the clay into an even taper. Squeeze the top of the cone into a thinner cone and hold it up in your left hand with the point downward [240].

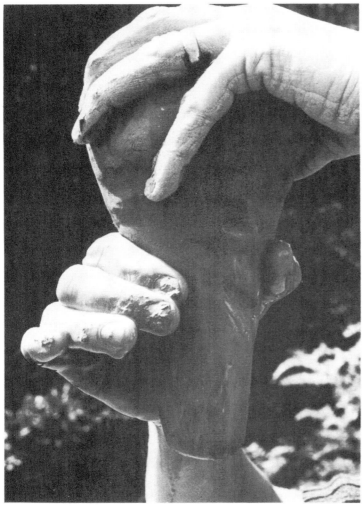

241

242

Wet your right hand and form a ring with your thumb and index finger. Put this ring around the top part of the clay that has been squeezed [241], and with one rapid motion pull the right hand straight down, until your arm is stretched out. While pulling down, close the ring progressively so that it is completely closed when you reach the bottom [242].

Make sure you touch only with the thumb and index finger. Repeat this three or four times, turning the cone with the left hand one quarter turn before pulling down. Make sure that your hand is well lubricated.

These motions should thin the clay with a perfectly even taper from top to bottom. You may continue to pull the clay until the handle is as thin and as long as you desire. Flatten the top of the handle with your thumb, keeping the underside round with the curve formed by your index finger [243]. The handle is then flipped

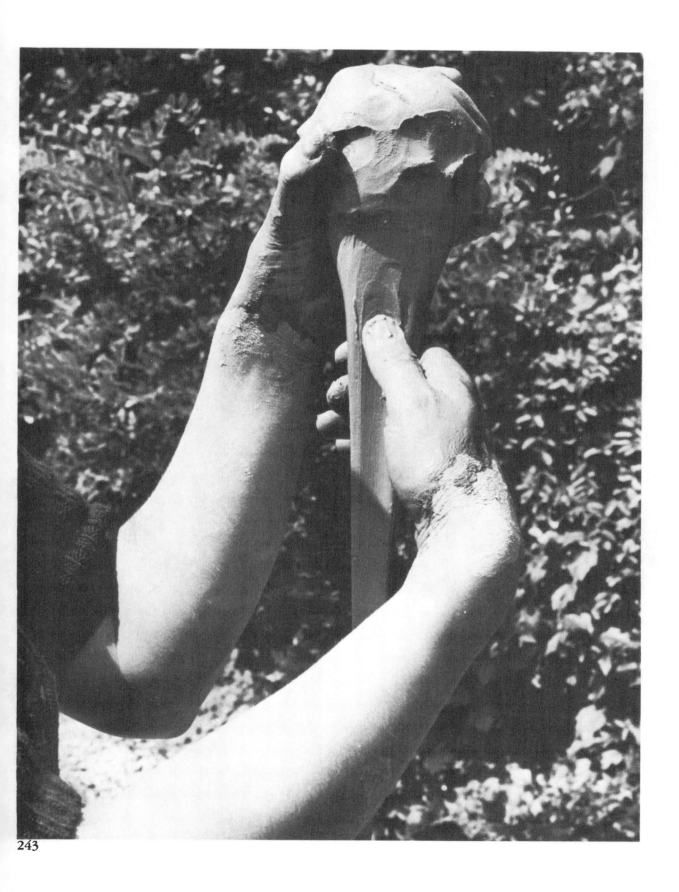

243

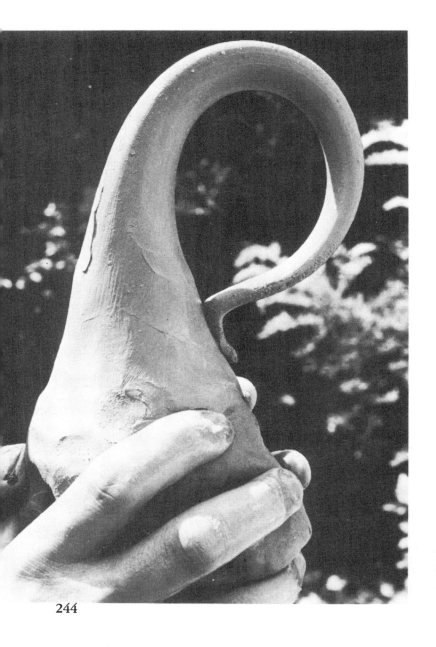

244

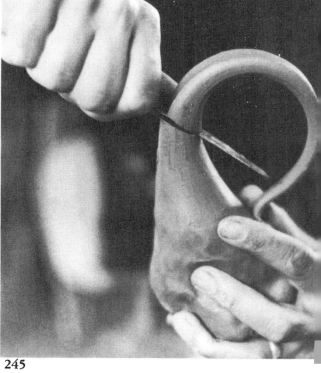

245

over to form a loop, which is allowed to dry to the leather-hard stage [244]. The section that fits the pot best is then cut out [245] and applied to the leather-hard pot, which has been trimmed [246]. Score and slip the area where the handle will be attached. Place a small ring of clay around the transition from the handle to the pot and work it into the handle and the pot to make the transition as subtle as possible [247].

Unfortunately, when done this way, the handle does not seem to grow out of the pot. To achieve this effect, the above method can be modified:

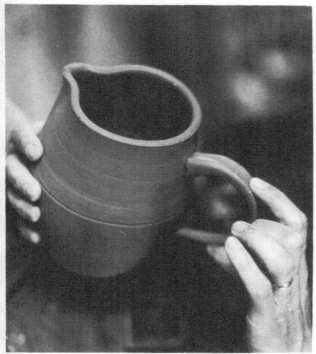

246

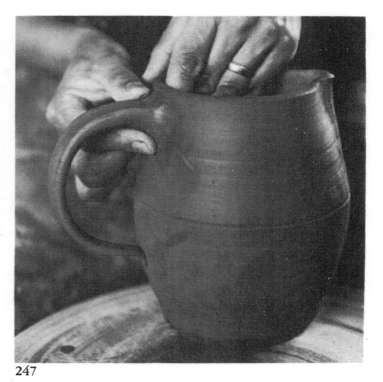

247

248

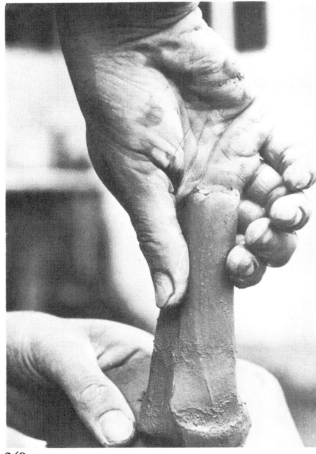

249

Partially pull the handle from the cone, three or four times. Then cut off the amount you need for the pot [248]. This partially pulled handle should be rather firm and thicker than the finished handle. Score and wet the area where the handle will be attached. The pot should have been trimmed by now. Cradle the pot in your lap, so that the left hand is free to support the pot on the inside.

With the thick end of the handle on the pot, work the clay into the pot by reversing the pulling process. Start from the thin end and, with

the thumb and half circle made by the index finger, push the clay to the pot [249]. Carry the motion through from the thin end to the pot and into the sides of the pot in one motion [250], carefully avoiding the creation of any thin spots. Do this three or four times all around the handle until it is well sealed. The curve of the tip of the thumb is an ideal tool to work the transition from the handle into the pot [251]. Since the finished handle should not come out of the pot at a right angle, the proper angle and the gradual transition are made at this stage with the thumb. The

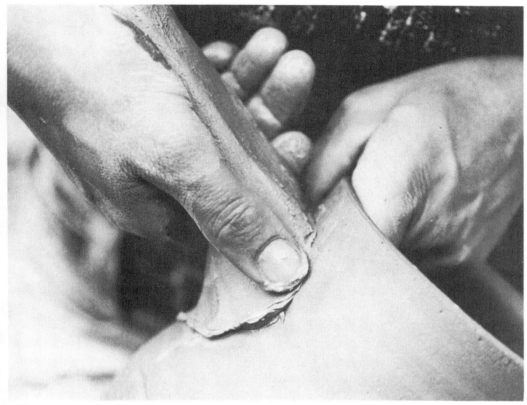

250

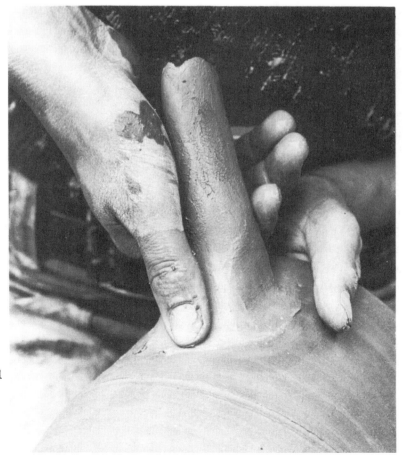

251

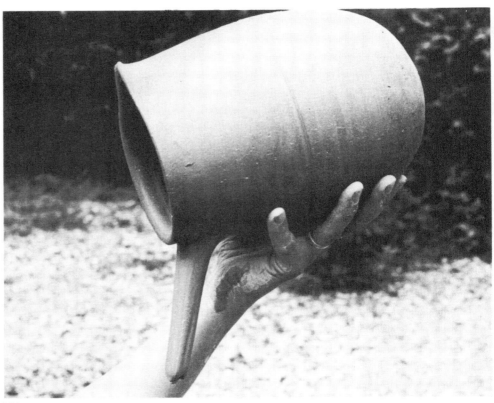

252

transition area can be cleaned off again with the thumb; the marks left, if done properly, add to the plastic feeling of the pot.

You are now ready to continue pulling the handle. Hold the pot up with the left hand. The top of the pot should face you and the bottom of the pot should be higher than the top [252]. This assures again·that the handle grows out of the pot at the proper angle, that is, with an upward curve. Pull the handle as if it were still attached to the cone, but keep your thumb on top to flatten that area and use the half circle made by the index finger at the bottom [253]. Be sure to pull all the way from the top so that this area is also thinned. Carry the pull all the way through [254]. Do not stop when the end of the handle is reached, just as a tennis player does not stop his swing immediately after he has hit the ball.

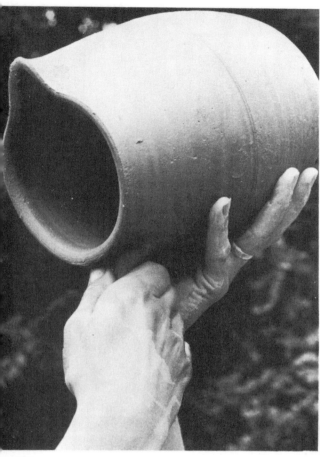

253

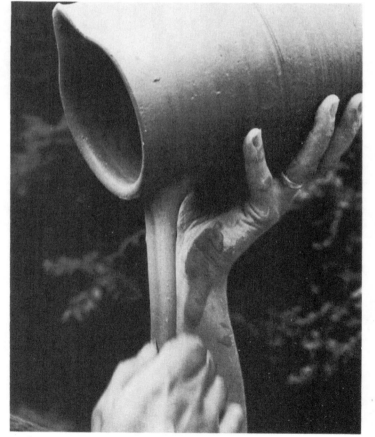

254

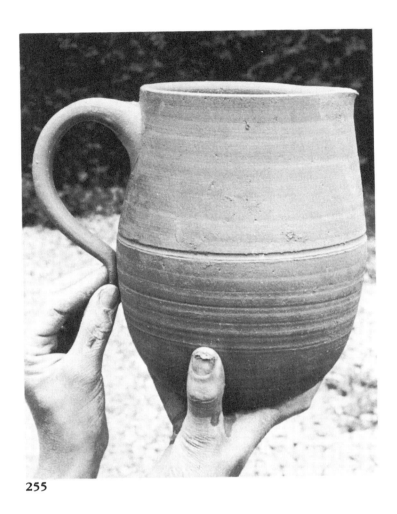

255

Repeat the pulls until the handle is as thin and as long as you desire. If you have created any thin spots as you attached the clay to the pot, they will become more pronounced in pulling and more than likely the handle will break off. If this happens, cut the clay off and start again.

Tilt the pot up and attach the bottom end of the handle to the pot by pressing in with your fingertips [255].

Remember that the handle has to extend from the pot only far enough for your fingers to get through. Any excess extension will make the pot heavy and awkward to use.

The handle should not be touched up immediately after pulling. If the taper was perfect, the tension in the curve cannot be improved.

Let the handle set for a short while and then drape some plastic over it to retard drying. You may also put the pot upside down after pulling the handle on it, to make sure the handle does not sag.

Summary

- Wedge three or four times amount of clay needed for one handle.

- Squeeze out thinner cone shape on top of cone formed by wedging [240].

- Wet right hand and form ring with thumb and index finger of right hand.

- Put this ring around top of smaller cone [241] and pull hand straight down, closing ring. This will thin clay and form handle [242].

- Repeat this motion until handle is as thin and long as desired.

- Flatten top of handle with thumb [243].

- Flip handle to form loop [244].

- Let loop become leather hard.

- Cut from loop section that fits pot best [245].

- Attach handle to pot [246, 247].

- Or repeat pulling from cone four or five times, turning clay one quarter turn before each pull.

- Snip off enough clay to use for one handle [248].

- Attach partially pulled handle to the trimmed pot by reversing pulling action. Going from thin end of handle to pot, push handle firmly to pot by using thumb and index finger of right hand [249]. While doing this, cradle pot in lap and support pot on inside.

- Work transition from handle to pot with tip of thumb [250, 251].

- Hold pot up with left hand, top of pot facing you [252]. Bottom of pot should be higher than top in order to assure upward curve of handle.

- Pull handle with thumb on top and half circle made by index finger of right hand to desired thinness and length [253, 254].

- Put pot right side up and attach bottom of handle with fingertips [255].

- Let handle dry slowly, with pot placed upside down.

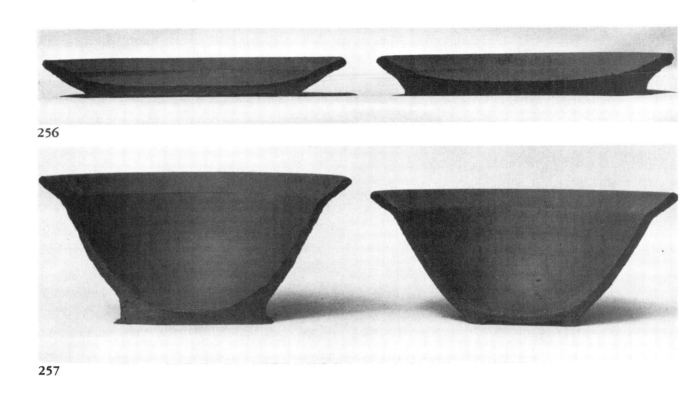

256

257

Deep Bowls and Flat Plates

The methods of throwing open shapes apply to throwing deep bowls as well as flat plates. It may be helpful, therefore, to compare the process of throwing them, using the same amount of clay for each.

To throw a flat plate of approximately twelve inches at the widest diameter [256] and a deep bowl [257], six pounds of clay are centered on a bat. The clay for the bowl, once it is centered, is spread to a block six inches wide at the bottom [258]; the clay for the plate to ten inches [259].

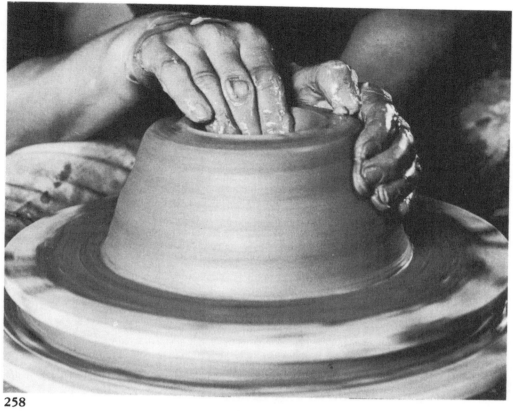

258

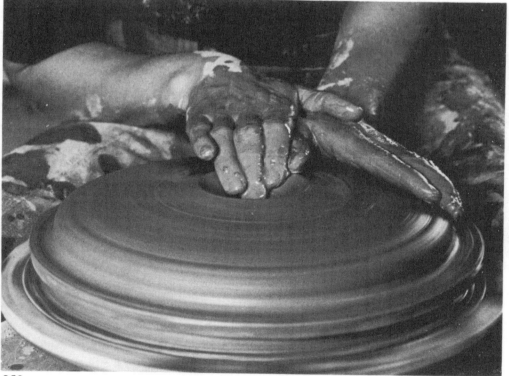

259

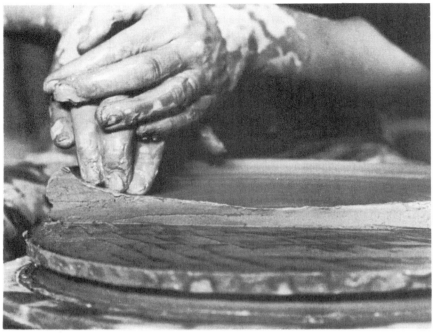

260

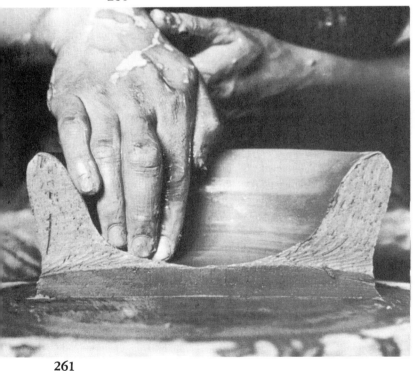

261

The hole is dropped in the clay for the plate to slightly less than double the thickness of the wall [260], while for the bowl slightly more is left at the bottom to accommodate the curve of the bottom [261]. When opening up, the rise in the bottom of the plate is gradual [260], while for the bowl the curve is steep [261].

Packing the bottom is done in the same way in both cases, though to a much greater extent in the plate since the bottom is 90 percent of the plate [260, 261].

In raising there is relatively little to do in the plate. Since it may be hard to get the joint of the finger under on the outside, the fingertips can be used in raising. For the bowl, raising is an important step. The walls have to be kept thicker, particularly at the rim and near the bottom. The degree to which the wall tapers outward reflects the final curve of the bowl [262, 263].

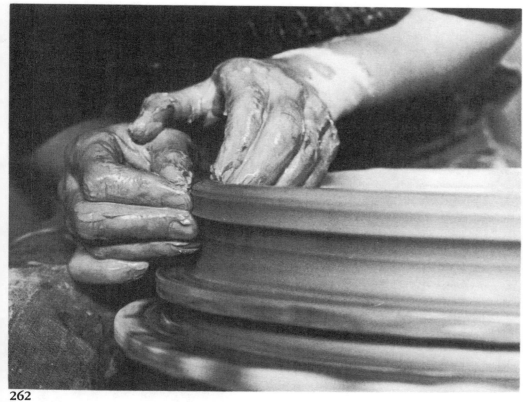

262

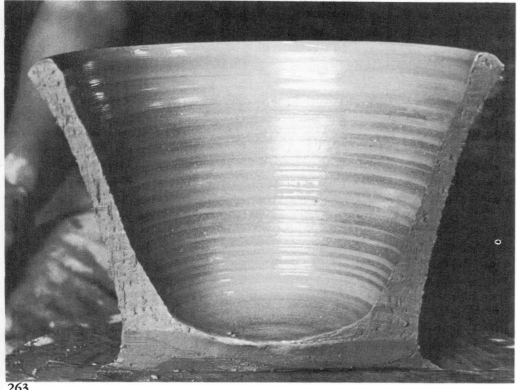

263

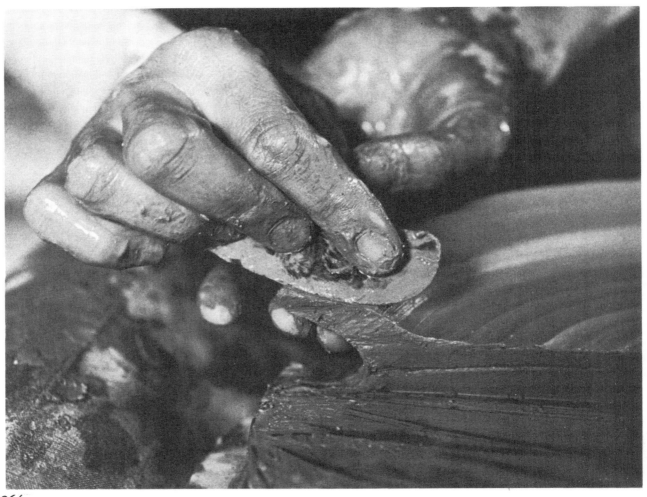

264

In shaping, all that has to be done on the plate is to continue the curve on the inside and create a strong rim either by changing the direction of the wall or by thickening the rim [264].

The walls of the bowl have to be shaped very carefully, keeping in mind the centrifugal force of the rotating wheel and the fact that clay cannot project outward very much without collapsing. The eye is on the inside rather than the outside of the bowl. The bowl may be shaped either from the rim down or from the bottom up. When using the flexible rib, the hands may re-

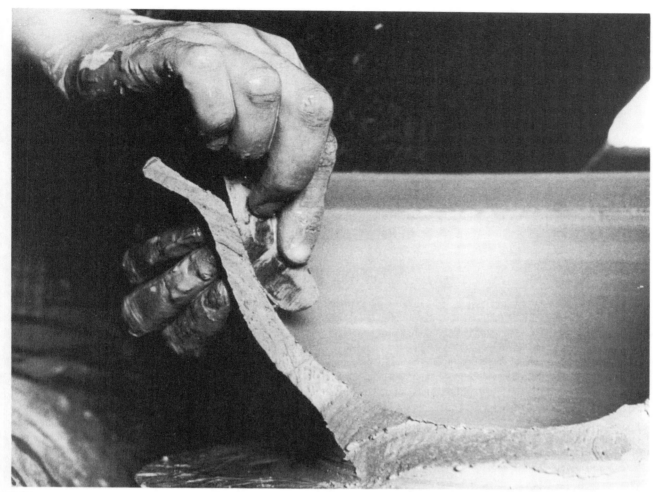

265

verse, with the left hand on the outside and the right hand on the inside of the bowl [265].

In trimming, the foot of the plate is placed near the edge [256]; the foot of the bowl, on the other hand, is closer to the center [257].

There is often the temptation to make a plate perfectly horizontal, with a small flange for the rim and without a foot. In my experience plates like these have a tendency to bulge up in the middle during firing. If the plate is thrown with a slight upward curve toward the rim and equipped with a foot, it is structurally much stronger.

APPENDIX

Ceramics is a broad, complex field. I have discussed just one of its major techniques—pottery thrown on the wheel—and have ignored handbuilding and sculptural techniques, pottery made in molds, and such topics as the history of pottery. Much or all of this is adequately available in other books, some of which are given in the Bibliographical Note. This appendix is intended to provide summaries and reminders of information the beginning potter can obtain in greater detail from other sources, but it is information that I feel is necessary to put wheel throwing in context.

Clay and Clay Bodies

Clay was formed by a geological weathering process from the igneous rock that formed the crust of the earth. Chemically, clay is a hydrated aluminosilicate, which means that it contains alumina and silica as well as chemically combined water. No clay, however, is that pure in its chemical composition. Clays vary a great deal and this variation is due to the fact that the parent rock might have had chemical additives, plus the fact that the clay, when transported from the original site by wind, water, or glacier, picked up what might, in a purely chemical sense, be called impurities.

Under the microscope the shape of all clay particles is flat and six-sided. These particles cling to each other; at the same time they slide on each other if sufficient water is present. The size of the particle varies a great deal, because the extent of the weathering process was different and/or the transportation of the clay resulted in sedimentation of different-size particles at different places, as well as grinding some of the clays into finer particles.

What all this means to the potter is that there are many different clays at his disposal that vary in their chemical composition and in their physical form.

Before going into the various types of clays, however, we have to discuss the properties that all clays have in common, as well as the terms that apply to all of them.

The terms "slip," "plastic," "leather hard," and "bone dry" refer to the amount of water added to the clay by the potter. This water is called the water of plasticity and should not be confused with the chemically combined water. Chemically combined water is driven off in the kiln when the temperature reaches 600 degrees.* No amount of soaking will put it back. The water of plasticity evaporates during the drying process prior to firing. This water can be returned to the clay time and time again by soaking the clay in water.

Greenware refers to all unfired ceramic ware.

All fired ceramic wares are classified according to the temperature at which the clay matures and fires well. Earthenware refers to all ceramic forms fired to about 1,800 degrees; stoneware is fired to about 2,300 degrees; porcelain is a white, translucent ware that has been fired in excess of 2,300 degrees. Each of these requires a different clay body and glaze.

All clays have four properties in common that are important to the potter. The various types of clay may differ in the degree to which a particular property applies, but most rules for working with clay can be deduced logically from these four properties:

1. Clay is plastic when sufficiently wet, due to the flat shape of the clay particle and the fact

* All references to temperature will be given in Fahrenheit.

that the particles cling to each other at the same time as they slide on each other. Plasticity is the quality that lets you push and stretch the clay without losing its shape. Clays vary a great deal in their plasticity, since plasticity depends largely on the particle size.

2. Clay shrinks as it dries and when it vitrifies. This fact should always be in the back of the potter's mind. The clay shrinks twice: first, when the water of plasticity—the lubricating water between the particles—evaporates, causing the particles to draw closer together. This means that the shrinkage depends on the particle size and the amount of water present. The shrinkage that occurs during vitrification is due to the fact that certain components of the clay melt, thereby tightening the structure of the clay.

The consequences of shrinkage are many. Clays of vastly different water content, physical makeup, and type cannot be joined. Clay walls of different thicknesses shrink at different rates; this may cause cracking. Non-shrinking materials cannot be used as *armatures,* and if non-shrinking materials like *grog* or fiberglass are added to the clay body, they have to be of a fine *mesh.* In drying and firing, provisions have to be made for the movement of the clay; in other words, the bottom of the pot should not stick to the board or shelf; in fact, a layer of fine grog is often put underneath very large pieces to facilitate the movement. Forms that touch the board or shelf in more than one place should be put on a clay slab that shrinks at the same rate. This releases the stress on the form. When stacking a kiln, tall pots should overhang another shelf only if the clearance takes the shrinkage of the pot into account.

3. Clay hardens as it dries. This property is continually exploited by the potter. Freshly thrown pots are extremely susceptible to distortion. A leather-hard pot, however, may be put

upside down and handled without fear of distorting it. If you want to build a form outward, you have to do so in steps, letting the clay become leather hard before putting any more weight on it.

4. Clay vitrifies when subjected to sufficient heat. This means that a chemical change takes place when the pot is fired. The clay becomes hard, durable, and, in the case of stoneware, impervious to water and acids. The transformation is total and the pot is virtually reborn in the firing. Vitrification occurs at different temperatures with different clays.

Clays, because of their variation in chemical composition and physical form, vary in color, texture, firing range, plasticity, and shrinkage. The potter has to select one that fits his needs. Although not impossible, it is difficult to find a type of clay that fits your requirements without alteration. For this reason most potters want a specific clay body, that is, a mixture of different types of clays and other minerals suitable to their needs and fitting their requirements as regards firing range, color, texture, shrinkage, and plasticity.

Among the most frequently used clays for such clay bodies are earthenware clays, ball clays, fire clays, and kaolins. Clays in each of these groups share certain characteristics and can be expected to behave in a certain way.

Earthenware clays are clays that mature at about 1,800 degrees. Their color and degree of plasticity varies a great deal. Depending on the amount of iron present, the clay may fire to a buff, brown, or black color. They may either be of high or low plasticity.

Ball clays are clays that are extremely fine-grained and therefore very plastic. They mature at about 2,300 degrees and fire to a buff color. Their small particle size accounts for their tremendous shrinkage.

Fire clays are clays that are very refractory.

They mature in excess of 2,700 degrees. Their particle size varies a great deal and their plasticity, therefore, varies accordingly. Usually they are quite coarse. Their color is buff.

Kaolins are clays that are white, very refractory, and almost always not very plastic. Most kaolins are clays that are found near the parent rock, which accounts for their "pureness."

Precise information about particular brands of any of these clays may be obtained from the company that mines them.

To formulate a clay body, decide what the characteristics of the clay should be. For a throwing body the right balance of plasticity and tooth is important. A clay that is too plastic tends to slump when one throws larger shapes. The firing range of the clay body you use is determined by the temperature that you fire the kiln to, and the color of the fired clay is determined by the likes and dislikes of the potter. The shrinkage of a clay should never exceed 15 percent.

Once the characteristics have been decided on, find a clay that comes as close as possible to these requirements; start with it as a base and make the necessary adjustments.

The addition of ball clay will increase not only the plasticity but also the amount of shrinkage.

The addition of fire clay will increase the maturing point of the clay body and, if a coarse fire clay is used, also add tooth to the clay.

The addition of earthenware clays will bring down the maturing point and, depending on which kind of clay is used, add plasticity and change the color.

The addition of kaolin raises the maturing point and has an effect on the color of the clay body. It decreases the plasticity of the clay.

Non-plastic materials may also be added. Grog, which is fired clay that has been ground to a variety of mesh sizes, decreases the amount of shrinkage of the clay body, adds tooth, and opens the clay body up so it can dry evenly. Ten percent is suggested for most throwing bodies, but clay bodies used for hand building and sculpture may contain 20 percent.

Flint, an indispensable ingredient in glazes, raises the maturing point of the clay body and adds to its hardness, but it also increases the *coefficient of expansion.*

Feldspar, a *flux,* decreases the maturing point of the clay body, but it also increases the strength of the bond between clay and glaze.

The formulation of clay bodies is a science. Color, texture, shrinkage, and plasticity may be the main concern to the potter, but the coefficient of expansion and the ability to absorb thermal shock also have to be considered. The plasticity of clay not only depends on particle size but also on the age of the clay mixture, the presence of carbonaceous material, the surface tension of the water of plasticity and even the electrical charge of certain types of clay particles.

Most potters arrive at a clay-body formula by a general knowledge of the types of clay available and experimentation. The beginning potter should go to an experienced potter for help, rather than to ceramic supply houses. The clay bodies sold there are often formulated by ceramic engineers and are not the result of practical experience. A combination of the technical knowledge of the ceramic engineer and the practical experience of the potter is essential. Any clay-body formula should be thoroughly tested before you mix large quantities. The tests should include a shrinkage test, an absorption test, and actual use under the same conditions in which the clay will be used. A clay-body formula is a very personal thing and what is perfect for one potter might not suit another.

Clay bodies can be mixed by the potter by simply weighing the ingredients, mixing them dry, and adding them to water to make a slip slurry.

This slurry is allowed to soak thoroughly for at least twenty-four hours. It is then poured onto plaster bats and allowed to dry to the proper consistency.

If large amounts of clay are used, this is very 'laborious, to say the least. Clay mixing machines, though expensive, can mix several hundred pounds in a short time. The kind of clay mixer that is adapted from a dough mixer is usually faster than the kind that extrudes the clay and requires premixing of the dry materials.

Commercial ceramic supply houses mix and sell clay bodies; they can be purchased in any amount from ten pounds to one ton. Buying small amounts of clay is expensive. Since clay improves with age and can be kept moist for months if it is properly covered, you should buy more than your immediate needs. Commercial outfits will mix clay according to your own specifications, but it is almost always necessary to buy one ton at a time. If you accept the formula of a supply house, be sure and test it prior to ordering large amounts.

Forming Techniques

Clay forms can be produced in many different ways. Whenever one thinks of clay forms, whether they are functional or sculptural, one has to think of them in terms of a hollow form made by hand-building techniques, throwing, or casting.

In this discussion it is impossible to deal with all the forming methods, but I will point out certain rules that apply to all, in particular to hand-building methods. Hand-built forms are usually arrived at by joining pieces that may be slabs, coils, or pinches of clay. In general, when joining clay, there are two different types of joints: butt and overlap. In a butt joint two pieces of clay butt against each other without overlapping. This type of joint is the weaker one of the two and additional clay has to be added to the joint on at least

one side for reinforcement. When one uses the overlap joint, it is enough to smooth the clay down on one side. The seams of the joints may be left untouched on one side to form a linear pattern on the pot.

Plastic clay will adhere to plastic clay, but when joining plastic clay to leather-hard clay and leather-hard clay to leather-hard clay, it is necessary to score deeply the surfaces to be joined and apply slip to soften the clay and act as a glue.

Refinements of form and surface can be achieved by paddling the form with a slightly absorbent tool, such as a wooden spoon. A variety of shapes can be used. Paddling should be done when the clay is leather hard, and it should be used to refine and clarify a form, rather than totally change it. Whenever possible, joints should be paddled slightly. This realigns the clay particles and makes the joint much stronger.

All forms, in particular composite forms, should be allowed to dry slowly and evenly. Since pots dry from the top down, it may be necessary to turn the pot upside down to ensure even drying. When the form does not allow this, the parts that seem to dry faster should be covered with plastic sheets.

Glazes and Glazing

Glazing is a very complex science that involves the use of many different materials. Within the context of this discussion I will deal with just enough technical information so that glazing can be done intelligently. I will in no way try to deal with the formulation of glaze recipes, or with the whole range of glazing effects.

Daniel Rhodes, in his *Clay and Glazes for the Potter,* defines glaze as "a glassy coating melted in place on a ceramic body." This glassy coating is composed of a number of minerals and metals that have been ground to a fine powder, carefully

weighed out according to a glaze recipe, mixed with sufficient water to make a glaze batch or slurry, applied to the pot, then fused by heat to the pot.

All glazes, since they are a form of glass, have to contain silica, a mineral that melts at 3,000 degrees and cools without forming a crystalline structure. This makes it one of the most important glass formers. In order to reduce the extremely high melting point of silica, it is mixed with other minerals that allow it to melt at a lower temperature. There are dozens of these minerals at our disposal. They are called fluxes. The choice of a particular flux depends on the desired melting point of the glaze and the effect the flux has on the texture and color of a glaze. Besides the combination of silica and fluxes, a glaze has to contain alumina. Alumina increases the viscosity of the glaze, which means that, instead of becoming a liquid like water, the glaze at the molten stage is honeylike and therefore sticks to a vertical surface.

The combinations of silica, fluxes, and alumina produce a transparent or opaque glaze, which may be shiny or matte. They do not produce color.

In general, potters refer to these minerals as raw materials. Some raw materials may fulfill one or more functions. Feldspar, for instance, contains silica, alumina, and a flux that makes it a glaze all by itself at approximately 2,300 degrees.

Color is achieved in a glaze by the addition of certain metallic oxides to the glaze, such as iron, cobalt, rutile, etc. Combinations of metallic oxides may be used. Remember that the raw material in the glaze may have an effect on a particular color where its intensity and its hue are concerned. The atmosphere in a kiln may also influence the color.

In oxidation, copper produces green; cobalt, blue; iron, tan, brown, or black; manganese, brown; rutile, tan; nickel, gray or brown; chrome, green; and vanadium, yellow.

In reduction firings, the metallic oxides vary a great deal more in the colors they produce. Iron may produce celadons, but also a yellowish green, a brown, and a red-brown. Cobalt is always blue, copper may be red or green, rutile is tan, and manganese is brown. Almost all oxides, if used in excess, will produce a black.

Certain metallic oxides may change the melting point of a particular glaze if they are added in large amounts. Iron is a particularly strong flux, while rutile is refractory. The potency of the metallic oxides also differs. One half of 1 percent cobalt in a glaze will produce a blue color, but iron, copper, and manganese have to be added in the amount of 2 to 4 percent to have any effect on the glaze.

The number of raw materials used in a glaze varies a great deal. Some glaze recipes are very simple; others may contain as many as fifteen ingredients.

One glaze recipe reads like this:

feldspar	60
whiting	12
kaolin	11
flint	15
zinc	2
red iron oxide	4%
rutile	2%

The numbers refer to a weight unit; and any weight unit may be used as long as it is carried through consistently, e.g., ounces, grams. The metallic oxides are usually given in terms of a percentage of the total weight of the base formula. The base formula is the glaze recipe without the metallic oxides used to produce the color.

Glaze recipes are usually arrived at, like clay bodies, by a general knowledge of the most commonly used raw materials and much experimentation. Most recipes are passed on and modified to

fit particular needs, and hundreds of them can be found in books and magazines. But, as with clay-body formulas, they must be carefully tested before putting them on a prized pot.

The raw materials are weighed very carefully and added to water, starting with the ingredients that are clay and have a low specific gravity. These first ingredients will keep the materials with high specific gravity, like feldspar and flint, in suspension. One percent bentonite, a very fine mesh clay, may be added to any glaze formula to help keep the glaze materials in suspension.

Only experience can teach you to judge the proper amount of water for the proper consistency of the glaze slurry. The glaze slurry must be screened to make sure all the materials are mixed properly and there are no lumps.

Applying glaze to the pot is done by brushing, dipping, pouring, or spraying. Brushing usually results in uneven application, although this may be a desirable effect. Lay the glaze on once when brushing; do not brush back and forth or you will remove more glaze than you put on. Pouring and dipping, or both, are most commonly used, because they save time and use less glaze.

Spraying produces an even coat of glaze and is particularly useful for complicated and large shapes. A spray booth with a fan and ventilation system must be used to avoid inhaling hazardous glaze materials.

The procedure for glaze application is governed by several considerations:

1. Most raw materials are in suspension in the glaze and not in solution; therefore, the glaze mixture has to be stirred thoroughly just prior to use.

2. The bisqued pot is like a sponge with a limited capacity for absorption. The absorbency depends on the temperature of the bisque firing: the higher the temperature, the less the absorbency. When the pot is exposed to the glaze slurry,

the pot absorbs the water and the raw materials are deposited in a layer on the pot.

3. Not only does the appearance of a glaze vary with different thicknesses, but if a glaze is applied too thickly, it will run or crawl, that is, pull away from the pot during firing. The thickness depends on several factors: the consistency of the glaze slurry, the length of time the pot is exposed to it, and the degree of absorbency of the bisque. A glaze should never be applied thicker than one sixteenth of an inch. If a glaze crackles when it dries before it is fired, the application is too thick. In most such cases the glaze will have to be washed off and the pot left to dry, and be reglazed.

4. Glaze will not stick to ware that is dusty. This defect will appear only when the glaze pulls away from the dusty places in firing. To avoid this, the pot has to be washed off with a damp sponge before glazing. But avoid wetting the pot too much, since this will reduce the absorbency of the bisqued pot.

5. Glaze will act like a glue in firing and fuse together whatever it touches. The pot must be totally free of glaze wherever it touches the kiln shelf.

When glazing, follow these steps:

Wash the bisqued pot off with a damp sponge.
Stir the glaze.

Apply the glaze by brushing, dipping, pouring, or spraying. If the inside of the pot and the outside are done separately, do the inside first, usually by pouring. Then wash off any accidental drips on the outside and glaze the outside.

Wash the glaze off the bottom of the pot. In the case of covered jars, clean those areas of the jar and cover that touch each other.

A common mistake of the novice is to try a great variety of glazes; the belief that this is what will make his or her pottery interesting is false. The experienced potter usually works with a

imited number of glazes, but exploits the full potential of each one.

The appearance of glazes can be varied in several ways. Variations in thickness will result in a different effect with most glazes. A glaze that is opaque when applied thickly may be transparent or semitransparent when applied thinly. The clay under the glaze will affect the outcome. Or a glaze may be brown with a thin application and yellow with a thick coat.

A glaze may be changed by the addition of a metallic oxide. The color of the glaze can be modified by painting a layer of metallic oxides, mixed with water, under or over the glaze. Rutile and vanadium have to go on top of the glaze; otherwise, their refractoriness will make the glaze crawl. The colorants that are already in the glaze batch must be taken into account at all times. It is easier to darken a light glaze than to lighten a dark one. A dark-brown glaze, for instance, will never be blue because the iron darkens the glaze so much. A white glaze, however, can be turned into various colors of different intensities by painting metallic oxides on or under the glaze.

Two or even three glazes may be put on top of each other. The combination will be totally different from the effect of any one of the glazes. One has to be careful not to be heavy-handed.

Glaze chemistry is a precise science. Substitutions of materials should be attempted only if one has a good knowledge of their chemistry. The use of ceramic materials has to be well organized. Most raw glaze materials are white and cannot be distinguished from one another. Precise labeling of materials is essential. When glazing, the mixtures should be marked and kept separate. Tools should be washed between each use. Some glaze materials are poisonous.

Lead or lead compounds, which are extremely poisonous, are the most frequently used flux for earthenware glazes and should be used with great caution. For safe and proper use of lead glazes, refer to W. G. Lawrence, *Ceramic Science for the Potter,* **pp. 200ff.**

In general, earthenware glazes tend to be shiny and brightly colored. Their surfaces, however, are softer and less impervious to acid than stoneware glazes.

Stoneware glazes tend to be muted in color. Brilliant reds and yellows are impossible to achieve. Their surfaces, however, are much more resistant to acids. Lead is not used as a flux, as it becomes volatile at stoneware temperature.

Typical porcelain glazes are transparent or semitransparent to emphasize the whiteness and translucency of porcelain clay. The bond between clay and glaze increases with temperature; the bond is highest with porcelain, where no clear demarkation can be detected.

Detailed information on special glazing effects such as lusters, fuming, Egyptian paste, salt glazing, and raku can be found in Daniel Rhodes, *Clay and Glazes for the Potter.*

Glazing is just one way of treating the surface of the pot. One can fire the pot to maturity without further treatment. Some clays have interesting colors and textures, particularly if they are fired in a reducing atmosphere. If the whole piece is left untreated, it may be put into a glaze firing without first going through a bisque firing.

The color of the clay itself may be altered by the use of certain metallic oxides as stains, in particular iron and manganese. Iron oxide and manganese are mixed with water and applied to the clay as a wash. This results in a darkening of the clay body rather than in a glassy coating. The colors after firing are different from those achieved when these oxides are used as part of a glaze. Staining can be done on greenware as well as on bisqued pottery. Shading and highlighting on a textured surface can be accomplished in a very controlled and subtle manner by partially rub-

bing the stain off. In the case of bone-dry green-ware, this can be done with a dry sponge or rag, or even with your hands. In the case of bisque ware, the stain can be rubbed off with a damp sponge.

Staining is particularly successful on top of light-colored clay bodies. To lighten a dark clay body is more difficult. Sometimes rutile, mixed with water and a tiny bit of any glaze or flux to cut down its refractory quality, will accomplish this.

Clays of different colors can be used as slips on the clay body to change its color in some areas. They have to be applied on greenware, preferably when leather hard. Kaolin makes a stark-white slip and can be colored with metallic oxides. Slips are usually applied with a brush, and because of their opacity, they work on any clay. After bisquing, a glaze, particularly a transparent or semitransparent one, can be put over the slip.

Slips, stains, and untreated clay can be used in conjunction with glazes. Glazed and unglazed areas can very effectively be played against each other on a pot.

A record should be kept of all glazing and decorating methods for future reference.

Kilns and Firing

Firing may well be the most exciting part of the process of making pottery. When the clay is exposed to heat, it changes radically, both in its physical form and in its chemical composition. It goes through various stages, the most important of which are the expulsion of the atmospheric moisture at 220 degrees and the expulsion of the chemically combined water at 600 degrees. The expulsion of the chemically combined water is the first major chemical change and is irreversible. Quartz conversion, a change in the silica crystals,

and the change of all clay components into oxide form, occur by the time the pot reaches the stage of vitrification, the final step in firing. Vitrification means that certain components of the clay melt and form a crystalline structure within the clay. This causes the hardness and durability of the fired clay. Vitrification, if carried to an extreme, results in complete melting. A clay body is mature when vitrification has taken place to the extent that the clay is hard and durable and, in the case of stoneware and porcelain, impervious to water and acid. As we have seen, clays mature at different temperatures and it is essential to know the maturing point of your clay.

Firing schedules have to take these changes into account. The first critical change is the expulsion of the atmospheric moisture and chemically combined water. The water is driven off in the form of steam, and because of the force of steam and the danger of explosions that would burst the pot, you must proceed slowly with the firing at this point. Depending on the complexity of the shape and the thickness of the ware, as well as the denseness of the clay body, three to five hours should be allowed to reach 1,000 degrees. Very thick sculptural pieces are fired even more slowly at this stage. At the time of oxidation of all components, at 1,600 degrees, it is essential that enough oxygen be present in the kiln. Vitrification should also be allowed to proceed slowly and evenly throughout the kiln, since shrinkage occurs at this stage. Depending on the type of ware that is fired, the kind of clay body used, and the temperature one fires to, firings take between six and twenty-four hours. After the desired firing temperature has been reached, all holes in the kiln are closed to slow down the cooling of the kiln. As a rule of thumb, the cooling period should be at least as long as the firing period. The pieces should not be removed from the kiln until they can be touched with bare hands.

In firing we distinguish between bisque and glaze firing. If the ware is to be glazed, most potters bisque-fire their ware, which means they fire to a point just before vitrification starts. This way the ware is still absorbent but strong enough to be handled in glazing. After glazing, the ware is fired to the proper temperature for clay and glaze.

The most reliable way to measure the heat in a kiln is with the use of pyrometric cones. Cones are small pyramidal shapes an inch or two high made from ceramic materials. They are numbered from 014, the lowest, to 14, the highest normally used in pottery. The numbers correspond to the temperatures at which the cones bend. Potters never talk about temperature in terms of degrees but in terms of cone number. Cones are so reliable because it is not only the degree of heat that makes them bend but also the length of time they are exposed to heat.

Methods of firing have changed radically over the last five thousand years and have evolved from piling pots over a few sticks of wood and covering them with branches to kilns with highly sophisticated heat-control units and burner systems.

Studio potters distinguish between kilns that are heated by electricity and those that are heated by burning a fuel—oil, gas, or wood. Electric kilns are always fired with a neutral or oxidizing atmosphere, while fuel-burning kilns may be fired in a reducing atmosphere, which means that, during the final stages of the firing, the oxygen input is cut down to produce a reducing flame. This results in the formation of carbon monoxide. This carbon monoxide is hungry for oxygen and strips the metallic oxides in the clay and glazes of oxygen, thereby "reducing" the oxygen content of the metal. This very often results in a different color in the clay and glaze. Iron is especially susceptible to reduction. The reduced form of iron, FeO, has a lower melting point than Fe_2O_3 and

therefore fuses more. This makes clay bodies that are beige in oxidation a warm brown in reduction. Specks in the clay that look like thin needle points in oxidation spread out in reduction. Firing in a reducing atmosphere demands not only a fuel-burning kiln but also surroundings that are fireproof and equipped with a good ventilation system.

Kilns, particularly fuel-burning kilns, are a major investment. Many potters today build their own kilns, but this should not be attempted without a thorough knowledge of all the materials involved and considerable experience in the various kiln-firing techniques.

Kilns are made of refractory firebrick. Firebrick comes in two forms, soft and hard. Soft firebrick is light, porous, and therefore a good insulator; it may be cut with a hacksaw or pruning saw. It comes rated according to the temperature it can withstand. A 23 firebrick should be exposed to only 2,300 degrees. Soft firebrick is very expensive and tends to fatigue faster than hard firebrick. Hard firebrick is heavy, hard to cut, and not as good an insulator. It is rated as high duty and super duty and is cheaper, but it needs additional insulation. Most commercially built kilns and all electric kilns are made of soft firebrick.

In an electric kiln the heat is conducted through coils, called elements, set into the brick on the inside. A good electric kiln should have Kanthal (a registered trademark) wiring. Electric kilns come as top loaders or with a side door; top loaders are cheaper.

The electric kiln should be equipped with a number of switches, so that no more than two rows of elements are on one switch. Each switch should be calibrated for low, medium, and high to allow for control over the heat advance. For school use, most kilns come with an automatic shut-off. There are two types: one that holds the

pyrometric cone in metal prongs—when the cone bends, the prongs move and turn the kiln off; the metal prongs disintegrate fast and make this type of shut-off unreliable. A shut-off that works in conjunction with a pyrometer, though a great deal more expensive, is more reliable. The best way is to watch for the cones to bend and shut the kiln off manually.

Fuel-burning kilns are designed to include burner opening, a firebox, and an inside wall, called the bag wall, that deflects the flame so that it does not directly hit the ware inside. While the inside space of electric kilns can be used entirely for the pots, fuel-burning kilns often lose up to one half their inside space to the firebox, bag wall, and areas left free so air can circulate freely. The designs of fuel-burning kilns are varied, but generally are divided into two types, updraft and downdraft. In an updraft kiln the flame comes in at the bottom, is deflected up by the bag wall, and goes out the top. This type of kiln is easier to build and cheaper. However, it results in wasted heat and usually does not fire as evenly as a downdraft kiln.

In a downdraft kiln, the flame is deflected up by the bag wall and drawn down and out the flue in the bottom by the draft created by the chimney. Downdraft kilns are more expensive to build and buy because of the chimney, but they use heat more efficiently, since it is circulated up and down through the kiln; they also tend to fire more evenly. Heat-measuring devices other than cones are unreliable in fuel-burning kilns, since the reducing atmosphere quickly decomposes metal.

The burner systems on fuel-burning kilns vary. A kiln may be equipped with a number of small burners or two large ones. We distinguish between a natural-draft burner which works very much like a Bunsen burner, and a forced-air burner with an electric blower. An oil burner always needs a blower for complete combustion. Wood-burning kilns really test the dedication and patience of a potter. Continuous stoking is necessary over long hours of firing. The speed of stoking is critical. Those using wood-burning kilns, however, strongly believe that the results well justify the effort.

Fuel-burning kilns may not be installed just anywhere. They are a potential fire hazard and should be installed according to local law and operated only by an experienced potter.

Stacking the kiln is mostly a matter of common sense. There are only two rules to observe. In bisque kilns the pots may touch each other, the walls of the kiln, and the posts; the pots have to be bone dry before bisquing. In a glaze kiln, pots may not touch each other or the walls or the posts. To stack kilns, posts and kiln shelves are needed. Hard firebricks, cut by a motorized masonry saw, make excellent posts. Kiln shelves have to be made of silicon carbide for stoneware and porcelain firing; mullite and fire-clay shelves are sufficient for earthenware firing. For glaze firing, kiln shelves must be coated with kiln wash, a mixture of kaolin and flint, which acts to separate glaze drips and the silicon carbide.

In a school situation kiln space is precious. Every cubic inch has to be used. Fuel is costly and a tightly stacked kiln is important. It is therefore wise to group according to size all the pots ready for the kiln. In a bisque kiln pots may be stacked on top of and inside each other, but caution is advised. Do not put a heavy pot on a pot with a thin rim. When stacking pots inside each other, a pot should sit directly on the bottom of the pot beneath it. Careful planning is essential when stacking a small kiln. Place the posts into the kiln first; use three for each shelf, one in the middle of one side and two at the ends of the opposite side. When putting the pots in, remember to fill corners with small pots, and make sure that none of the pots is taller than the posts. Place small

balls of clay rolled in alumina hydrate—a very refractory material that acts as a separator—on the posts and place the shelf on top. Be careful not to sprinkle any of the alumina hydrate on the pots; it will leave a rough mark. For the next layer, place the posts directly over the posts below so the weight is carried through to the floor of the kiln. In general, the shorter pots are placed at the bottom, the taller ones toward the top. This makes the stack more solid.

The smaller the kiln, the more dead space there is in relation to the usable space.

Buying a kiln should be done carefully. Let yourself be guided by the same principles as in buying a wheel. Get advice from experienced potters. Compare the various brands and investigate thoroughly what grade of material has been used. Consider the options. Buy a kiln built for the professional, not for the hobbyist, and buy with the future in mind.

266

Wheels

Wheels come in many varieties. Unfortunately, the popularity of thrown pottery has resulted in the manufacture of some bad wheels. The purchase of a wheel should therefore be approached as carefully as the purchase of a car. If purchased properly, a wheel can be considered a lifetime investment. Its choice should therefore depend, not on present skills, but on future plans.

One can group the wheels that are available today into treadle wheels, kick wheels, and variable-speed electric wheels. Treadle wheels should be eliminated because the potter has to be in constant motion moving a treadle sideways with one foot while keeping the upper body steady.

Kick wheels [266–8] consist of a heavy flywheel that is kicked with the right foot, an axle shaft that transfers this motion to the wheelhead, and a sturdy frame, either wood or metal. Kick wheels are made so that one can sit [266, 267] or stand [268]. The potter first kicks the flywheel into motion, then throws while the momentum of the heavy flywheel keeps it going. When the wheel slows down, the clay is released, the flywheel kicked, and the throwing then resumed. Throwing and kicking are never done at the same time.

A good kick wheel needs a sufficiently heavy flywheel of no less than one hundred pounds, good bearings, a sturdy frame that does not rock when the wheel is kicked, a comfortable footrest, and an adjustable seat.

Kick wheels can be purchased in kit form or,

267

since their mechanics are quite simple, can be designed and built from parts of other machines. The axle of a car makes a perfect shaft, the flywheel may be cast concrete or a wooden frame filled with sand or bricks, and the wheelhead can be purchased separately. The advantages of a kick wheel are complete control over the speed, particularly when one wants to go very slowly; quiet operation and reasonable cost; and the simplicity of the design. It is best used for small and medium-size pots. The disadvantages are that it is difficult to throw large pots, particularly tall ones. The energy spent in kicking a wheel all day is considerable. This problem can be eliminated by using a kick wheel with a motor that can be engaged to the flywheel to give it the momentum.

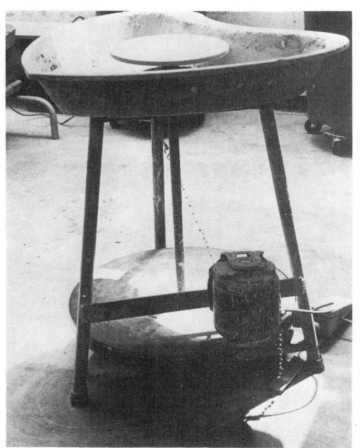

268

269

270

271

The disadvantage of the motorized kick wheel is that the sudden increase in speed may jar the pot off center.

Most electric wheels [269–71] are smaller and lighter than kick wheels. The wheelhead should rotate freely, even when the motor is not turned on, and it should be located in such a way that one can cradle it between one's legs. The splash pan should be easily removable for cleaning and in case it gets in the way.

The rpm range should always be from zero to 160 or 200, and should be infinitely variable within that range.

Depending on the horsepower rating of the motor, an electric wheel can turn as much as one hundred pounds of clay.

The power transmission from the motor to the wheelhead can be through belts, cones, or a worm-gear reducer, the latter being the most reliable.

The most common speed control works by controlling the voltage. Some speed controls are mechanical. On such wheels, be sure the mechanical parts are as simple as possible and well made, so they do not slip and jam. The speed control should always be operated by the foot so the hands are free to throw. Some have dual controls, for hands and feet.

The advantages of a good electric wheel are obvious. Less space is taken up, it can be moved easily, one's energy can be put into throwing rather than kicking the flywheel, and there is no limit to the size of the pot that can be thrown.

The disadvantages center mostly around the problems of buying the right wheel and the high cost of a good wheel.

As I pointed out before, buying a wheel should be approached the same way as buying a car; this is particularly true when one buys an electric wheel, since few people will understand the technical data.

First, go to several experts, experienced potters, for advice. A reliable source of information is the ceramics department of a college. Usually several types of wheels are used, and most students and faculty are quite vocal about the advantages and disadvantages of a particular wheel. For an electric wheel to hold up over five years in a school pottery shop without repairs is the equivalent of the use of the wheel by one potter for a lifetime. Buy your wheel from a dealer who is the authorized distributor of that wheel for the area and has a good reputation for making repairs promptly. Do not buy a wheel that has to be shipped across country for service.

Do not buy a wheel you may soon outgrow. A wheel that can handle fifty pounds can always handle five pounds; the reverse is not always true. Buy a wheel built for a professional even if you are a hobbyist. Stay away from wheels with fancy seating and splash-pan arrangements. Some electric wheels come in kit form, but be sure the savings are substantial enough to justify the hours spent in assembling the wheel.

GLOSSARY

ARMATURE—support used in sculpture

BAG WALL—the wall on the inside of a fuel-burning kiln that deflects the flame from the ware

BALL CLAY—a clay with a very fine particle size

BASE FORMULA—the part of a glaze formula without the metallic oxides that act as a colorant

BAT—a disk made out of exterior plywood, masonite, chipboard, or plaster on which one throws shapes that are difficult to lift off the wheelhead

BENTONITE—a very fine-grained clay used mostly as a suspender in glazes

BISQUE—the firing in which the temperature is brought up to a point just before vitrification sets in

BONE DRY—completely air-dried

CALIPERS—tool used to measure diameter of forms

CHUCK—any form that can hold a pot that has to be trimmed upside down and cannot rest on the rim; usually a pot thrown for the purpose

CLAY BODY—a mixture of different types of clays and minerals for a specific ceramic purpose

COEFFICIENT OF EXPANSION—index of the amount of expansion of a material when heated

CONTACT AREA—area of the hand that touches the clay during the throwing process

CRAWLING—a glazing defect caused by dirty bisque or a glaze application that is too thick

EARTHENWARE—all ceramic ware that matures below 1,800 degrees

ELEMENTS—the electrical coils inside an electric kiln

FIREBOX—part of a fuel-burning kiln where the flames enter and are deflected up

FIREBRICK—a brick that can withstand the high temperature that a kiln is fired to

FIRE CLAY—a clay with a high maturing point

FIRING RANGE—the range of temperatures at which a clay becomes mature or a glaze melts

FLUX—the group of minerals that reduce the melting point of silica

GLAZE BATCH—mixture of glaze materials and water

GLAZE FIRING—the final firing

GREENWARE—all ceramic ware prior to firing

GROG—fired clay ground to various mesh sizes

KAOLIN—a white, refractory clay with low plasticity

KEYS—small balls of clay used to hold a pot on the wheelhead during trimming

KILN WASH—mixture of kaolin and flint that is painted on one side of the kiln shelf to act as a separator between the glaze drips and the shelf

LEATHER HARD—stage of the clay between plastic and bone dry

MATURING POINT—the temperature at which the clay becomes hard and durable

MESH—screen size; the measurement of particle size

MINERAL—earthy substance with a definite chemical formula

OXIDATION—the method of firing where complete combustion takes place, or the type of firing that results from the use of an electric kiln

PLASTIC—the condition of the clay where it is neither too wet nor too dry to work with

PORCELAIN—all ceramic ware made of a white clay and fired above 2,300 degrees

PRESSURE AREA—the area on the hands that exerts pressure on the clay during the throwing process

PYROMETER—device used to measure the temperature inside a kiln by measuring the thermo-electric charge of two dissimilar metals

PYROMETRIC CONE—a small pyramidal form com-

mercially made from ceramic materials and used to measure the heat in the kiln

RAW MATERIALS—the minerals that are used in the formulation of a glaze

REDUCTION—the method of firing in which the incomplete combustion of the fuel produces free carbon monoxide, which in turn strips the metallic oxides in the clay and glazes of oxygen

REFRACTORY—resistant to melting

REPROCESSING—reclaiming clay that is either too wet or too dry to be worked with by soaking it in water until it breaks up and then pouring it on plaster slabs to dry to the proper consistency for reuse

SLIP—clay at a mayonnaise consistency

SOCKET—the part of a cover that is inserted into the jar

STONEWARE—all ceramic ware fired between 2,100 and 2,300 degrees

TOOTH—roughness

VITRIFICATION—the melting of certain clay components and the forming of a glassy structure within the clay

WATER OF PLASTICITY—the water that makes clay plastic

WEDGING—method of kneading clay to make it homogenous

WHEELHEAD—the rotating disk on which the pot is thrown

BIBLIOGRAPHICAL NOTE

Daniel Rhodes, *Clay and Glazes for the Potter,* is an excellent source of detailed information on clay, glazes, and firing for the studio potter, while W. G. Lawrence, *Ceramic Science for the Potter,* deals with the same subjects from a more scientific point of view; it is a good supplement to Rhodes.

F. H. Norton, *Fine Ceramics, Technology and Applications,* deals with the technology of clay, glazes, and firing, as well as commercial production methods, without reference to the studio potter. It is nonetheless a useful source.

C. F. Binns, *The Potter's Craft,* and Bernard Leach, *A Potter's Book,* are classic pottery books. Dealing with the history of ceramics, clay, and glaze technology, as they apply to the studio potter, and firing and forming methods, they are nevertheless very personal books reflecting their authors' approach to the field of ceramics.

For a more philosophical approach to pottery, Marguerite Wildenhain, in *Pottery: Form and Expression* and *The Invisible Core,* shows how clay shapes the potter. M. C. Richards, *Centering in Pottery, Poetry, and the Person,* takes centering as a starting point for developing a philosophy of life.

For potential kiln builders, Daniel Rhodes, *Kilns,* and *The Kiln Book* by Frederick L. Olsen, give a thorough look at kiln-building materials, design, and operation, while Hal Rieggers, in *Primitive Pottery* and *Raku,* offers a historical look at kilns and at alternative ways of firing.